PACIFIC COAST

AMERICA'S SCENIC WESTERN SHORELINE

BY STEVEN L. WALKER

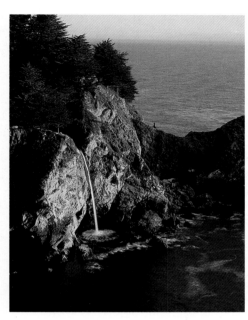

Above: Waterfall at McWay Cove in Julia Pfeiffer Burns State Park along the Big Sur Coast.
PHOTO BY LARRY ULRICH

Special thanks to Dorothy K. Hilburn for her writing, editing and research contributions and to Julie Nicole Graff for her research, editing and writing assistance.

Front Cover: Cuffy Cove near the town of Elk on the Pacific Coast of Mendocino County.
PHOTO BY CARR CLIFTON

Background: Surf-rounded rocks on Fanshell Beach, Monterey Peninsula, California.
PHOTO BY CARR CLIFTON

Left: The rugged Big Sur coastline south of the Monterey Peninsula in Central California.
PHOTO BY LARRY ULRICH

Back Cover: Sunset glow paints a delicate picture on boulders at Salt Point State Park, California.
PHOTO BY CARR CLIFTON

Below: Courting Caspian terns share a fish.
PHOTO BY JEFF FOOTT

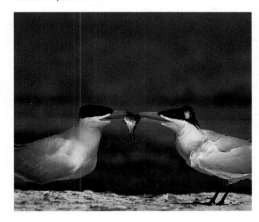

 CAMELBACK
GROUP, INCORPORATED

 CANYONLANDS
PUBLICATIONS & INDIAN ART

Designed by Camelback Design Group, Inc., 8655 East Via de Ventura, Suite G200, Scottsdale, Arizona 85258. Phone: 602-948-4233. Distributed by Canyonlands Publications, 4860 North Ken Morey Drive, Bellemont, Arizona 86015. For ordering information please call (520) 779-3888.

Requests for additional information should be made to: Camelback/Canyonlands Venture at the address above, or call our toll free telephone number: 1-800-283-1983.
Library of Congress Catalog Number: 95-70820
International Standard Book Number: 1-879924-22-6

Proudly printed and bound in the U.S.A.

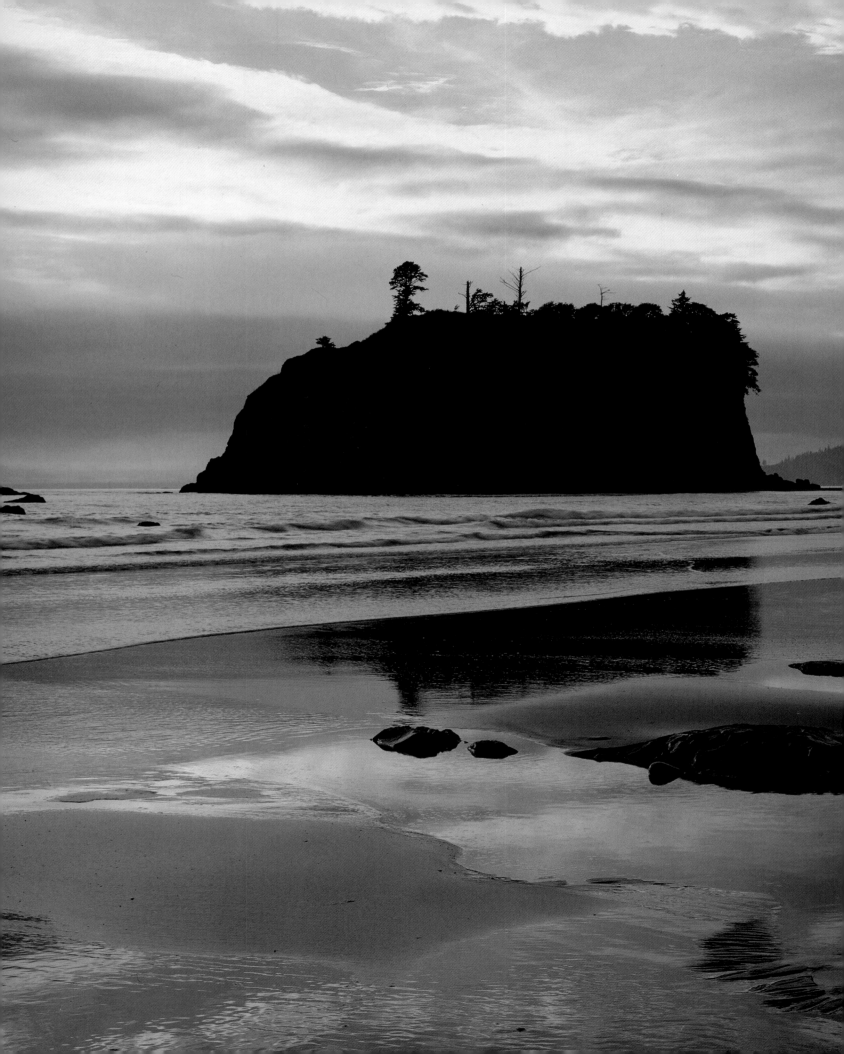

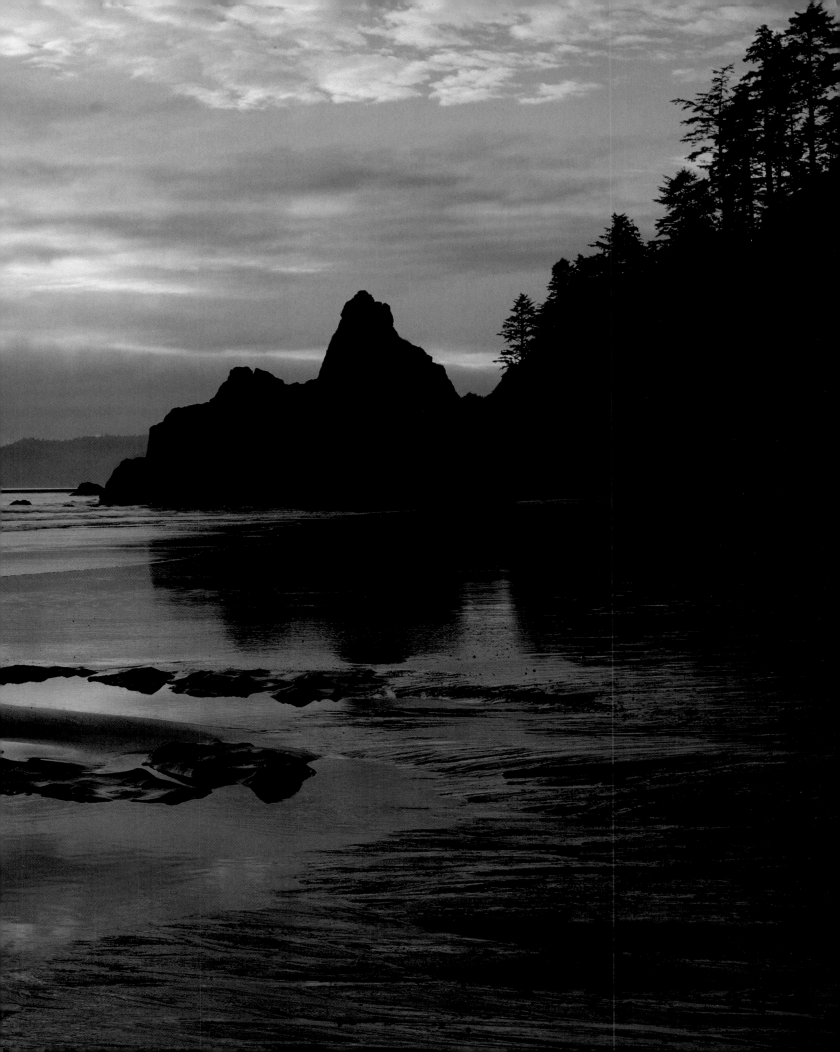

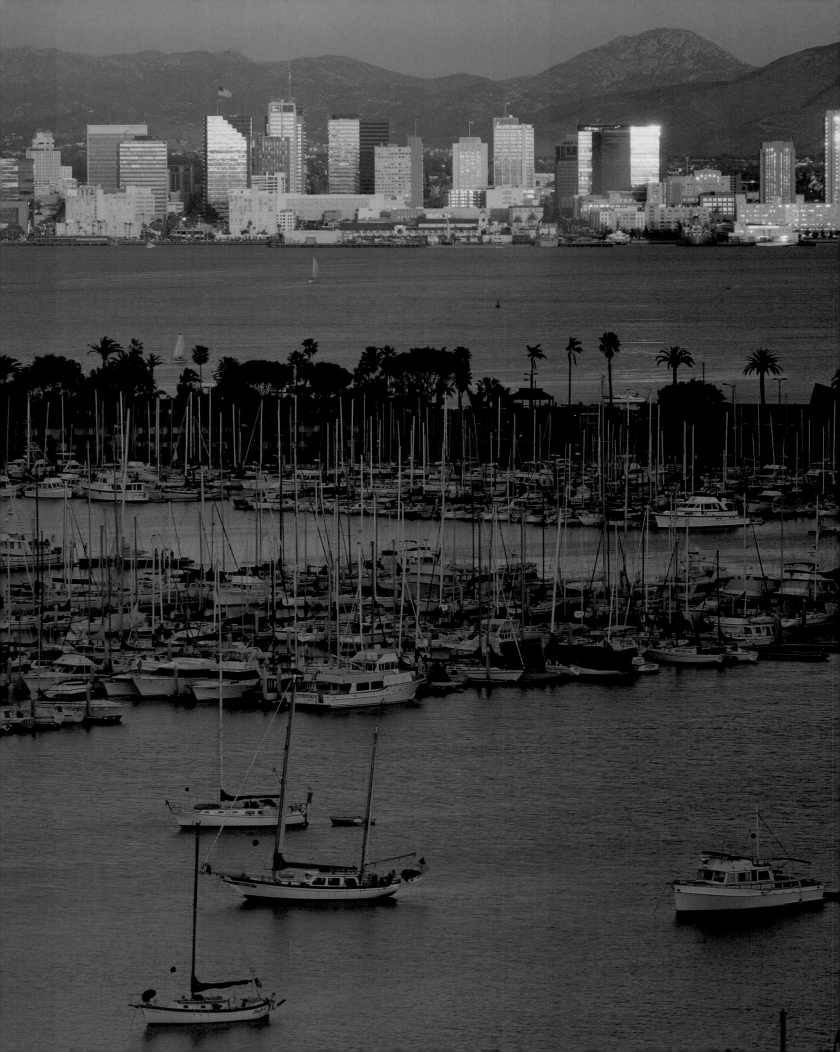

SOUTHERN CALIFORNIA

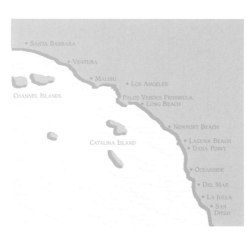

The Southern California Coast, from San Diego to Ventura, features some of the best weather in the Northern Hemisphere. Humidity levels are low, and mean average temperatures are in a comfortable range throughout the year. The picturesque coastal views, coupled with a robust economy in the region since the end of WWII, has led to growth that has raised populations to increasingly higher levels.

The Pacific Coast, the leading edge of the North American Continent, was shaped by the relentless pounding of the Pacific Ocean, forever eroding shorelines as it pounds rock to pebbles and pebbles to grains of sand. Cliffs and headlands are assaulted by storms working their way inland from the ocean and tides, or waves, endlessly shift smaller rocks and sand from beach to beach. Rivers and streams draining into the Pacific form estuaries and bays. The Pacific, from the Spanish word meaning "peaceful," is far removed from a tranquil environment.

The earliest inhabitants of the Pacific Coast migrated from Asia via an ancient land bridge across the Bering Strait during the Pleistocene Epoch, or Ice Age, at least 11,000 years ago and perhaps as many as 37,000 years ago, or more. The exposed land bridge allowed grazing animals and early hunters access to the New World in migrations that lasted until the end of the last Ice Age, around 11,000 years ago.

The first Europeans to enter the region were Spaniards with the expedition of Juan Rodríguez Cabrillo, in 1542, who sailed into San Diego Bay on September 26, while searching for a passage to the Atlantic Ocean and for wealth for the Spanish Crown. Finding neither, further exploration of the coast was postponed sixty years until Sebastián Vizcaíno sailed to San Diego on November 10, 1602.

After surveying the area, Vizcaíno withdrew, and it was yet another 160 years before the Franciscans began establishing missions along the coast. In 1769, four expeditions were sent by Spain to claim the northwest coast of the Americas. Gaspar de Portolá commanded the expeditions, two by sea and two by land. In his company was Junípero Serra, a Franciscan in charge of converting natives to Christianity.

On July 16, 1769, Junípero Serra founded the Mission Basilica San Diego de Alcalá, the first of 21 missions in California that stretched from San Diego to Carmel. The missions were built 30 miles apart so that a journey from one to the next would be roughly equivalent to a day's walk. Indians working the missions produced distilled spirits, raised crops and tended herds and flocks to benefit the mission.

In 1821, Mexico gained independence from Spain and mission lands were released to the Mexicans, beginning the California Rancho period. Southern California, no longer a Spanish possession but not yet a territory of the United States, was now a part of Mexico.

In January of 1848, gold was discovered at Sutter's Mill and the Americans flooded into California. On February 2nd of the same year, Mexico ceded its California holdings to the United States through the Treaty of Guadalupe-Hidalgo. California was now a United States territory, two years later statehood arrived.

With the Americans came the Germans, Irish, Portuguese, Chinese, Dutch, French, Italians and other settlers, a kaleidoscope of cultures that continued to expand as Japanese, Koreans and Vietnamese arrived during this century, all adding their influences to the Golden State.

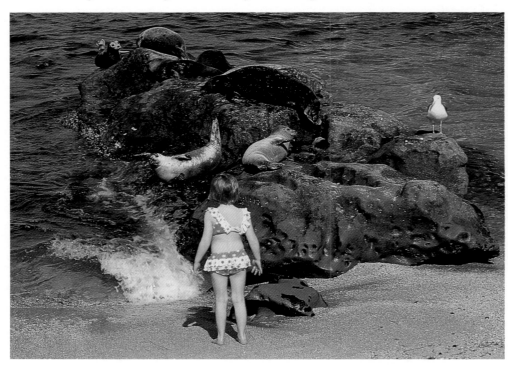

Preceding Pages: Sunset reflects on the shoreline and outlines sea stacks at Olympic National Park, Washington.
PHOTO BY JEFF GNASS

Left: Sunset from Point Loma highlights the San Diego skyline as dusk settles over Shelter Island Yacht Basin in spring.
PHOTO BY JEFF GNASS

Right: Harbor seals, a California gull and a young girl study one another at Children's Beach, La Jolla.
PHOTO BY GREG VAUGHN

SAN DIEGO...

In the heady days of Spanish exploration, no potentially rich land was too far away to conquer. Juan Rodríguez Cabrillo found himself afloat on the glittering Pacific waters in 1542,

Above: Mission San Diego de Alcalá, founded by Padre Junípero Serra on July 16, 1769, was first in a series of twenty-one Spanish missions in California that stretched from San Diego to Sonoma.
PHOTO BY DICK DIETRICH

searching for a passage to the Atlantic Ocean and wealth for the Spanish Crown. He sailed into San Diego Bay on September 26, although further exploration of the area was postponed sixty years until Sebastián Vizcaíno sailed to San Diego on November 10, 1602.

Vizcaíno came in search of pearls, as well as to survey the area. He bestowed upon it the name San Diego, in honor of Saint Didacus. After surveying the area, Vizcaíno withdrew and transformation of the native inhabitants

to Christianity was delayed for more than 160 years until Spanish Franciscan missionaries began to establish missions along the coast.

In 1769, four expeditions were sent by Spain to claim the northwest coast of the Americas. Captain Gaspar de Portolá commanded the expeditions, two by sea and two by land. In his company was Padre Junípero Serra, a Franciscan in charge of converting natives encountered to Christianity.

Portolá and Serra traveled separately with the land expeditions and reached San Diego nearly three months after the sea expeditions. June 29, 1769, Captain Portolá arrived to find the sea faring members of the expeditions in poor condition, with much of the crew lost to scurvy. Survivors were sent to gather additional supplies and Portolá considered aborting the mission. When additional supplies eventually arrived, Portolá decided to press on.

On July 16, 1769, Junípero Serra founded the Mission Basilica San Diego de Alcalá, the first of 21 missions in California. Padre Serra was instrumental in establishing nine other missions that stretched from San Diego to Carmel. Five years later, under the guidance of Padre Luís Jayme, the mission was relocated. Lack of water, poor soil conditions and a limited labor supply demanded the move. In December of

1774, construction of a mission six miles to the northeast was completed. The Mission Basilica San Diego de Alcalá story extended three centuries as building continued through the 1890s and it was rededicated in 1931.

El Camino Real, Spanish for The Kings Road, represented the missions which were built 30 miles apart so that a journey from one to the next would be roughly equivalent to a day's walk. Mission residents produced spirits, grain and olive oil, raised herds and flocks, and tended vineyards and orchards. In 1821, Spain

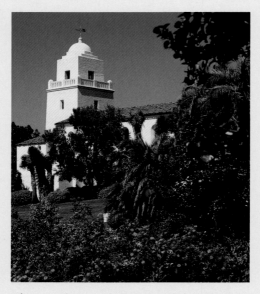

Above: Junípero Serra Museum. Junípero Serra, a Franciscan with a doctorate in theology, established nearly half of California's missions.
PHOTO BY DICK DIETRICH

lost its hold on Mexico and the missions were secularized. Mission possessions were released and the California Rancho period began. San Diego, no longer a Spanish territory but not yet a United States territory, was now a part of newly formed Mexico.

San Diego's first primary election was held on December 18, 1834, and when the elected officials took office on the first day of 1835, San Diego was officially a pueblo of 47,000 acres granted by Mexico.

In January of 1848, gold glittering at Sutter's Mill sent US citizens into a frenzy. And, on February 2, the gold fields and surrounding lands were transferred to the United States by the Treaty of Guadalupe-Hidalgo. California was now a United States territory, with statehood arriving just two years later.

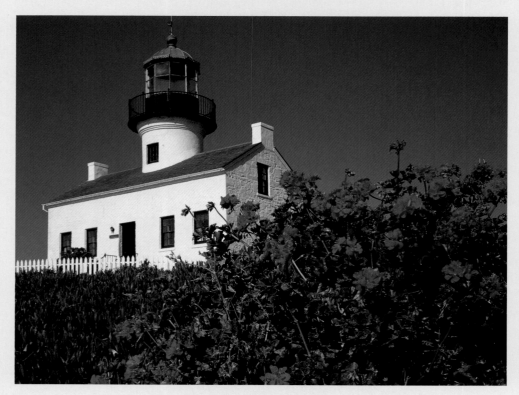

Left: Old Point Loma Lighthouse, Cabrillo National Monument, San Diego. Built in 1854 of sandstone and brick, Old Point Loma Lighthouse is one of only eight New England style lighthouses found on the West Coast. By 1891, heavy fogs caused the lighthouse to be abandoned. Its duties were assumed by the new Point Loma Lighthouse.
PHOTO BY JEFF GNASS

In 1867, Alonzo Horton foresaw potential in the San Diego area and purchased 960 acres of land for $265, where he built Horton Wharf and Horton House Hotel, both well-equipped to handle hordes of new settlers to New Town. New Town's survival was secured when Old Town, the original Spanish settlement, burned to the ground in 1872.

2,600 people populated San Diego in 1880. Five years later, a railroad connected San Diego to the rest of the country, bringing the "Boom of the Eighties." By 1887, some 40,000 people inhabited the city. A lack of jobs turned boom to bust and only 16,000 remained a year later. Construction of the Naval Base, in 1917, proved a catalyst for San Diego's continued growth.

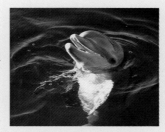

Right: The sea life at Sea World on San Diego's Mission Bay is educational and entertaining.
PHOTO: JEFF FOOTT

HISTORY OF BALBOA PARK...

Much of San Diego's growth has been reflected in the development of Balboa Park, one of the first land areas in the United States to be reserved purely for recreational purposes. In 1868, when the park idea was first blossoming, the area looked little like it does today. There were no trees and the only mammals present were coyotes, rabbits, bobcats and squirrels. Wildflowers consisted of pansies, violets, monkeyflowers (or mimulus), mallows, penstamens, hyacinths and white popcorn.

A livelier landscape was envisioned by many. In 1889, a tree-planting club was established by Dr. J.P. LaFevre who collected $1 per month, per member, for trees to be planted on the west side of the park. The Ladies Annex raised an additional $500 and planted even more trees.

Kate O. Sessions is credited with most of the landscaping. Called the "Mother of Balboa Park," she planted most of the initial trees. She leased 30 acres of City Park, later renamed Balboa Park, for a nursery when her Coronado nursery site became too small. The city asked for 100 trees per year for the park and 300 trees for use in other areas as her rent. This annual rent was often exceeded. Initially, her seeds were imported from South America, Asia, Australia, Spain, Baja California and New England. She grew Monterey cypress, jacaranda, cork oak, Torrey pine, pepper tree and stately eucalyptus.

San Diego Wild Animal Park, in San Pasqual Valley, Escondido, is operated by the Zoological Society of San Diego and features expansive habitats.
PHOTO BY CHUCK PLACE

Kate O. Sessions won the Meyer Medal for Foreign Plant Importation from the American Genetic Association in 1939, the first woman to be so honored.

Where Ms Sessions used her green thumb in the park's conception, George White Marston used his considerable time and money. From beginnings as a clerk at Horton House, he later was to own a very successful retail operation. His first love may well have been education, he opened a free reading room and many of his monetary contributions still benefit several colleges. His interest in education was equal to his love of nature. He used his own funds to bring a New York expert to San Diego to help plan the

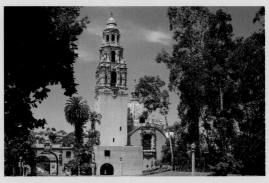

Balboa Park, San Diego. PHOTO BY DICK DIETRICH

park. As Park Commissioner in 1903, Marston oversaw construction of the park's infrastructure and its original plantings. In 1929, he presented Presidio Park and the Junípero Serra Museum to the city of San Diego.

October 10, 1910, City Park was officially and eponymously renamed Balboa Park for Spaniard Vasco Núñez de Balboa, the first European to see the Pacific Ocean from the Gulf of Uraba. Harriet Phillips, an area resident, submitted the name in a contest held to name the park.

San Diego city officials decided to showcase the city by promoting an exposition. Colonel David C. Collier and the Panama–California Exposition Company organized an exposition to be held in 1915. It was a grand success for Collier.

Colonel Collier, his title granted by an appreciative governor, was said to have been San Diego's greatest asset by many. His participation in the 1915 Exposition included suggesting Balboa Park as its location and the progress of the human race for a theme. He also proposed that the Navy be allowed to use some of the exposition buildings during World War I. Collier's own time and money were generously spent as he lobbied in Sacramento and Washington, D.C. for funding. His work received national acclaim as he continued to promote and produce national and international expositions. In 1922, he was U.S. representative to the Centennial Exposition in Brazil. Four years later, he became Director-General of the Sesqui-Centennial celebration in Philadelphia. Finally, in 1933, he gave the theme, "Century of Progress," to the Chicago World's Fair. His hard work and idealistic views have not been forgotten. On Plaza de California's west wall one can find a bas-relief of the Colonel as well as a remembrance honoring his varied talents.

Exposition groundbreaking on July 19, 1915, was a success, drawing visitors from around the world. In 1935, another two year exposition was held after many of the original buildings were

refurbished. More than 7 million people visited the second exposition, spending a much needed 30 million dollars in San Diego during the Great Depression.

Each exposition was followed by a world war. During World War I, Balboa Park was used for Naval Training and in World War II, the park was again utilized by the Navy. The art gallery and museum sheltered the sick and dying, while the Federal Building and the Balboa Park Gymnasium served as sleeping quarters for San Diego based servicemen.

The San Diego Zoo is an important part of Balboa Park. Kate Sessions introduced the flora to zoo grounds and Dr. Harry Wegeforth, a surgeon for the first exposition, introduced the fauna. He envisioned the zoo in 1916 and made newspaper announcements seeking other interested townspeople. Only five people responded and attended the first meeting, so Dr. Wegeforth was basically forced to work alone. He was the zoo's first planner, manager, promoter, financial advisor and the sole financial supporter during its early years. He developed the Zoo Hospital and organized the Zoological Society. In 1922, Balboa Park made a magnanimous gesture and donated 200 acres of land to the zoo, albeit rough terrain that was hard to cultivate in an area then obscure and difficult to reach from the parking area.

Today, the San Diego Zoo is considered one of the finest in the world and is still entrusted to the Zoological Society of San Diego, although it is owned by the city of San Diego, which also owns the San Diego Wild Animal Park in the Escondido area. The Zoological Society of San Diego operates the San Diego Wild Animal Park facility which features expansive natural habitats.

Balboa Park, with its 1400 acres of mature flora and very diverse fauna, is the largest municipal park with cultural themes in the United States and is visited by millions from around the world each year, a proud monument to San Diego's past, present and future.

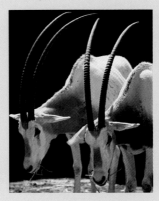

Scimitar-horned Oryx at Balboa Park's spectacular San Diego Zoo.
PHOTO BY CHUCK PLACE

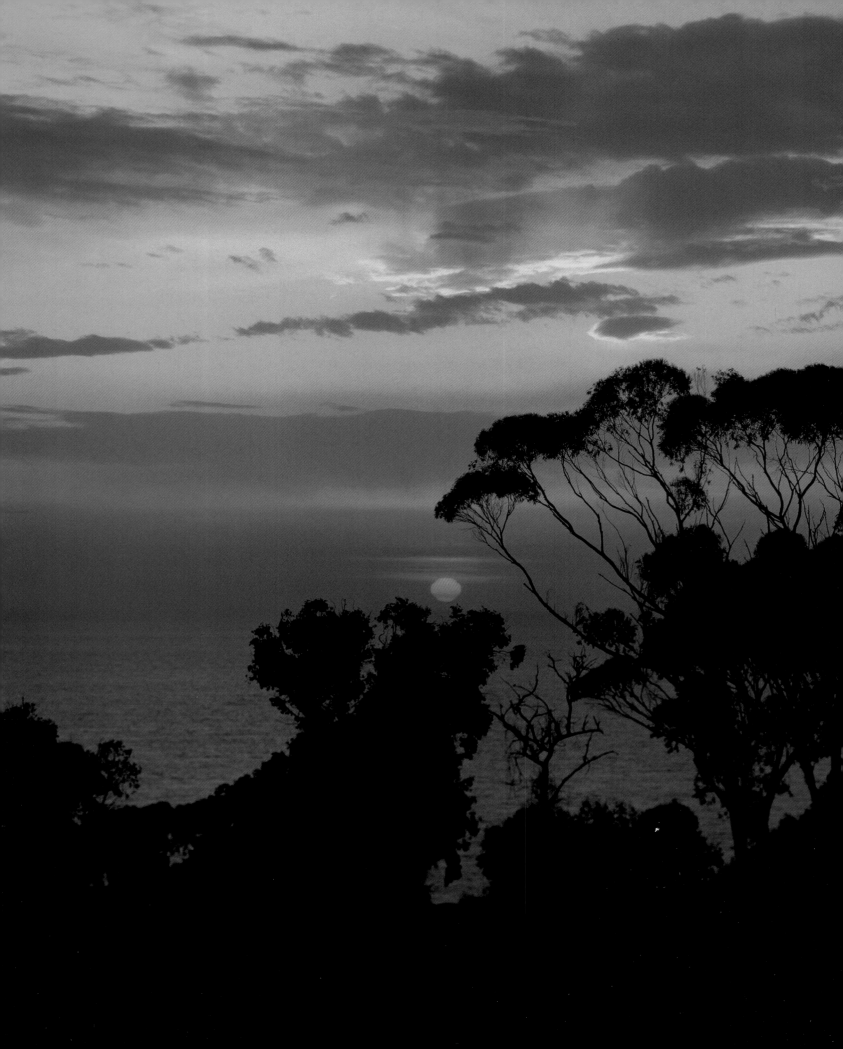

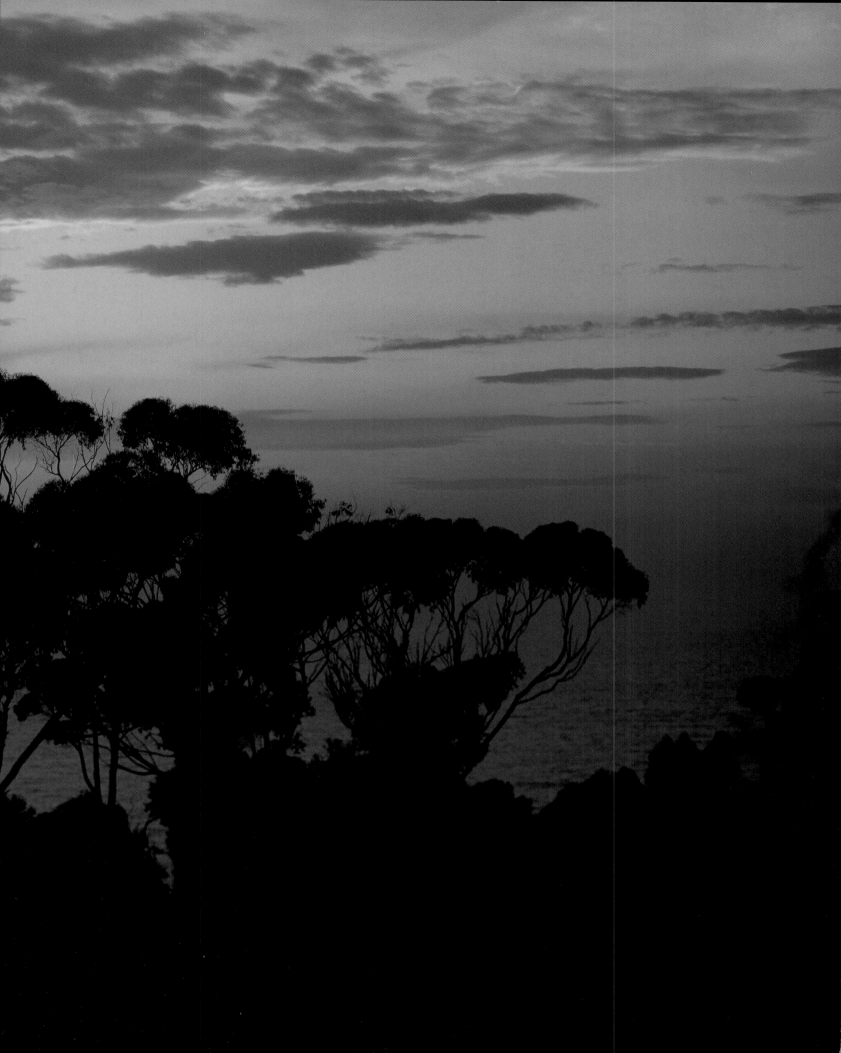

THE ORANGE COAST...

The coast of Orange County, with its mild year-round temperatures, is considered to be the home of some of the best beaches in Southern California. Although traffic can be a problem, the rock-free sands of Newport Beach, Corona Del Mar, Huntington Beach and Seal Beach are comfortable and clean for sunbathing and beach games. Headlands and tide pools of Laguna and San Clemente are as picturesque and teeming with wildlife as those found anywhere in the world. Doheny and Capistrano, in south Orange County, are less crowded than northern beaches and capture the feeling of days long gone by on much of the Southern California Coast.

Much of the coastal land of Orange County was contained in Spanish land grants. The successors to the Spanish

Above: Surf grass at Pelican Point, Crystal Cove State Park, Orange County (between Corona Del Mar and Laguna). PHOTO BY LARRY ULRICH

grants were able to use their huge blocks of land to shape Orange County's coastal region to fit their own master plans, releasing land for sale in small quantities to insure high land prices. In effect, creating a conceived limited supply and demand. Resulting high densities

of the developed areas will remain forever in not-so-silent testimony to the greed of a few.

Historically unique, Laguna Beach was one of the few areas along the Orange Coast not included in the Mexican land grants, which has allowed the area to be developed with a charm and natural beauty that no "master plan" can create. During the westward journeys of early California travelers, men on horseback and families in wagons went miles out of their way to squeeze through Laguna and Aliso canyons to enjoy the inspiring scenery from the cliffs and beaches of Laguna and South Laguna.

In the 1870s, settlers began home-steading Laguna, which remained a remote destination until the Pacific Coast Highway opened in 1926 and the area became much more accessible. Today, Laguna is known internationally for its active art colony and panoramic ocean vistas. Three

Preceding Pages: Eucalyptus trees at sunset on the La Jolla coast.
PHOTO BY: DICK DIETRICH

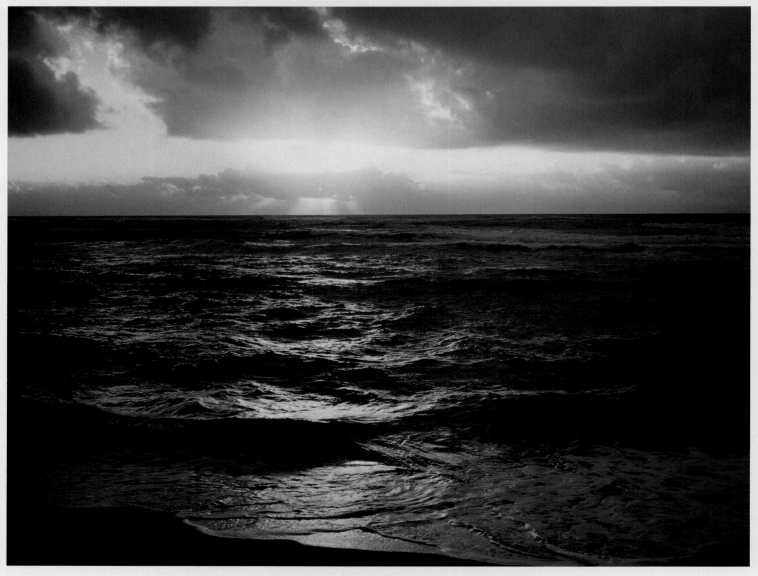

notable festivals occur annually in the city: the Festival of Arts and Pageant of the Masters and the Sawdust Festival. The Pageant of the Masters combines construction arts and live models to recreate historical art in an outdoor amphitheater. A sense of realism is created that has long amazed and captivated art lovers and critics. Laguna's festivals occur during the summer, taking advantage of near-perfect Pacific Coast weather.

Marine life along most of Orange County's coast is protected. Marine life refuges shelter California mussels, limpets, snails, barnacles,

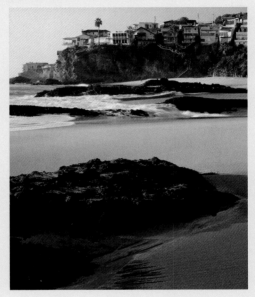

Above: Difficult access to Thousand Steps Beach in Three Arch Bay, South Laguna, has long kept crowds to a minimum, making the area a favorite with local beach goers.
PHOTO BY LARRY ULRICH

shore crabs, abalone and algae, as well as offshore wildlife including California sea lions, Cormorants and California brown pelicans. The northern part of Cresent Bay to the northern part of Laguna's Main Beach has been named an ecological preserve along with 752 acres of Upper Newport Bay, managed by the Department of Fish and Game, and 202 acres in the San Joaquin Freshwater Marsh Reserve overseen by the University of California.

In 1873, James and Robert McFadden arrived from Delaware to start a lumber and shipping business at the mouth of the Santa Ana River. Fifteen years later, the McFadden brothers built

Left: The sun sets over the tranquil Pacific Ocean off the Orange County Coast.
PHOTO BY DICK DIETRICH

Right: Mission San Juan Capistrano was founded by Franciscan Padre Junípero Serra in November of 1776, the seventh Spanish mission founded in California. On March 19th each year, St. Joseph's Day, swallows return to the mission from their winter migration to Argentina.
PHOTO BY TOM TILL

the Newport Beach pier, the first pier on the Pacific Coast, to off-load freighters at sea and moved their business to land purchased on the Balboa Peninsula. They named the surrounding area Newport.

Balboa was incorporated as part of the City of Newport Beach in 1906. The Balboa Pavilion, with its signature cupola on Newport Bay, was end of the line for the Pacific Electric Railway and a dance hall during the Big Band era, featuring top acts including both Jimmy and Tommy Dorsey, Glenn Miller, Benny Goodman and their bands. The pavilion was restored in 1962.

Balboa Island, connected by an auto ferry to the Balboa Peninsula, was annexed by Newport in 1916. During the 1930s Newport became more popular with the rich and famous and in ensuing years Harbor Island, Lido Island, Bay Island, Linda Island and Bay Shores were developed along with most of the buildable sites along the cliffs and bluffs overlooking the harbor and the Pacific Ocean.

Newport Harbor is home to more than 9,000 yachts, with roots that can be traced back to 1911 when the first yacht club was founded. Newport Harbor is the starting point of the 125-mile Ensenada Race, which ends in Baja

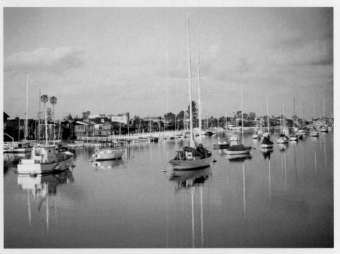

Above: Pleasure boats moored offshore of Balboa Island in Newport Harbor. More than 9,000 yachts may be found in Newport Harbor, the most popular anchorage on the West Coast.
PHOTO BY LARRY ULRICH

California's coastal town, Ensenada, Mexico.

Southern Orange County was first settled by Franciscan Padre Junípero Serra, the founder of Mission San Juan Capistrano in 1776. The mission influenced the region's early growth. Dana Point, named for Richard Henry Dana, author of the classic novel *Two Years Before the Mast,* was visited by Dana as a sailor on his voyage from Boston around Cape Horn to California in 1834, his ship stopping at the mission to collect hides. In 1924, early land developers named the area Dana Point in the author's honor, hoping to add romance and charm by association to their lot sales.

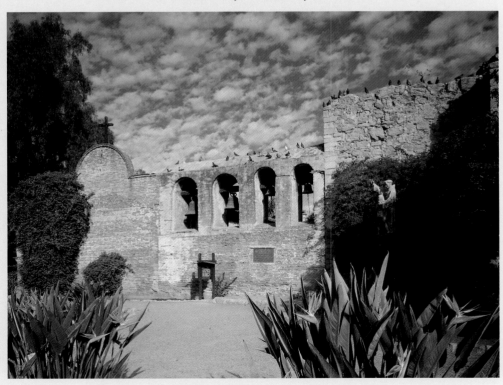

THE SOUTH BAY...

The beaches fringing Los Angeles are as varied and unique as their residents. As Pacific Coast Highway winds north, visitors pass the same beaches that inspired the rock groups of the sixties, whose music helped to make legend of the balmy weather, great surf and beautiful girls of California beaches.

Founded in 1888, Long Beach soon became popular as a premier beach resort known for its long, sandy beaches and calm surf. Today, Long Beach is the home to the *Queen Mary*, permanently docked there in 1967 after 1001 trips across the Atlantic Ocean. Visitors from around the world visit the *Queen Mary* just to stroll the stately decks of one of the largest oceanliners ever to sail the seas.

Once across the Vincent Thomas Bridge, San Pedro's popular windsurfing beaches beckon.

San Pedro's Wilmington and Terminal Islands form the Port of Los Angeles, one of the largest man-made, deep-water ports on the coast.

North of San Pedro are the beautiful bluffs of the Palos Verdes Peninsula. The peninsula is made up of a series of picturesque coves; Abalone Cove, Lunada Bay, Bluff Cove and Malaga Cove. Abalone Cove serves as an ecological preserve and offers those brave enough

SANTA CATALINA ISLAND...

A world away from California's busy streets lies an island paradise. Easy access by ship allows even the not-so-intrepid adventurer a refreshing change of pace, while traveling by sea plane is an Indiana Jones-like experience.

Santa Catalina Island formed as the Farallon Plate collided with the North American Plate about 100 million years ago. As the heavier oceanic plate slid beneath the continental plate marine sediments were changed by heat and pressure into the metamorphic rocks forming the island.

The island's earliest inhabitants date to somewhere between 4,000 and 5,000 years ago. The most recent inhabitants, Pimugnans, arrived from the Great Plains around 2500 years ago. The Pimugnan culture, 2500 inhabitants at its height, was almost completely eradicated by Russian sea otter hunters in the early 1800s. Survivors were relocated to the San Gabriel Mission for their protection, and thereafter referred to as Gabrielinos.

Portuguese navigator Juan Rodríguez Cabrillo discovered the island in 1542, naming it San Salvador. Sixty years later, Sebastián Vizcaíno renamed the island Santa Catalina Island and claimed it as a safe haven for Spanish treasure galleons bound for Spain.

Systematic raping of Catalina's resources were not the only illicit activities to flourish. In the 1800s, sea otter populations were devastated by Russians and Aleuts who sold sea otter furs to Chinese merchants in Canton. The Chinese, in return, replaced the sea otters with shiploads of illegal Chinese immigrants, using the island as a stepping stone to the United States. During Prohibition, the island was a favorite smugglers' haven, facilitating the flow of drugs and alcohol from freighters to the mainland via the island's more remote beaches and bays.

The island was granted to Thomas Robbins by Governor Pío Pico in 1848, beginning a history of private ownership. George Shatto, owner from 1887 to 1892, enticed tourists to Avalon, a resort and later the island's principal city. In 1892, the Banning family bought the island and formed the Santa Catalina Island Company, acquired in 1919 by William Wrigley, Jr., the chewing gum magnate. In 1929, at a cost of $2,000,000, the

Right: Seawater surges around kelp-covered rocks on Salta Verde Beach with the Palisades in the distance, Santa Catalina Island.
PHOTO BY JEFF GNASS

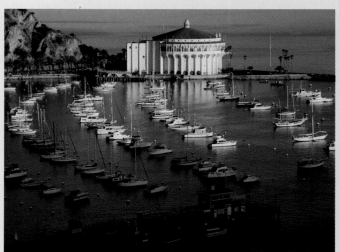

The Mediterranean styled Casino has been a landmark in Avalon Bay since its construction in 1929.
PHOTO BY JEFF GNASS

landmark Casino was built and attracted visitors to its gaming tables, which were then outlawed on the mainland and short-lived on the island. Santa Catalina Island Company's able leadership kept the island's tourism industry flourishing.

The Wrigley family, in a magnanimous gesture, donated 85 percent of the island's lands to the non-profit Santa Catalina Island Conservancy in 1972, to protect the island for all time.

Flora on the island's 75 square miles includes velvet cactus, prickly pear, cholla, black sage and

California sagebrush on the Pacific side. In higher elevations and coastal grasslands wild apple, California lilac and California mahogany abound. Catalina cherry, Catalina ironwood and island oaks are also found.

Land animals include American bison, black buck antelope, California ground squirrel, Island fox and mule deer along with feral cats, goats, and pigs. Birds include Catalina quail and Bewick wren, unique to the island, along with kingfisher, brown pelican, cormorant, great blue heron, bald eagle, red-tailed hawk, osprey and a variety of gulls, finches and more. The Institute for Wildlife Studies and the Catalina Conservancy aided in the salvation of the bald eagles and peregrine falcons on the island, near extinction in the 1950s.

Rattlesnake, garter snake, alligator lizards, side-blotched lizards, gopher snake, king snake and skinks scurry about dry areas. Slender salamander, arboreal salamander, Pacific treefrog and bullfrog are the island's amphibians.

The island's 54 miles of coastline support a variety of marine life. In shallow waters, kelp bass, sheepshead, opaleye and garibaldi dwell. Farther off the shore, marlin, tuna, sharks, pilot whales, barracuda, dolphin, gray whales and bat rays abide. Harbor seals, northern elephant seals and California sea lions can be found on rocks and buoys around the island.

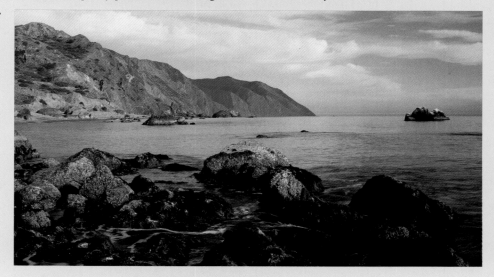

to traverse its steep paths some spectacular tidepools. Early developers intended to make the peninsula a millionaires' haven but the interruption of World War I changed their plans and the peninsula, with its gently rolling hills and spectacular ocean views, filled with the upper-middle class who settled in with alacrity.

Northward along the coast, travelers pass by the sandy white beaches of Redondo Beach into Hermosa and Manhattan Beaches. Both towns are filled with quiet neighborhoods, but draw crowds of weekend beach goers and sand volleyball players.

Marina Del Rey and Santa Monica are next on our trek along the coast of California. Once a duck marsh, Marina del Rey was developed in the late 1960s and is the largest man-made yacht harbor in the world, with over 10,000 slips. The marina is known for singles bars and luxury condominium complexes.

Venice Beach has been a popular gathering place for the odd and unusual since the early 1900s. Named after

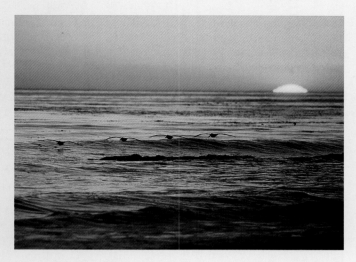

Right: Pelicans in formation at sunset.
PHOTO BY GLENN VAN NIMWEGEN

Below: Malibu pier at Surfrider State Park.
PHOTO BY LARRY ULRICH

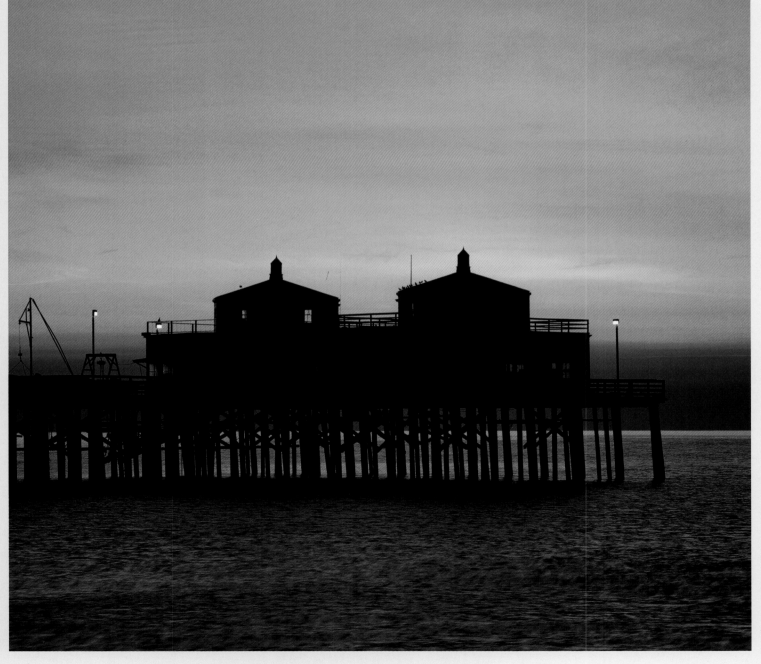

LOS ANGELES COUNTY...

Venice, Italy, by Abbot Kinney in 1905. Kinney had hoped to develop his 160 acres of marshland into an Italian wonderland, complete with canals and gondolas. Unfortunately, Kinney's plan was never completed. Today only a few canals remain and Venice is known more for Muscle Beach and string bikinis than canals.

With their easy accessibility to Los Angeles, Santa Monica and Pacific Palisades have been home to some of the most famous people in show business, including Mae West and Will Rogers, both residents of Santa Monica in its heyday. The Santa Monica Pier is a legacy left over from the turn of the century and enjoyed by many today. The antique carrousel and other carnival games are still popular with the local residents and visitors alike.

Last in the long line of Los Angeles beaches is the most famous beach of all, Malibu. It's the residents rather than the beaches that make Malibu so famous, although the beaches lined with their beachfront villas are very beautiful.

Resting on some of the most expensive land in all of California, Malibu has been a coveted and closely held secret from its beginning. Frederick Rindge bought the land, known as Malibu since the Chumash Indians occupied the area, and, with his wife May, tried to keep the rest of the world out of their own private paradise. They erected fences and even went so far as to dynamite their own roads in an effort to deny access to what they considered their private domain. Fortunately, shortly after his death in 1905, a decision by the Supreme Court upheld the states' right to build a road along the coast, through the Rindge estate.

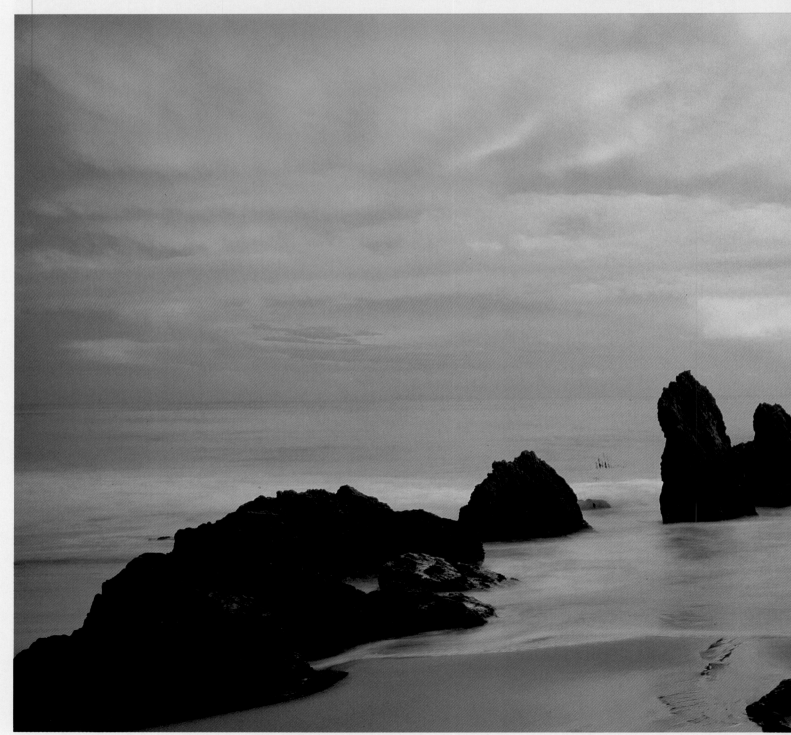

In keeping with the grandeur of the natural scenery, Malibu is home to the J. Paul Getty Museum, built to house the billionaire's art collection. Mr. Getty died before completion of the present building but left the museum in trust, making it the richest museum in the world and enabling acquisitions of any work of art the trustees deemed appropriate.

Malibu's population is not restricted to the beaches, but climbs steep canyons and ravines ripe with vegetation and

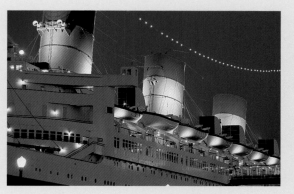

teeming with wildlife. Visitors who find time to explore the Santa Monica Mountain range crowding Malibu to the Pacific are afforded spectacular views. Even in highly populated areas, the Pacific Ocean still shines.

Left: *Queen Mary* rests dockside in Long Beach after 1001 Atlantic crossings. The *Queen Mary* is one of the largest steamships ever constructed.
PHOTO BY JEFF GNASS

Below: Clearing winter storm at El Matador State Beach in Los Angeles County.
PHOTO BY LARRY ULRICH

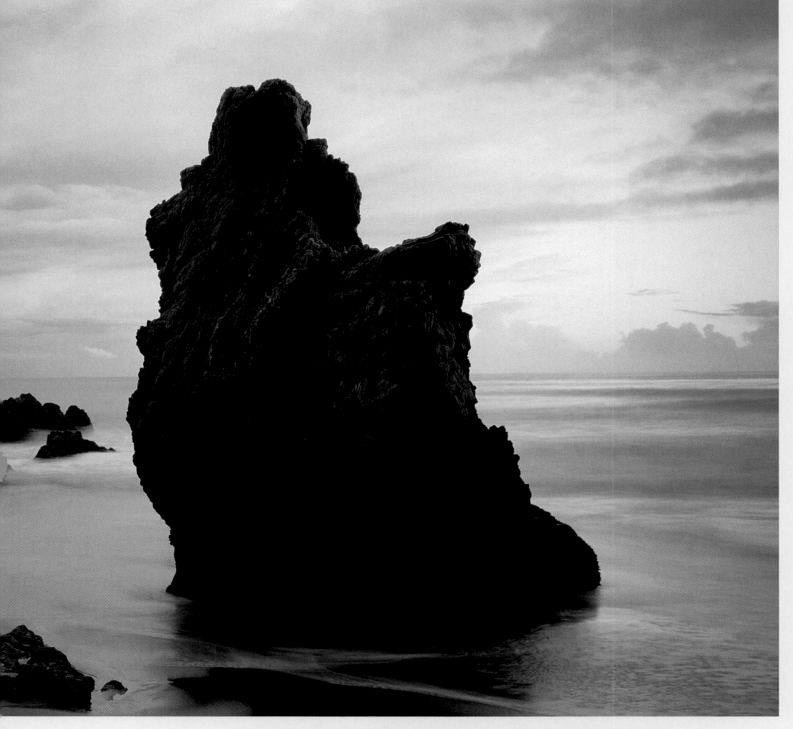

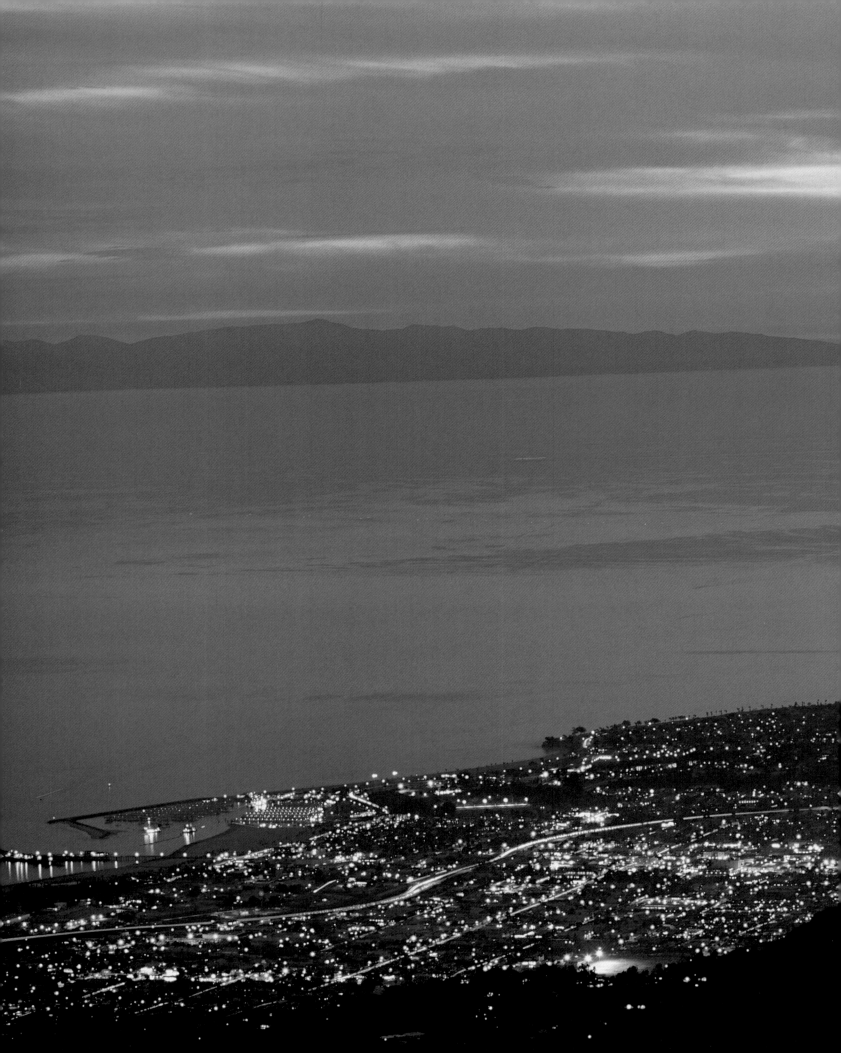

THE CENTRAL COAST

California's coast, from Santa Barbara north to Big Sur, has escaped much of the rapid growth experienced by the Monterey Peninsula, the Bay Area and Southern California. The resulting low density, coupled with the strong influences of Spanish and early California rancho architecture, echoes feelings of the gentle days of California's pre–statehood existence.

The first European to visit Santa Barbara was Juan Rodríguez Cabrillo who claimed the area for Spain in 1542. However, it was another Spaniard who gave Santa Barbara its name. When explorer Sebastián Vizcaíno's storm beaten ship entered the calm waters of Santa Barbara channel on December 4, 1602, a thankful ship's priest named the channel and the land around it Santa Barbara, after the patron saint of mariners.

Located 90 miles north of Los Angeles, Santa Barbara is one of California's most beautiful beach towns. Since the devastating earthquake of 1925, when many of its older buildings were damaged or destroyed, the city has maintained its quaint image by establishing a strict architectural board of review to evaluate all public and private building plans, ensuring continuity in Santa Barbara's historical early California architectural heritage.

Long before the Spaniards visited this part of the coast of California, Chumash Indians called the area home. The Chumash were hunters and gatherers who depended on the land and sea for survival. Their area yielded such bountiful harvests that the Chumash did not have to rely on agriculture to supplement their food stores. Acorn, manzanita, miner's lettuce and seaweed were only a few of the foods gathered by the Chumash. The ocean, local streams and their traditional hunting grounds all contributed to their continued subsistence.

Santa Barbara was the center of the Chumash territory, which extended as far south as Malibu (a Chumash place name) and north to San Luis Obispo, including the Channel Islands, a region containing hundreds of Chumash villages with the largest villages located along the coastline near Santa Barbara.

In 1782, the Spanish established a presidio, Spanish for "army fortress," in Santa Barbara, beginning a presence that forever altered the lives of the area's native inhabitants. Although their mission was not to enslave or eliminate local cultures, but to bring the enlightenment they believed Christianity offered, forces beyond their comprehension proved disastrous.

Chumash life changed drastically during the Spanish occupation of the late 1700s. They were gradually introduced to Christianity and were integrated into most areas of mission life. Although the Chumash were assigned tasks well within their capabilities and were treated benevolently by the padres, they rebelled for a period of a few months in 1824. They were pardoned and returned to the mission with little bloodshed by either party.

Unfortunately, contact with the Spaniards led to the Chumash's ultimate demise. European diseases killed thousands of these unfortunate Indians, who had no natural immunity against European viruses. There were 1792 Chumash living at Mission Santa Barbara in 1803; in 1836, only 481 remained alive; by 1839, only 246 were left. Instead of flourishing under the mission system Chumash populations dwindled until 1952, when Ignacio Aquino Tomás, the last known Chumash tribal member died.

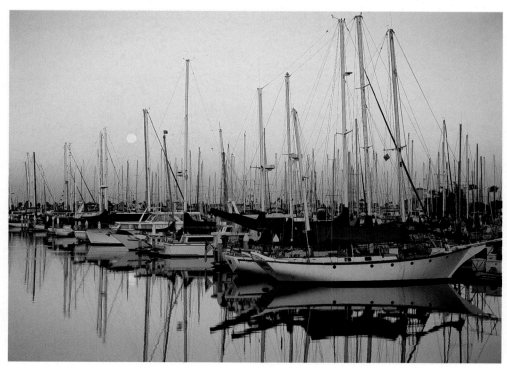

Left: Santa Barbara night lights and the outline of Santa Cruz Island under moonlight.
PHOTO BY LARRY ULRICH

Right: Ventura Harbor in the early morning fog. The city's name, Ventura, is an abbreviation of San Buenaventura, the Franciscan mission that was established here in 1782.
PHOTO BY LARRY ULRICH

SANTA BARBARA...

Mission Santa Barbara was founded in 1786, the tenth mission established by the Spanish in California. Over the years, three churches were built on the mission grounds. The previous mission was destroyed by an earthquake in 1812. The mission was rebuilt in 1815 and is often referred to today as the "Queen of the Missions" because of its unusual stone facade and beautiful towers. Mission Santa Barbara is the only California mission in continuous use since its construction.

Santa Barbara's Museum of Natural History houses artifacts of the Chumash including tools and utensils. The Santa Barbara Courthouse houses a recreation of a Chumash tomol, a twenty-foot long canoe used by the Chumash for fishing and to travel between the mainland and the Channel Islands to trade with Chumash tribes living there.

Neighboring Montecito has long lured the rich and famous with splendid views and beautiful

Right: Western sycamore and Santa Cruz Island from El Capitan State Beach.
PHOTO BY LARRY ULRICH

CHANNEL ISLANDS NATIONAL PARK...

The Channel Islands group consists of eight separate land masses off the California coast. San Miguel, Santa Rosa, Santa Cruz and Anacapa, which is actually three small isles with a total area of around one square mile, make up the northern islands, while the southern islands consist of San Nicolas, Santa Barbara, Santa Catalina and San Clemente. The five islands of Channel Islands National Park are the four northern islands– San Miguel, Santa Rosa, Santa Cruz and Anacapa– and Santa Barbara Island. Of the three remaining islands, both San Clemente and San Nicholas are owned by the Navy and Santa Catalina has long been privately held.

There are several different schools of thought regarding the geological formation of the islands. Scientists for a time believed the four northern islands may have once been attached to the mainland at Point Magu because of the presence of land animals in the fossil record and their presence in historic times. A lack of convincing geological evidence linking the islands with the mainland has led many to challenge this theory.

Evidence shows that the islands were formed in part at least 14 million years ago by volcanic activity, rising from the sea at its height but then slowly sinking until little remained above sea level. During the Ice Age, more than one million years ago, the sea level fell and the northern islands were exposed as a connected group called Santarosae. It is believed that during the Ice Age, when the water levels dropped, the islands were connected forming a "superisland."

Thousands of years before the arrival of the first Spanish explorers, the Chumash Indians inhabited the Channel Islands. Dates of their earliest settlements remain ambiguous, verifiable radio carbon dates place them on the islands about 8,000 years ago while other evidence has been uncovered that may date to 35,000 years ago. The Chumash were excellent boat builders and built a canoe-like craft, called a *tomol*, to travel between the islands and the mainland to trade with other Chumash tribes.

Two Spanish explorers, responsible for most of the discovery of Southern California , discovered and named the Channel Islands. In September of

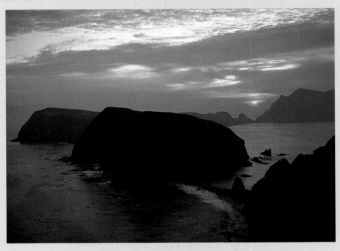

Above: Anacapa Island, actually three separate isles, stretches across five miles of the Santa Barbara Channel but has a total land area of around one square mile.
PHOTO BY LARRY ULRICH

1542, Juan Rodríguez Cabrillo left Mexico hoping to find a shorter route between Europe and Asia via a northwest passage. Instead he found waters too rough for his ships and a gangrene infection led to his death on San Miguel.

Sebastián Vizcaíno explored the Channel Islands and named the southernmost islands in 1602. The other islands were named by him as well, but the names were short lived. Captain George Vancouver and men of the Portolá expedition renamed three of the northern islands Anacapa, which comes from "anyapah," an Indian name meaning "ever-changing."

The Channel Islands have become a sanctuary for many endangered plant and animal species. Its diversified habitat enables a unique blend of species to survive within its boundaries.

Congress established Channel Islands National Park in 1980 to protect plants and wildlife of San Miguel, Santa Rosa, Santa Cruz, Anacapa and Santa Barbara islands. In the years since, The Nature Conservancy has acquired much of Santa Cruz Island and, by 2008, should own the entire island.

Protected wildlife includes six species of pinnipeds: California sea lion, Stellar sea lion, harbor seal, northern elephant seal, Guadalupe fur seal and northern fur seal. Seabirds include brown pelican, black storm petrel, western gull, Cassin's auklet, cormorant, and pigeon guillemot. More than sixty land and marine bird species are also present. There are eighty plant species on the island, of which some sixty are threatened or endangered.

The waters surrounding the Channel Islands, and its inhabitants, are protected as well. Channel Islands National Marine Sanctuary surrounds the five islands included in the park by six nautical miles, protecting fauna including twenty species of marine mammals.

Kelp beds around the islands support nearly 1,000 species. *Macrocystis pyrifera,* a brown seaweed, grows up to 200 feet to reach the surface.

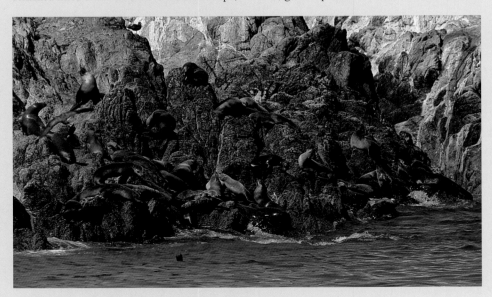

Right: Harbor Seals, one of the six species of pinnipeds protected in the Channel Islands National Marine Sanctuary, bask in the sun.
PHOTO BY LEN RUE, JR.

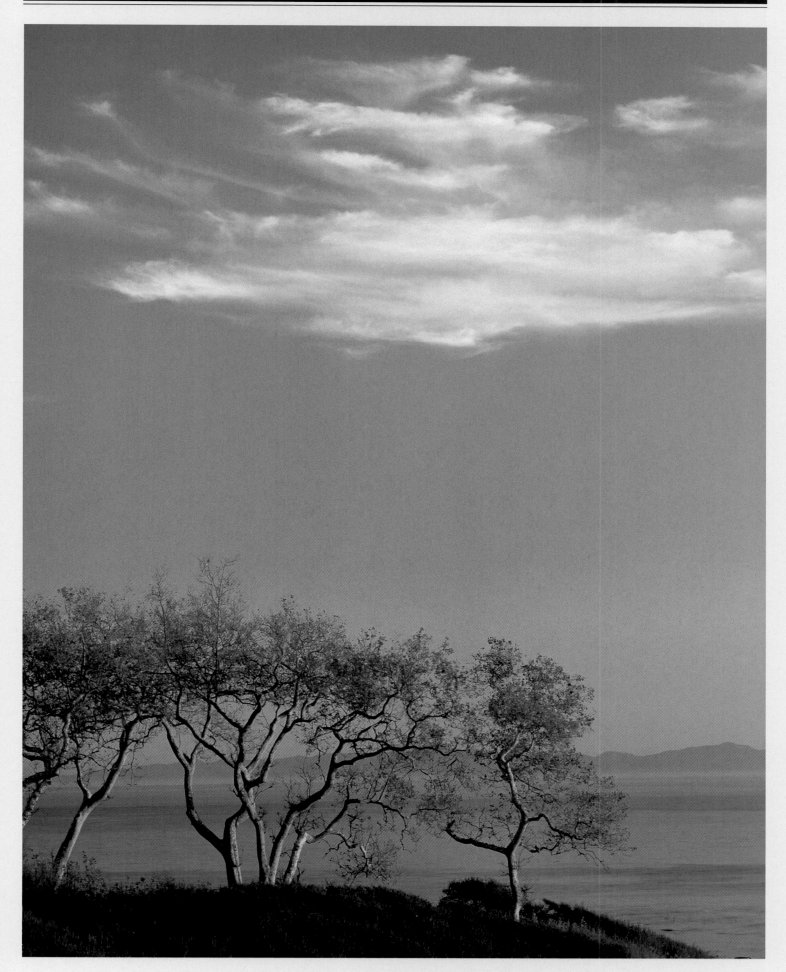

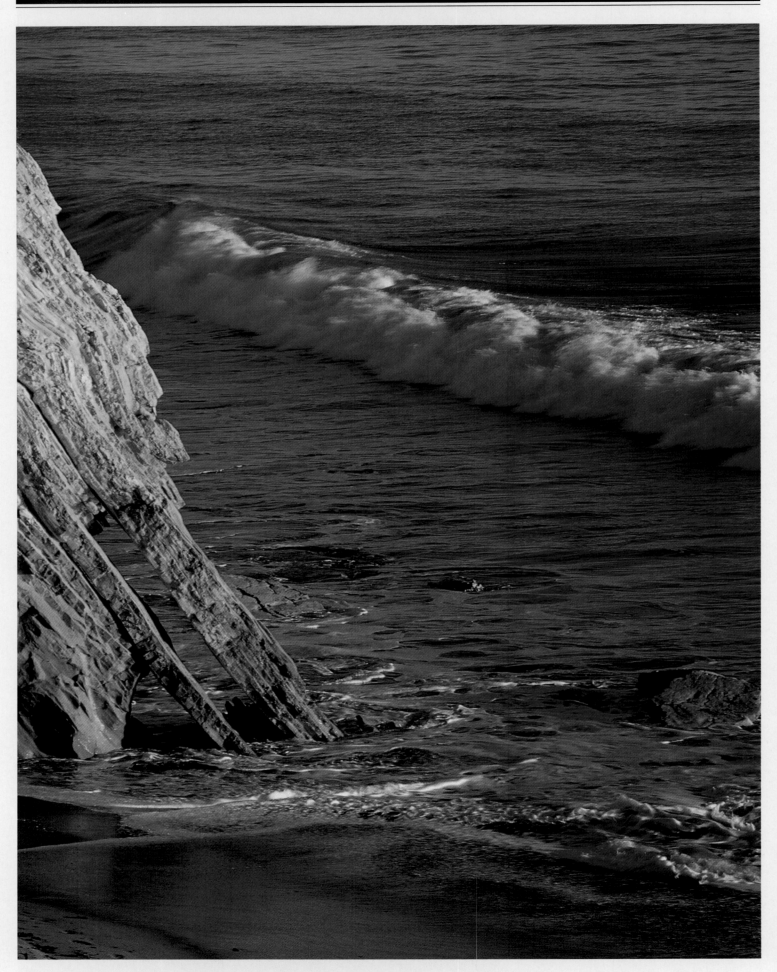

mansions. Tourists stroll the historic Spanish Presidio or the shops and restaurants along State Street, the main street through the historic town. Santa Barbara is also home to Sterns Wharf, California's oldest continuously working pier. Constructed in 1872, Sterns Wharf offers a variety of shopping and dining opportunities in a picturesque setting.

Traveling north on U.S. 101 after leaving Santa Barbara's city limits the next town encountered is Goleta, home of the University of California at Santa Barbara. Several state beaches are worth

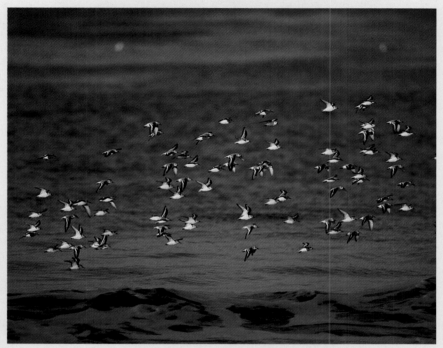

Above: Sanderlings in flight over the shoreline at Gaviota State Park. Santa Barbara was named by a thankful ship's priest when explorer Sebastián Vizcaíno's storm beaten ship entered the calm waters of Santa Barbara Channel on December 4, 1602. The priest named the channel, and the land around it, Santa Barbara, after the patron saint of mariners. Santa Barbara, a Roman maiden, was beheaded by her father for becoming a Christian.
PHOTO BY GLEN VAN NIMWEGEN

Below: The Santa Barbara County Courthouse was constructed in the late 1920s, after the devastating earthquake of 1925 destroyed much of the town. The courthouse building, an excellent example of the Spanish Colonial architecture adopted to rebuild the town, houses exhibits detailing the area's past.
PHOTO BY CHUCK PLACE

Following Pages: A rainbow signifies the end of a winter storm over the Pacific at San Augustine Beach on the Hollister Ranch near Point Conception in Santa Barbara County.
PHOTO BY LARRY ULRICH

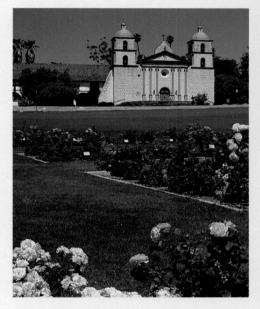

Above: Mission Santa Barbara, founded in 1786, was the tenth Spanish mission to be established in California. Three churches were built on the mission's grounds, the previous building was destroyed by an earthquake in 1812. The church above, constructed in 1815, is often referred to as the "Queen of the Missions."
PHOTO BY DICK DIETRICH

noting including El Capitan State Beach; the cove at Refugio State Beach and its stately palms; and the beach at Gaviota State Park with its fishing pier.

Inland areas along Santa Barbara's coast are also worth visiting, including Santa Ynez and Solvang. Santa Ynez, to the north on State 154, has rolling hills in fertile valleys graced with beautiful ranches, including Michael Jackson's Neverland and several world famous Arabian horse ranches. Solvang, a Danish community, has maintained strict Danish traditions in the entire town since 1911. Its architectural review board allows only authentic Danish designs. The entire town leads a traditional Danish life, from costumed festivals to traditional foods.

Left: A sandstone headland at El Capitan State Beach in Santa Barbara County shows evidence of continued erosion by wave action.
PHOTO BY LARRY ULRICH

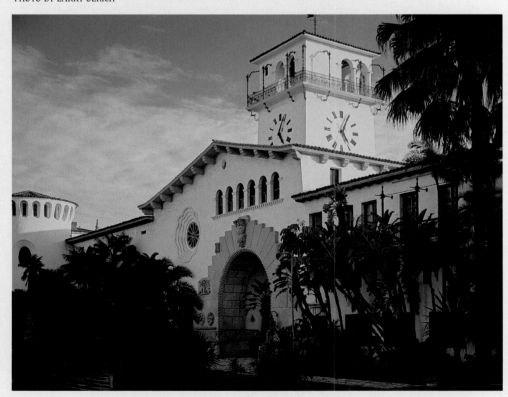

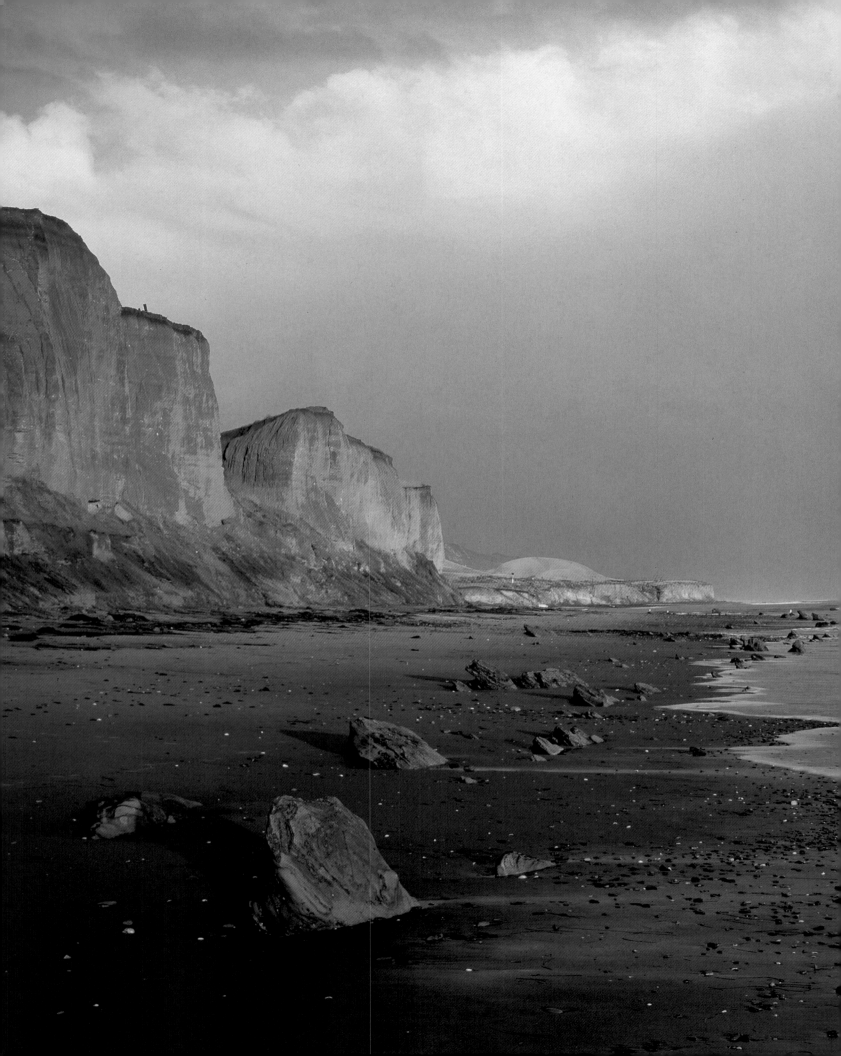

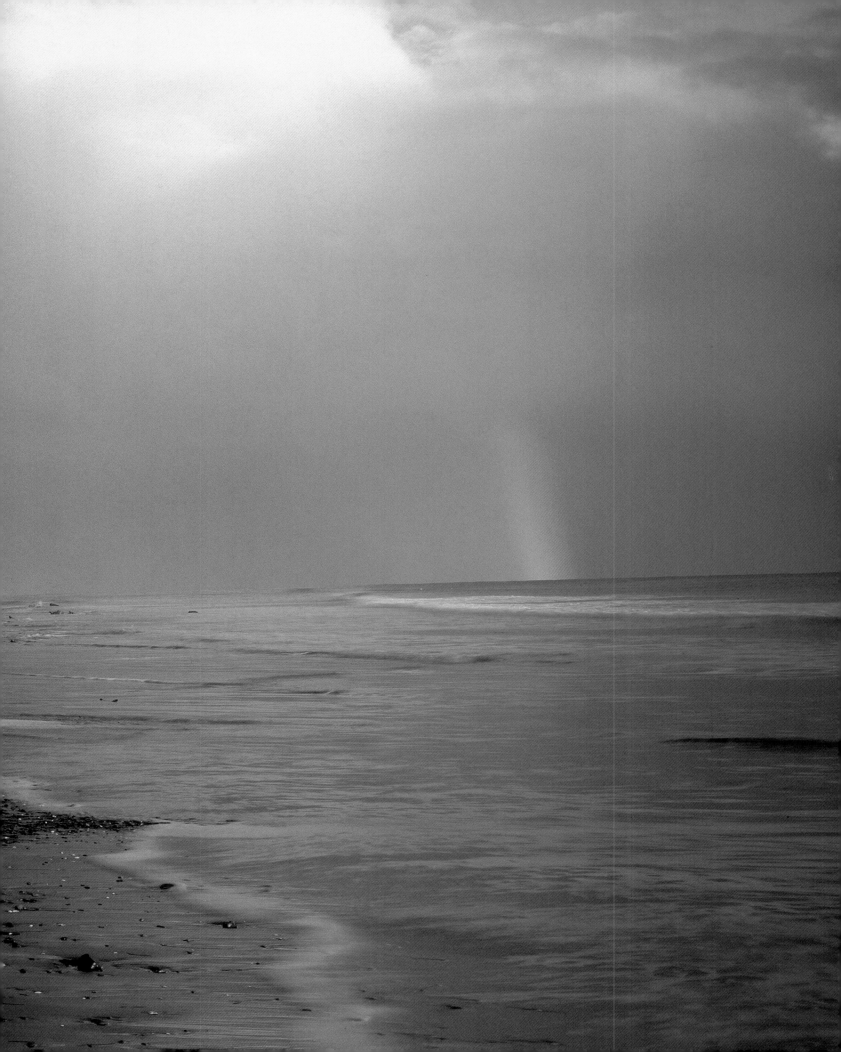

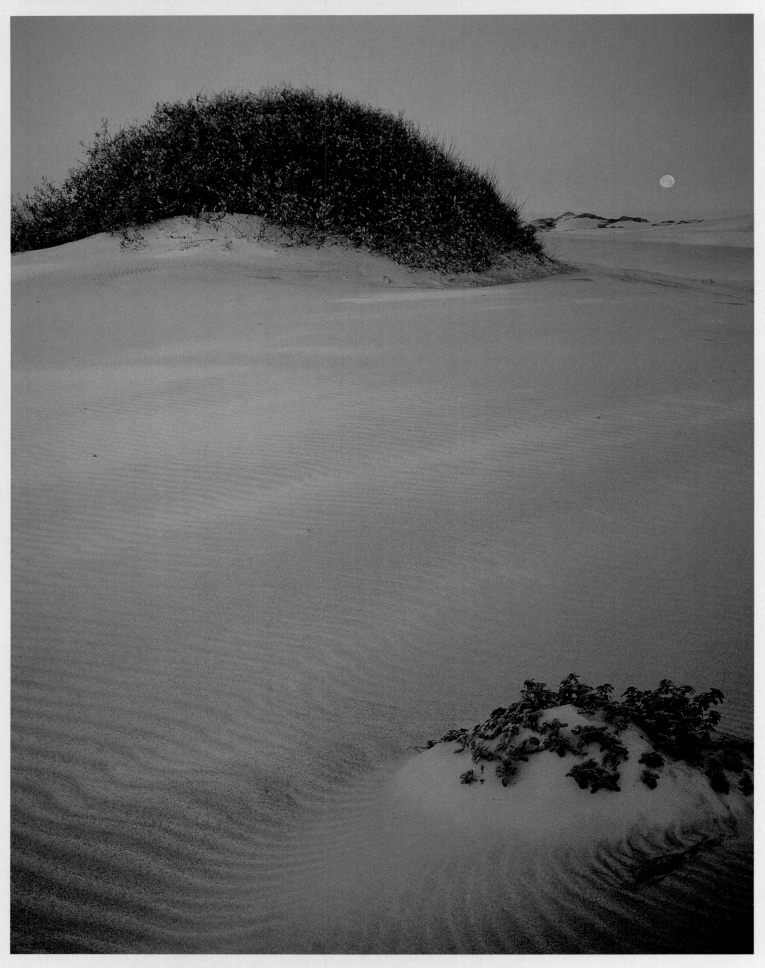

THE CENTRAL COAST...

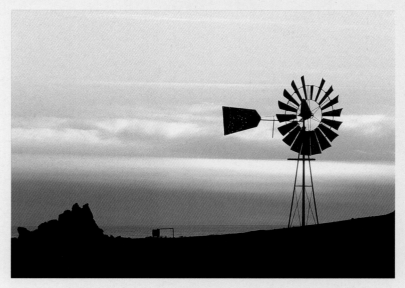

Above: Windmill silhouetted at sunset, Cayucos Point, San Luis Obispo County.
PHOTO BY LARRY ULRICH

Left: Moonset over Nipomo Dunes near Oso Flaco Lake, Pismo Dunes State Recreation Area.
PHOTO BY LARRY ULRICH

Below: Cove near Piedras Blancas Lighthouse at sunset. Point Piedras Blancas, San Luis Obispo.
PHOTO BY JEFF GNASS

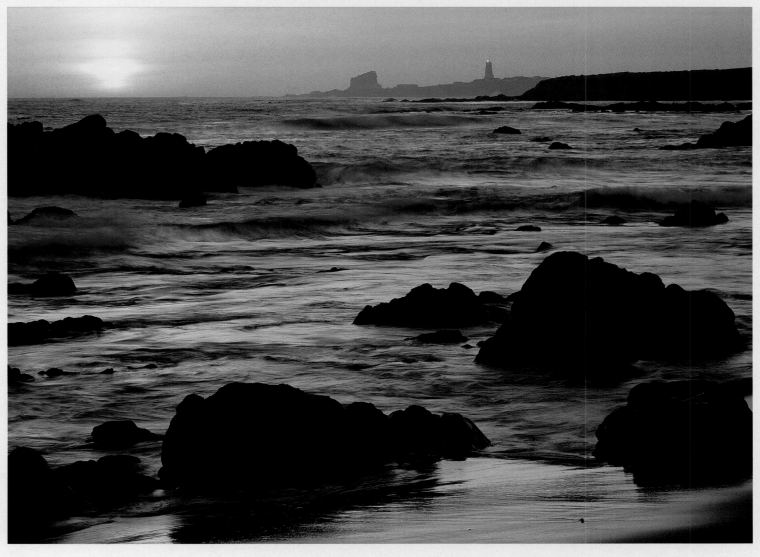

THE CENTRAL COAST...

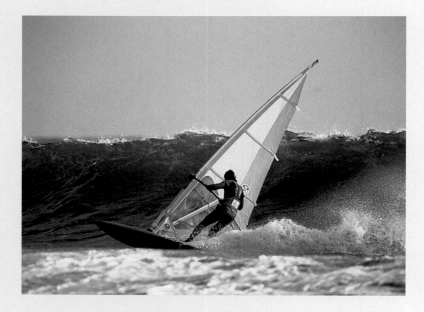

Above: Boardsailing combines the best elements of surfing and sailing off the Central California Coast near San Luis Obispo.
PHOTO BY LARRY ULRICH

Below: Morro Rock, a 576 foot high monolith, is the last of nine volcanic peaks between San Luis Obispo and Morro Bay. Morro Rock is a protected nesting ground for endangered peregrine falcons, nearly wiped out earlier by DDT poisoning. Morro Bay State Park.
PHOTO BY DICK DIETRICH

Right: Wave patterns and eroded bluffs, Montana de Oro State Park.
PHOTO BY CARR CLIFTON

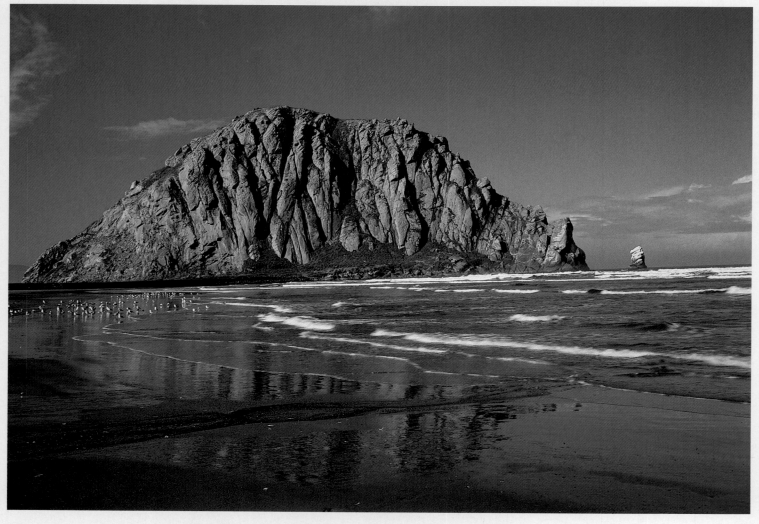

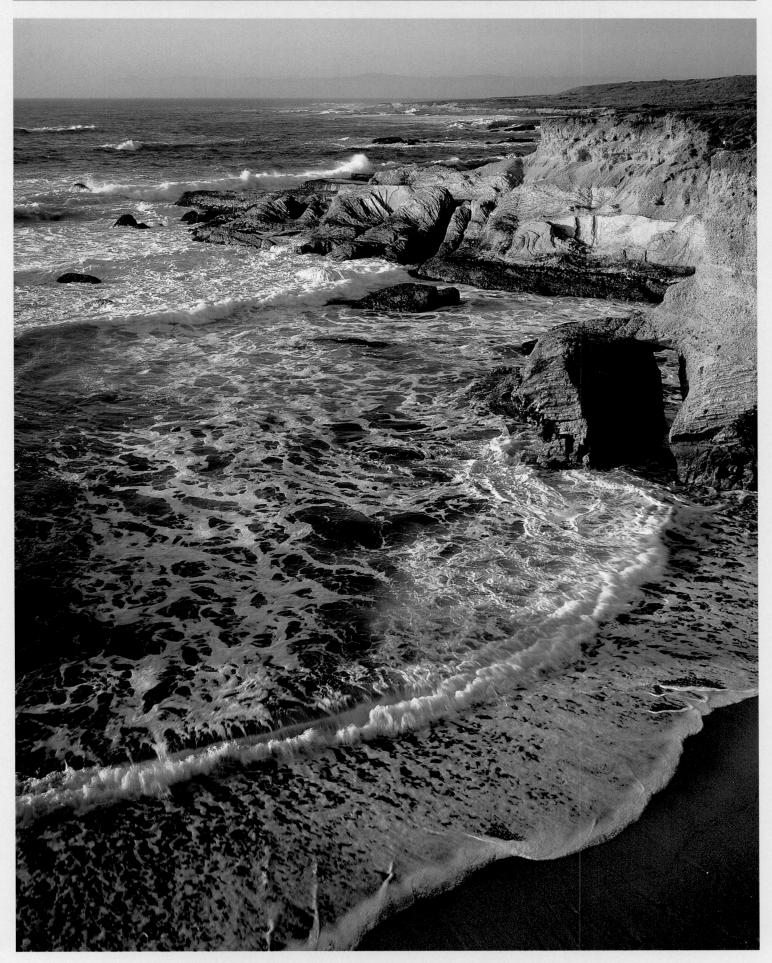

THE CALIFORNIA MISSIONS...

When the first Spanish missionaries arrived in San Diego on January 9, 1769, their mission was simple. Claim, through exploration and occupation, Alta (Upper) California before the Russians or English could take control, and civilize the natives they encountered by converting them to Catholicism.

Captain Gaspar de Portolá was the head of the 1769 expeditions which originated in La Paz, Baja California. Two expeditions went by sea and two by land. Padre Junípero Serra, a theology professor who was assigned the task of converting the natives to Christianity, traveled as head of a land expedition, reaching San Diego on July 1, 1769.

The Spanish king's plan was to construct a series of missions and presidios 30 miles apart, or roughly one day's journey from each other. In this way, they would show possession of California and its natives, and have the support of the soldiers and settlers from neighboring missions in the event of attack by hostile Indians or foreign interests.

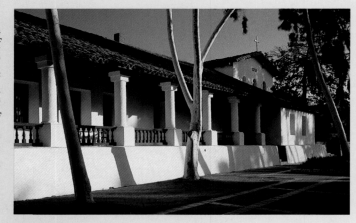

CALIFORNIA MISSIONS

CALIFORNIA

San Francisco de Solano
San Rafael Arcangel
San Francisco
San Jose de Guadalupe
San Francisco de Asis
Santa Clara de Asis
Santa Cruz
San Juan Bautista
Monterey — San Carlos Borromeo de Carmelo
Nuestra Senora de la Soledad
San Antonio de Padua
San Miguel Arcangel
San Luis Obispo de Tolosa
La Purisima Concepcion
Santa Ines
Santa Barbara
Santa Barbara
San Buenaventura
San Fernando Rey de Espana
San Gabriel Arcangel
Los Angeles
San Juan Capistrano
San Luis Rey de Francia
San Diego de Alcala
San Diego

In order of founding

1	San Diego de Alcala	July	1769
2	San Carlos Borromeo de Carmelo	June	1770
3	San Antonio de Padua	July	1771
4	San Gabriel Arcangel	Sept.	1771
5	San Luis Obispo de Tolosa	Sept.	1772
6	San Francisco de Asis	Oct.	1776
7	San Juan Capistrano	Nov.	1776
8	Santa Clara de Asis	Jan.	1777
9	San Buenaventura	Mar.	1782
10	Santa Barbara	Dec.	1786
11	La Purisima Concepcion	Dec.	1787
12	Santa Cruz	Aug.	1791
13	Nuestra Senora de la Soledad	Oct.	1791
14	San Jose de Guadalupe	June	1797
15	San Juan Bautista	June	1797
16	San Miguel Arcangel	July	1797
17	San Fernando Rey de Espana	Sept.	1797
18	San Luis Rey de Francia	June	1798
19	Santa Ines	Sept.	1804
20	San Rafael Arcangel	Dec.	1817
21	San Francisco de Solano	July	1823

On July 16, 1769, Padre Serra founded the Mission San Diego de Alcalá, the first of what would eventually become 21 missions in Alta California founded by Padre Serra and his successors. Padre Serra left San Diego in 1770 to continue his quest to colonize the coast. He met up with Portolá and his overland party on the Monterey Peninsula.

Mission San Carlos Borromeo de Monterey was the second mission founded in the system and, like Mission San Diego de Alcalá, was later moved to a better location with easier access both to water and to the Indians they were to convert. The new location became San Carlos Borromeo de Carmelo in 1771, and the presidio stayed in Monterey.

Padre Junípero Serra loved Carmel so much that he chose it as his permanent residence while he traveled up and down the coast in his calling to settle California. Serra died in Carmel, at age 71, of a tubercular infection.

It was the usual practice of the gray-robed missionaries to build an *enramada*, or a light shelter made of tree branches, which, once blessed, would represent the founding of a new mission. Several huts would then be built to serve as the mission and presidio until such time as the natives and soldiers could build a sturdy structure.

The transformation of the neophytes, as the Christianized natives were called, began with their indoctrination in the ways of the Catholic religion. Neophytes were expected to live within the mission grounds, or within close proximity, and to become integrated into Spanish life by following the laws of the church and settlement.

The neophytes were taught to farm crops that included corn, beans, wheat, and barley. They raised cattle, kept fruit orchards, tended vegetable gardens, and they produced wine and olive oil. Neophytes supplemented their diets by hunting rabbits and squirrels and by

Above: Mission San Luís Obispo de Tolosa was established in 1772 and was the fifth of twenty-one Spanish Missions in California.
PHOTO BY: LARRY ULRICH

fishing in the Pacific Ocean and nearby rivers.

Besides farming, the neophytes were taught to weave and sew. They were required to change their traditional form of clothing, or nakedness as was the case for most of the male Indians, to a more acceptable form of dress required by the Spanish missionaries.

Once the Indians became a part of mission life, they were expected to stay; this led to problems for many Indians who were used to freedom of movement without the schedules and restrictions imposed by the Spaniards.

The neophytes often left the confines of the mission community to visit relatives in their old villages. They would be forcefully returned to the mission by soldiers.

The most disastrous effect of the mission system on the natives was their exposure to

the 1830s. Many of the missions became privately owned ranches while others fell into various states of decline.

In the mid-1800s most of the missions, minus most of their land holdings, were returned to the Church for religious use.

Finally, after many years of damage caused by earthquakes and the effects of aging and neglect, private and civic groups began to band together to restore their local mission and to preserve remaining artifacts for the education and enjoyment of the thousands of people who visit the missions each year. The Spanish missions had a profound effect on the landscape and history of California, their influence is still found in the region's architecture.

Above: La Purisima Concepción Mission at Lompoc, California. The original buildings were destroyed by an earthquake in 1812.
PHOTO BY: DICK DIETRICH

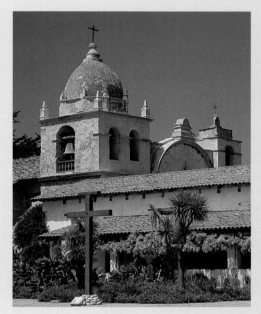

Above: Mission San Carlos Borromeo de Carmelo in Carmel, California, was the second Spanish mission founded by Franciscan Padre Junípero Serra, who loved Carmel so much that he made it his permanent home until his death in 1784. His remains are buried at the mission.
PHOTO BY: CHUCK PLACE

the white man's diseases, for which the Indians had no defense. Chicken pox, measles and venereal disease took the lives of thousands of Indians, often wiping out entire families.

Padre Serra and his predecessors continued their pursuit of souls along the coast, founding both San Antonio de Padua and San Gabriel Archangel in 1771, San Luís Obispo in 1772, San Francisco de Asis in 1776 and fourteen others until 1823 when the last, and northernmost mission in the system, San Francisco de Solano, located in Sonoma, was founded.

Spain lost its hold on Mexico in 1821, and the missions were secularized, or transferred from the churches to civil, or lay, control in

SPANISH EXPLORATION OF THE WEST

While Spanish explorer Juan Rodríguez Cabrillo was credited with discovering California in 1542, it was Sebastián Vizcaíno who gave lasting names to such places as San Diego and Santa Catalina Island on his 1602 exploration of the coast.

Captain Gaspar de Portolá and Padre Junípero Serra traveled the coast of California between San Diego and San Francisco founding twenty-one missions in the name of Spain.

Cabeza de Vaca overcame tremendous obstacles to make his way through the wilderness of the southern and southwestern United States and return to Mexico. Along the way, Cabeza de Vaca learned that the best chance of survival in Indian country was to arrive with the sign of the cross, and not by brandishing a musket. Cabeza de Vaca became so beloved by the Indians in the Southwest that when he rejoined his people in Mexico, he had a group of 600 admiring Indians traveling with him.

Francisco Vásquez de Coronado spent two years exploring the Southwest in search of the fabled Seven Cities of Gold. Coronado chased his dream as far east as Kansas, returned to Mexico empty-handed, and was tried for mistreating the Indians and mismanaging the expedition.

Juan Bautista de Anza traveled from Tubac, Arizona, overland to California and founded the city of San Francisco.

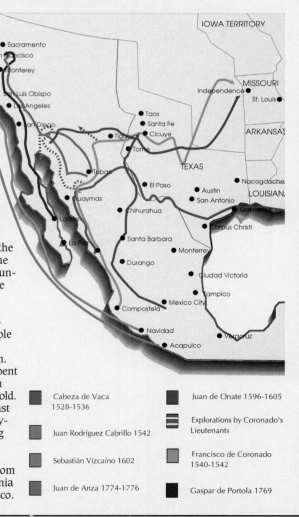

■	Cabeza de Vaca 1528-1536	■	Juan de Onate 1596-1605
■	Juan Rodríguez Cabrillo 1542	≡	Explorations by Coronado's Lieutenants
■	Sebastián Vizcaíno 1602	■	Francisco de Coronado 1540-1542
■	Juan de Anza 1774-1776	■	Gaspar de Portola 1769

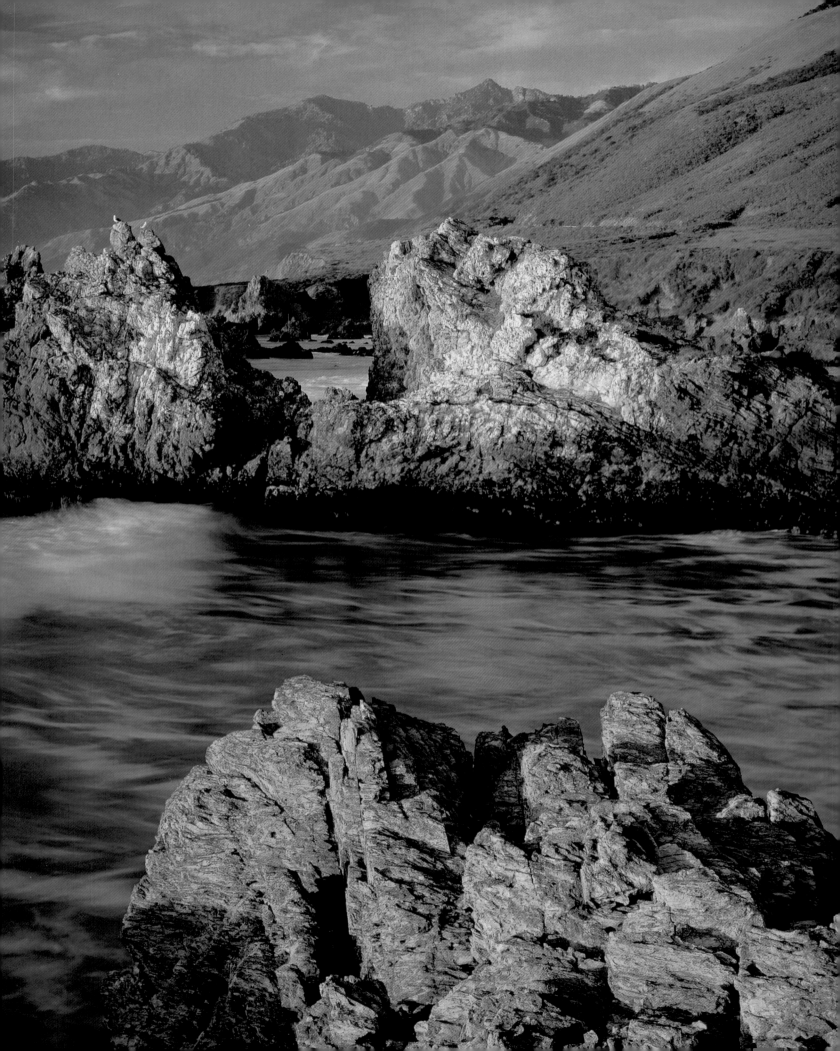

HEARST CASTLE

William Randolph Hearst inherited the land he called La Cuesta Encantada (The Enchanted Hill) from his mother, Phoebe Apperson Hearst upon her death in 1919. The ranch then included 50 miles of coastline and more than 240,000 acres of land, an area approximately one-third the size of Rhode Island. Hearst began the construction of his castle that same year, a project he pursued until 1947 yet never completed.

Perched high atop a hill, more than 1600 feet above the Pacific Ocean in the Santa Lucia mountain range, sits Hearst Castle. What began as a small undertaking to build "a little something" on William Randolph Hearst's favorite childhood campground grew into one of America's most beautiful, and one of its largest, unfinished estates.

When publishing magnate William Randolph Hearst was a boy, his father George Hearst was part owner of a gold mine in the Sierra Nevadas that turned out to be the silver-rich Comstock Lode and owned over 240,000 acres of Central California land, including about 50 miles of coastline. The senior Hearst often took young William camping on a stretch of land near the village of San Simeon. Father and son spent many summer days camping in tents on the future site of Hearst Castle.

George Hearst's wife, Phoebe Apperson Hearst, survived him and when she died, in 1919, she left most of her estate, including the Central California land, to her only child William, who then decided to build a home on his favorite property. Shortly after his mother died, Hearst traveled to San Francisco to visit Julia Morgan, a San Francisco Bay architect, previously commissioned by Mrs. Hearst for several projects including remodeling of the Hacienda, her residence in Pleasanton, California.

Even though William Randolph Hearst had originally met Julia Morgan in 1902, their longest assignment together became a project that was never completed. They worked together on

Hearst's San Simeon home for the following 28 years, until 1947, when Hearst left his San Simeon residence due to failing health.

Julia Morgan was well recognized as an architect long before William Randolph Hearst commissioned her for his San Simeon property. She was one of only a few women of her day to graduate from the University of California at Berkeley with a certificate in civil engineering. Morgan went on to further her education and was the first woman to attend and receive a degree in architecture from L'Ecole des Beaux Arts in Paris. Julia Morgan was 47 years old when Hearst hired her, and although Hearst Castle absorbed much of her time, she worked on other projects throughout her career. During her 50 years as an architect, she was involved with some 800 building projects.

Another legacy Phoebe Apperson Hearst left to her son was a love of collecting antiquities, which for young William began at the age of ten, when his mother took him on his first European tour. From then on William was an avid collector. The ensuing years found him collecting everything from tapestries, statuary and paintings to sixteenth century furniture. Hearst's many treasures were stored for years in warehouses awaiting a location that was grand enough to display them.

Plans for La Casa del Mar (House of the Sea), the first of three guest houses, were drawn in 1919. Plans for La Casa del Sol (House of the Sun) and La Casa del Monte (House of the Mountain) soon followed. Although the guest

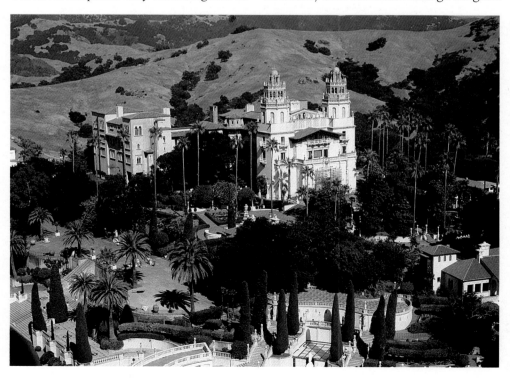

Left: Santa Lucia mountain range from the coast at Pacific Valley, Los Padres National Forest.
PHOTO BY LARRY ULRICH

Right: An aerial view of Hearst Castle, the former residence of publisher William Randolph Hearst. The estate contains 165 rooms and 127 acres of landscaped grounds including terraces, pools, walkways and gardens.
PHOTO: HEARST CASTLE/JOHN BLADES

houses are luxuriously appointed with a total of 47 rooms between them, they were never fitted with kitchens. Although Hearst himself lived in the largest guest house, La Casa Del Mar during the construction of La Casa Grande, the three guest houses were always considered satellites to the main house.

It was during the initial stages of planning that Hearst and Julia Morgan decided to erect

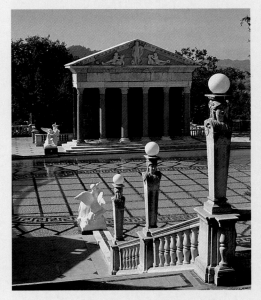

Above: The 104 foot long Neptune Pool was built to showcase the antique sculpture group sitting atop the Roman temple. Marble colonnades framing the temple were designed by Julia Morgan.
PHOTO: HEARST CASTLE/DOUG ALLEN

La Casa Grande, a cathedral-like structure that would end up boasting twin towers, 115 rooms, movie theater, two libraries and a dining room,

or Refectory, as Hearst called it, that could seat well over 25 guests per sitting. Hearst's grand structure was built as a showcase for his many collections and several rooms were built to hold specific items. Ceilings in the Assembly room were built high enough to accommodate a set of 16th and 17th century tapestries that cover the walls in the hall.

William R. Hearst and Julia Morgan combined several different styles of European architecture and added the work of modern artisans to give the structure a design that was Mediterranean Revival with a California feel. A prime example is the front entrance to La Casa Grande with its two 15th century Spanish guards on each side of a Spanish wrought iron gate which is topped by a fanned grill created by an iron worker on site during construction of La Casa Grande. A combination of European and Californian styles is found throughout the estate.

While La Casa Grande inspires awe, its beauty is further enhanced by the surrounding lush gardens and the incomparably beautiful pools. Rich top soil was brought in from the lowlands and hundreds of trees, bushes and flowers of countless varieties were planted to give the

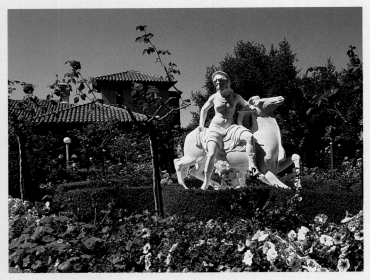

Above: A white marble statue reclines for all time amid a riot of color in the manicured grounds of the Europa Garden.
PHOTO: HEARST CASTLE/AMBER WISDOM

estate grounds the appearance of Eden. Hearst refused to cut down any of the mature native oak trees on the property and went to great expense to move trees that were in the way of construction. A wide variety of fruit trees were planted in the center gardens and two dozen different types of conifers were planted on the grounds, many brought to the hilltop fully grown. Visitors today can see pine, spruce, giant sequoia and cedar trees as well as fruit trees including orange, lemon, grapefruit and even kumquat trees.

The Neptune Pool, 104 feet long with a depth of up to ten feet and 345,000 gallon capacity, is located on the northwest side of the estate in a beautiful natural setting with panoramic ocean and mountain views. The pool is lined with white and green Vermont marble and was built as a showcase for a sculpture group set atop a Roman temple facade. Framing the Roman temple are marble colonnades designed by Julia Morgan. The pool contains numerous statues including seven Carrara marble groups carved in Paris by Charles Cassou in 1929 and 1930 specifically for the Hearst Neptune Pool.

The grounds of the Hearst estate are filled with notable sculptures, bubbling fountains, carved wellheads, a fish pond, and other works of art from around the world including Roman terra cotta storage jars, a Spanish cannon, sarcophagi and other collectables.

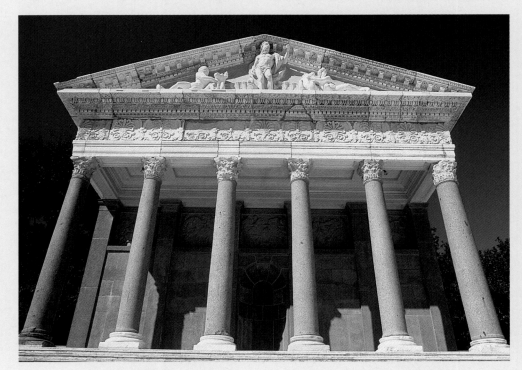

Left: Detail of the sculpture atop the Neptune Pool's Roman temple, depicting Neptune, without his ever-present trident, and two Nereids, the sea nymph daughters of Nereus. The Hearst Castle grounds also include the Roman Pool, an indoor pool lined with Venetian glass tiles, some of which have gold leaf fused inside. The Roman Pool holds 205,000 gallons of water.
PHOTO: HEARST CASTLE/JOHN BLADES

The indoor Roman Pool, located behind the main house, is so large that Hearst was able to build two tennis courts on top of it. No less impressive than the Neptune Pool, the Roman Pool holds 205,000 gallons of water and is lined with a mosaic of colored and clear Venetian glass tiles, many with fused gold leaf inside. The richly colored tile mosaics were created by Italian artisans who worked on the project for three years, tiling the pool and the room's floor, walls and ceiling with elaborate

of the world's largest private zoos on Castle grounds to add to the beauty of the estate. On display in habitats that were designed by Julia Morgan and Hearst were tigers, ostriches, zebras, chimpanzees, and even an elephant. Hearst also bred both dachshunds and Kerry Blue terriers in kennels behind La Casa Grande and raised Arabian horses on the surrounding ranch land.

Failing health caused Hearst to leave his San Simeon home in 1947. Julia Morgan ceased her work on Hearst Castle the same year. When Hearst died in 1951, his beloved castle was left as we find it today, unfinished, but still a glorious reflection of a bygone era and the crowning achievement of William Randolph Hearst and Julia Morgan.

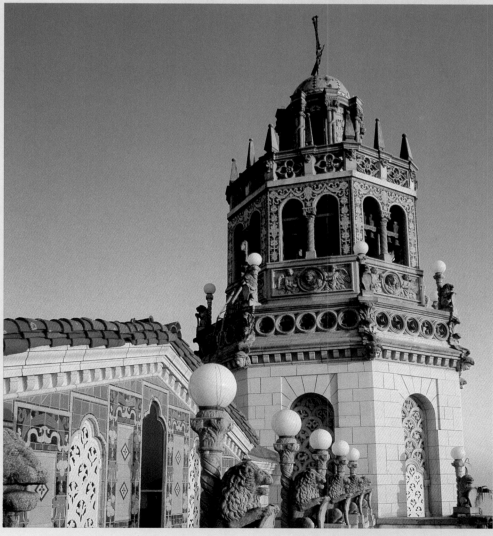

Above: The rear courtyard of La Casa Grande. La Casa Grande has 115 rooms, a movie theatre, two libraries and a dining room that could seat well over twenty-five guests in a single sitting.
PHOTO: HEARST CASTLE/AMBER WISDOM

Above: La Casa del Sol, the "House of the Sun," was completed in 1921. The third of three guest houses, La Casa del Sol contains eight bedrooms, eight bathrooms and two sitting rooms.
PHOTO: HEARST CASTLE/DOUG ALLEN

designs. The "T" shaped pool has a diving platform above its ten foot depths resembling a theatre balcony and the leg section of the "T" is a 4 foot deep wading pool. Marble statues are gracefully displayed against the Venetian glass tile background and lit by lights behind alabaster shades on marble lamp posts. With a skylight allowing the sun to shine in on the the blue and gold tiles that line the pool and its sparkling water, the Roman Pool makes an enchanting vision. The Roman Pool is said to have been very popular with the many famous celebrities and dignitaries that William Randolph Hearst entertained at his San Simeon Ranch throughout the years.

For the entertainment of his guests and his own personal enjoyment, Hearst created one

Right: The warm glow of the afternoon sun on the Lion Bridge at La Casa Grande. Although William Randolph Hearst never fully completed building La Casa Grande it was the nonetheless the center of indoor activities at Hearst Castle.
PHOTO: HEARST CASTLE/JOHN BLADES

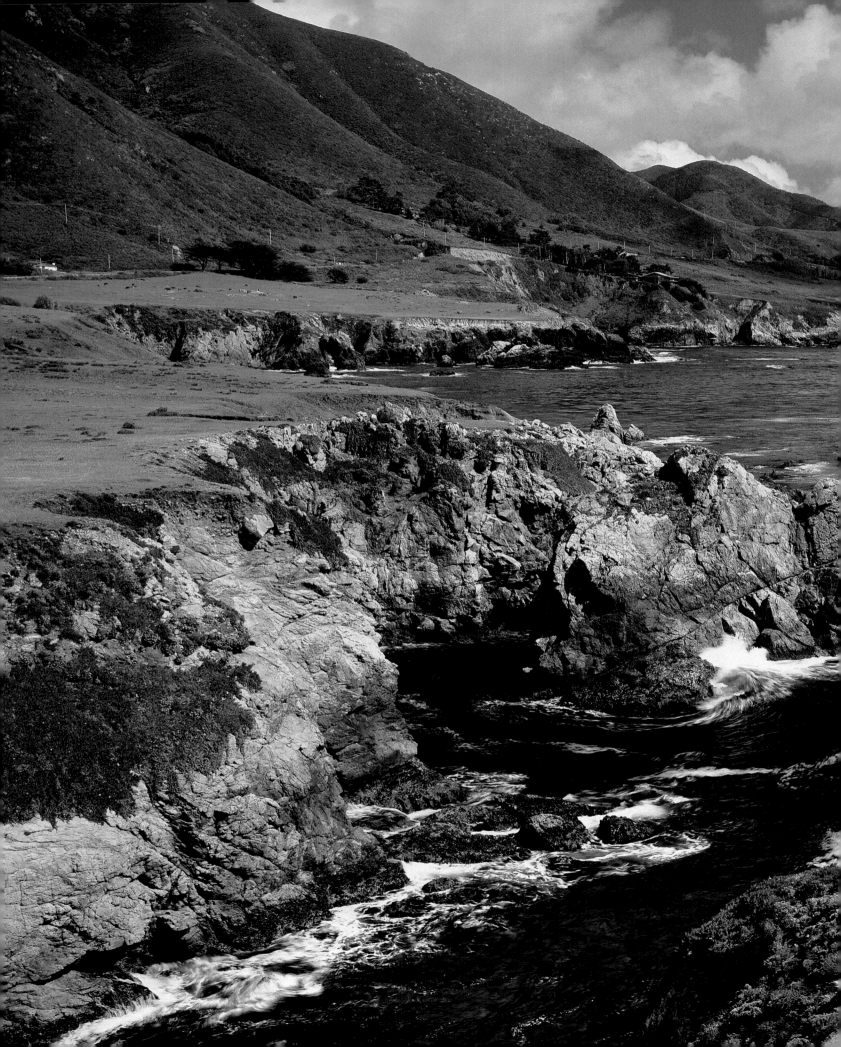

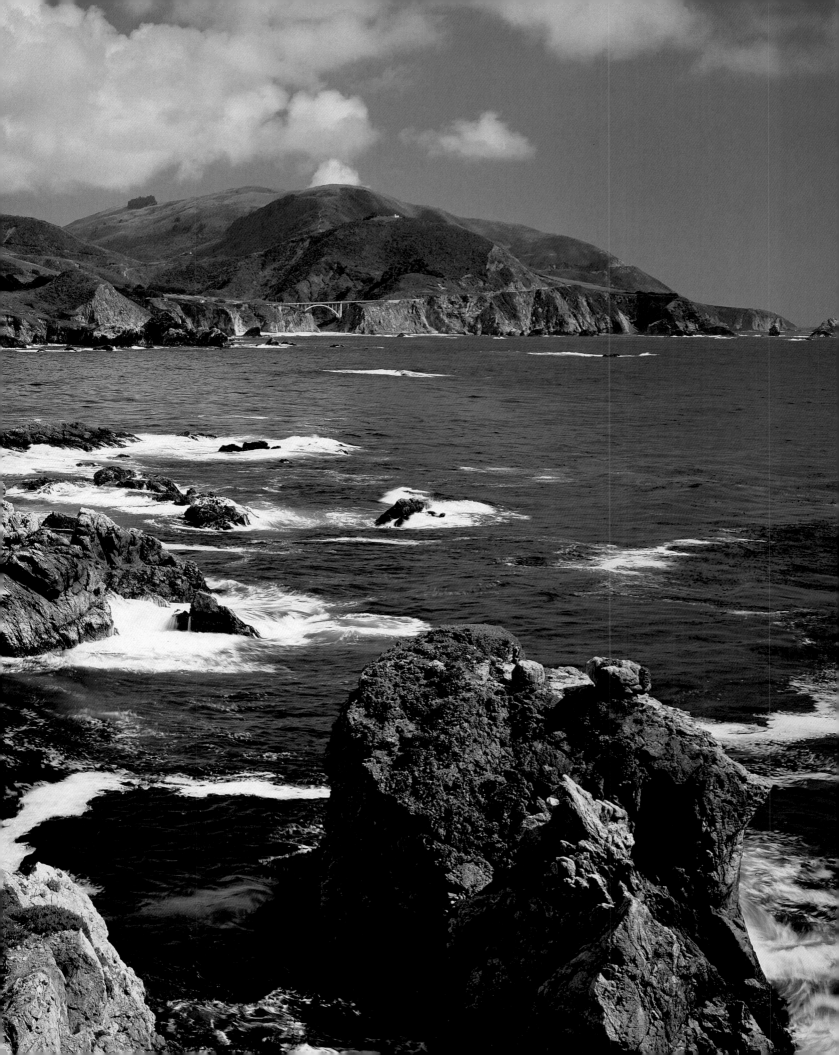

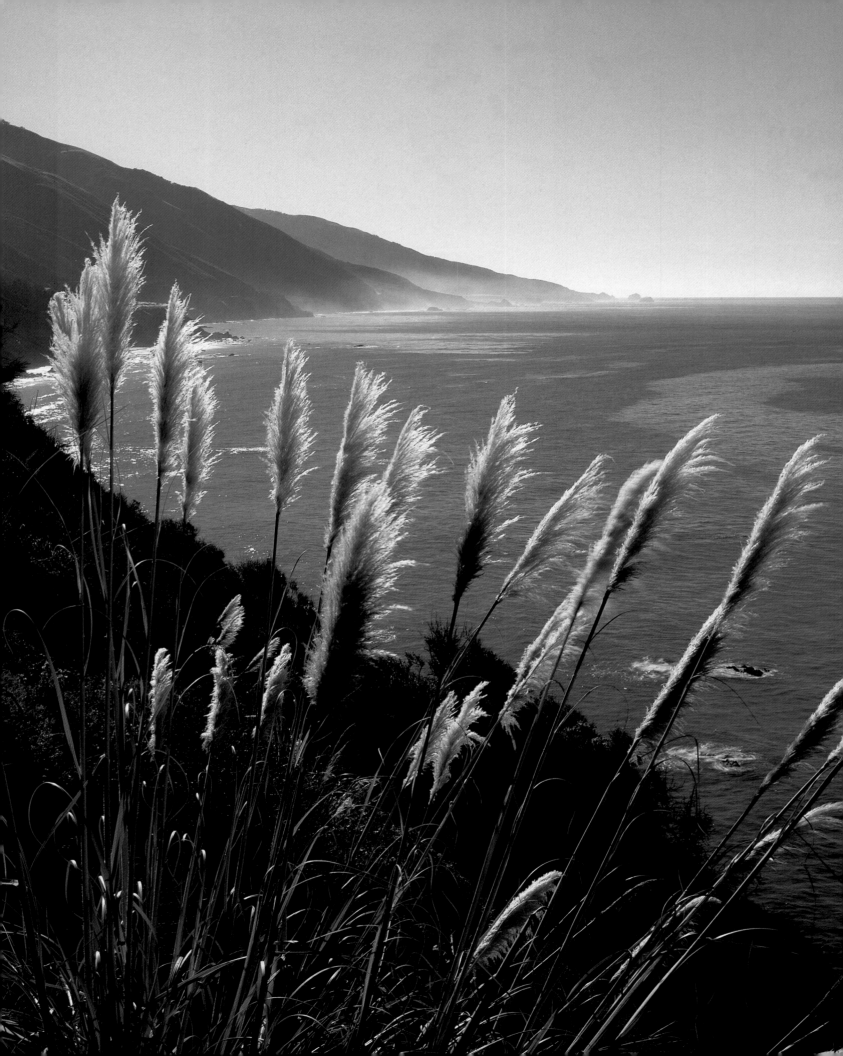

Big Sur

Few places in the world can compare with the natural splendor of the rugged Pacific Coast shoreline along Big Sur's coastline. Here, the Santa Lucia mountain range meets the Pacific Ocean. Waves continually pounding granite and sandstone bluffs create an ever-changing seascape while groves of giant coast redwoods, shrouded in fog on cliffs overlooking the ocean, seem to change to scrub-covered slopes with deciduous trees, and back again, from vista to vista as the road winds from near sea level to elevations of 1,000 feet. Fog may blanket lower elevations of the road with a cool gray mist while higher turns and ridges bask in the glory of California sunshine.

Located approximately 300 miles north of Los Angeles and about 150 miles south of San Francisco along U.S. Highway One, the Big Sur area is the 90–mile coastline between Carmel in the north and San Simeon to the south. Big Sur was historically an isolated area. In 1919, $15 million was appropriated by the state legislature to construct a road through the area for national security. Convict laborers from San Quentin constituted much of the labor force. In 1937, when the highway was finally opened, its usage was restricted and during the second world war, usage was totally prohibited.

Captain John Roger Cooper is distinguished as the original owner of the oldest surviving building along the Big Sur coast, a cabin built in 1861. The site of Captain Cooper's cabin was originally known as Rancho El Sur, a land grant made to the captain courtesy of his nephew, Juan Bautista Alvarado, who was provisional governor of California at the time. Upon Captain Cooper's death, his Rancho El Sur was divided among his five children. A generation later, in 1968, his granddaughter, Frances Molera, sold the land at a generous discount to the Nature Conservancy, who will manage and conserve the property for the benefit of the environment for all time. The site of Captain Cooper's original cabin was renamed Andrew Molera State Park for her brother Andrew.

In the late 1860s, homesteaders arrived and began staking claims to Big Sur Valley, attracted by the area's wide open spaces and natural beauty. The Pfeiffers, Partingtons, McWays, Burns, Andersons and Posts were among the early settlers and their names, among those of other pioneers, can still be found on local landmarks. Big Sur Valley neighbors Pfeiffer Big Sur State Park, named for John Pfeiffer, the son of 1869 homesteader Michael Pfeiffer. The state park, established in 1934, consists of 821 acres. Eleven miles to the south is Julia Pfeiffer Burns State Park, named for Michael Pfeiffer's daughter, which has more than 3,500 acres and includes a 1,680 acre underwater reserve that is dedicated to the protection of marine life.

While the earlier settlers in the Big Sur area were primarily ranchers and farmers, the 1880s through the early 1900s brought another type of settler, those who would strip the land of its natural resources for profit, and the industrial side of Big Sur emerged. Tanbark oak trees were lumbered for their tannic acid–important in the

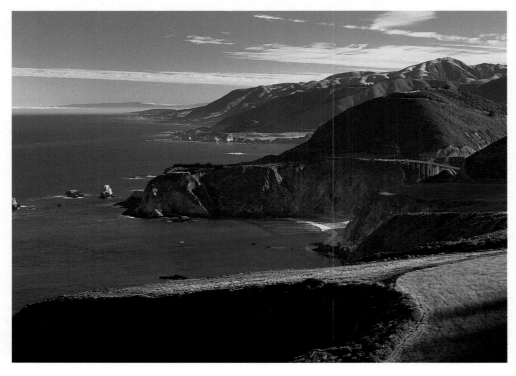

Preceding Pages: The swirling surf reflects colors of turquoise and blue along the Big Sur Coast.
PHOTO BY DICK DIETRICH

Left: Pampas grass above the Big Sur Coast near Rockland Landing at Julia Pfeiffer Burns State Park in Monterey County.
PHOTO BY JEFF GNASS

Right: Bixby Creek Bridge, one of the world's largest single-arch bridges, spans Bixby Creek as it empties into the Pacific.
PHOTO BY LARRY ULRICH

BIG SUR CONTINUED...

making of astringents, inks and tanning. The bark was transported by mules which pulled "go devils" (wheeled carts) to the coasts where ships at Notley's Landing, the mouth of the Little Sur River or Partington Cove would continue the transport. Limestone was smelted in Bixby Canyon and Limekiln Canyon. Redwood trees were cut down to fire the kilns used for the limestone smelting. Population of the area reached its highest levels, surpassing even today's, but eventually dwindled along with the marketable natural resources of the area.

In 1887, construction began on the Point Sur Lightstation, perched 361 feet atop a volcanic rock promontory 19 miles south of Carmel. Point Sur had long been the site of disastrous

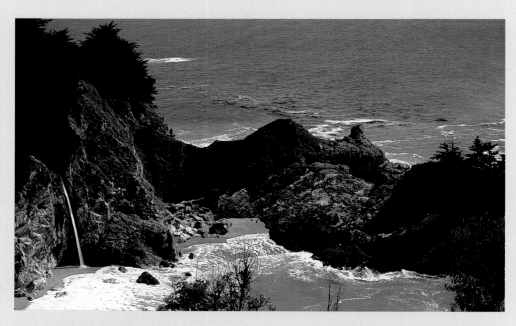

Right: A waterfall plunges from Saddle Rock into the ocean at McWay Cove in Julia Pfeiffer Burns State Park on the Big Sur coast.
PHOTO BY CHUCK PLACE

Below: Waves break against Big Dome in Cypress Cove at Point Lobos State Reserve.
PHOTO BY CHUCK PLACE

shipwrecks. The lightstation remained on duty until 1972, with generations of light keepers helping to make shipping lanes off the Big Sur coast a safer place. In 1980 it was designated

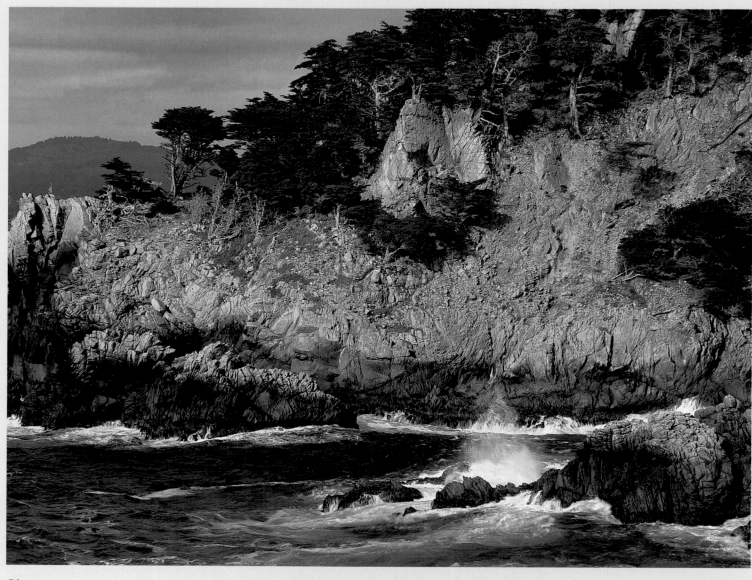

a State Historic Landmark. Restoration began in 1985 after the Department of the Interior transferred control of the property, which is still legally owned by the U.S. Coast Guard, to the California Department of Parks and Recreation. Today, Point Sur Lightstation is the only intact lightstation on the California Coast that is open for public tours.

As the loggers and miners left Big Sur to find untapped natural resources elsewhere, a new breed of inhabitant, anxious to savor the views

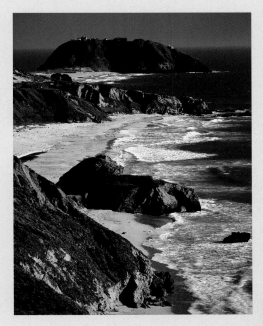

and commune with nature, began to arrive following the end of World War II. Lumbermen and miners were replaced by inhabitants from the literary realm and the art world who found the Big Sur area offered them affordable living conditions in an environment inspiring in its natural beauty and nurturing in its tranquil and remote setting. In 1944, Henry Miller, then considered risque for his 1930s works *Tropic of Cancer* and *Tropic of Capricorn,* began a seventeen year residency. Jack Kerouac, beat generation author of *On the Road* and Ansel Adams, one of the world's foremost landscape photographers, were among the many gifted artists that have called Big Sur home.

It was not until the early 1950s that electric service arrived along the Big Sur coast. In the following decades the area has attracted new residents seeking harmony with the environ-

Above: The Point Sur California Sea Otter Game Refuge protects California sea otters which were almost completely wiped out by fur hunters in the last century.
PHOTO BY LARRY ULRICH

Right: Emerald waters in China Cove at Point Lobos State Reserve. The waters off Point Lobos teem with undersea life and offer great diving opportunities.
PHOTO BY WILLARD CLAY

ment and greater spiritual awareness.

The Big Sur coast today is home to coast redwood, sycamore, big-leaf maple, black cottonwood, and rare Monterey cypress, with its twisted and gnarled shapes. Wildflowers cover the hills with splashes of color much of the year, while the air is filled with the sounds of Stellers jay, canyon wren, dark eyed junco, chestnut backed chickadee, band-tailed pigeon, water ouzel, redtailed hawk, sanderling, golden eagle, tufted puffin, willet, cormorant and belted kingfisher.

Land animals include the black-tailed deer, possum, mule deer, raccoon, gray fox, rabbit, ring-tailed cat, bobcat and squirrel along with an occasional black bear and mountain lion. Salamanders, toads, lizards and snakes slither through the brush while offshore California sea otter and five species of pinnipeds–the California sea lion, northern fur seal, northern elephant seal,

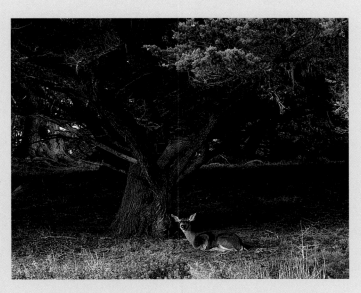

Above: A Blacktail deer (Odocoil eus hemionus) at Point Lobos State Reserve. Point Lobos, shortened over the years from Punta de Lobos Marinos–Point of the Sea Wolves–was named for the sea lions seen resting on offshore rocks.
PHOTO BY JEFF FOOTT

Stellar sea lion and harbor seal feed on the wide variety of fish and crustaceans found in the rich kelp beds offshore. Each year, the gray whales cruise by on their migration between breeding grounds off Baja California and their summer feeding grounds off Alaska.

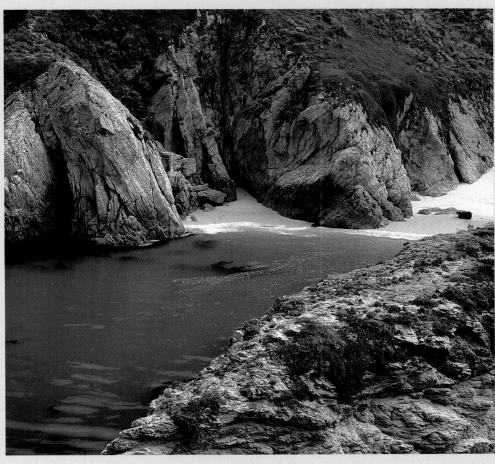

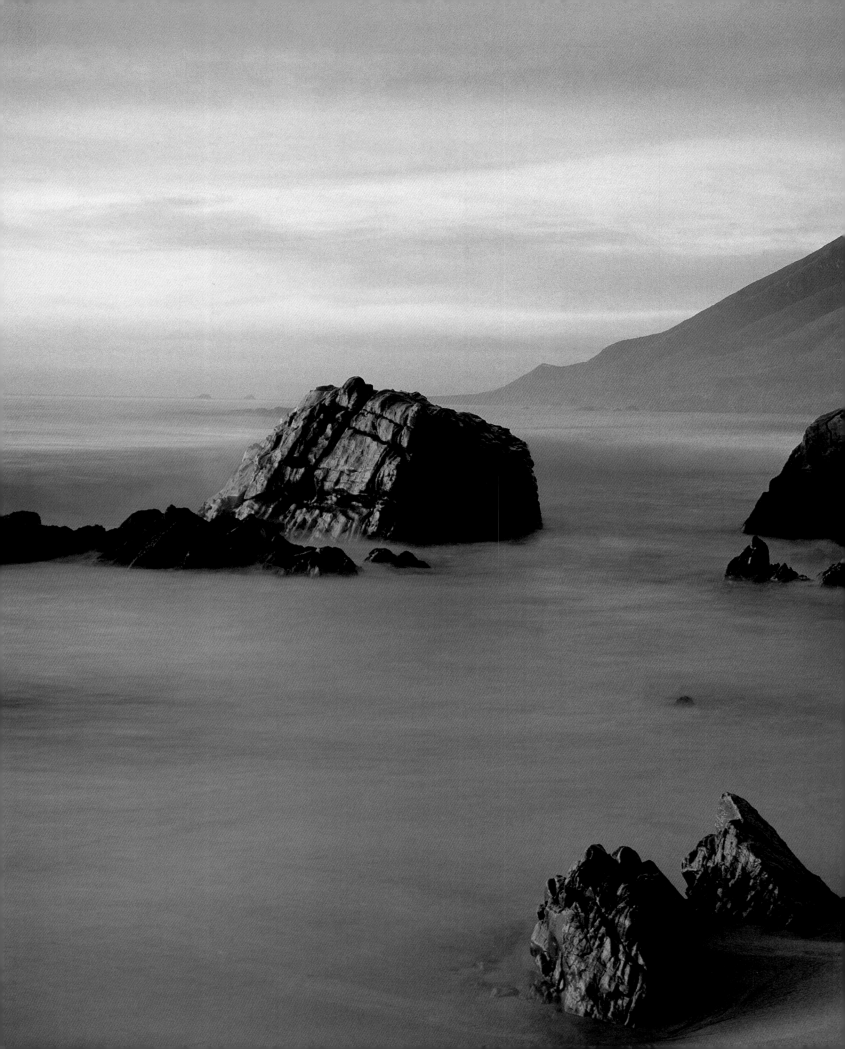

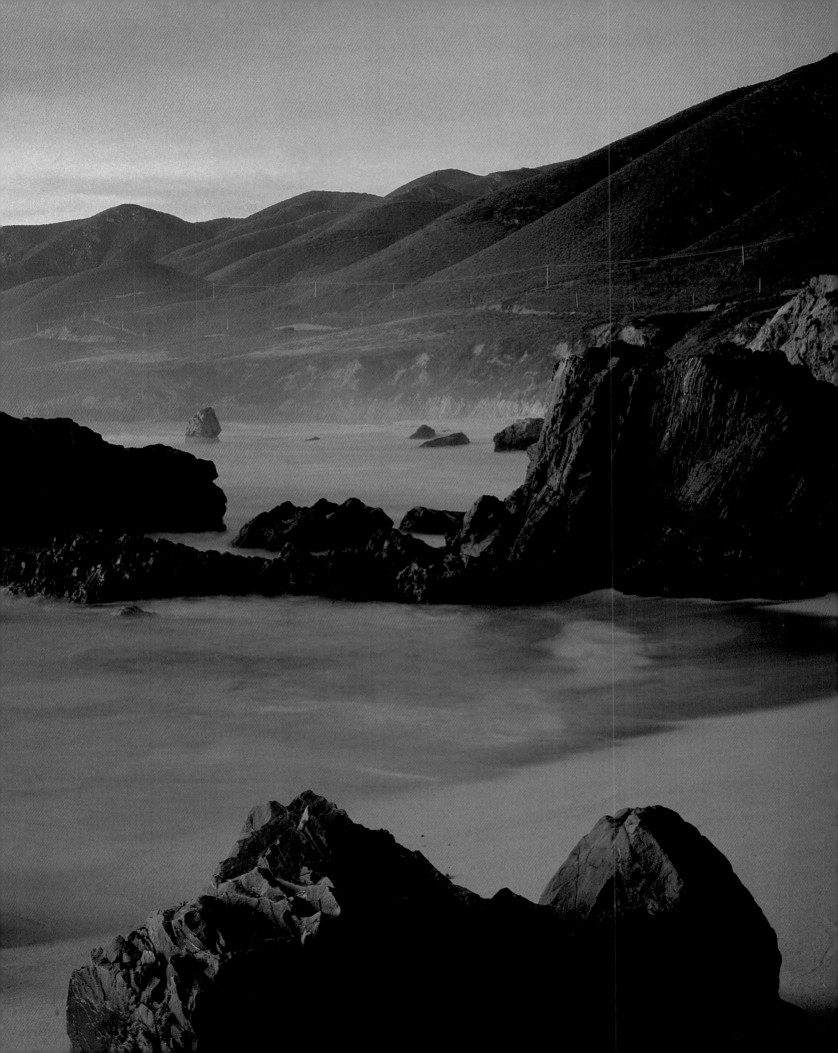

WILDLIFE OF THE PACIFIC COAST...

The Pacific Coast teems with a wide variety of wildlife in a diverse range of biotic communities from the Mexican border in the south to the Canadian border in the north.

In the more inhabited areas of Southern California, larger mammals such as deer and mountain lions are seldom seen by city dwellers but are present in the outlying areas. In foothill areas of Laguna Beach deer can still be found late on summer nights leaving the mountains to munch on lawns and gardens. Recently, mountain lions (also known as cougar, puma, painter, catamount and panther) have been in the news for attacking young children in urban parks. Although it has been some time since black bear have been seen in Southern California, it is not uncommon to find fox, opossum, raccoon, bob cat, rabbit, squirrel, coyote and a host of smaller mammals in areas that have

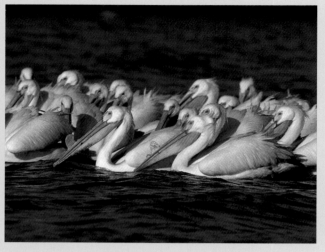

Above: A group of white pelicans (Pelecanus erythrohynchos) at rest. White pelicans, with wing spans reaching 9 feet, are the larger of the two pelicans found along the Pacific Coast.
PHOTO BY JEFF FOOTT

Preceding Pages: Sunset highlights remnants of a headland along the coast near Point Sur.
PHOTO BY CARR CLIFTON

not been completely covered with concrete and blacktop. Rattlesnake, garter snake, side-blotched lizard, alligator lizard, gopher snake, king snake and skinks slither about in less populated areas.

The Pacific Ocean off the coast of Southern California is home to a colorful cast of marine characters. Several species of playful pinnipeds including harbor seals, California sea lions and northern elephant seals, can be found lounging on rocks, buoys and even the transoms of pleasure boats in the harbors.

Farther offshore, marlin, tuna, sharks, pilot whales, barracuda, dolphin, gray whales, and bat rays abide along with kelp bass, sea bass, sheepshead, albacore, opaleye, moray eel, sand dabs, garibaldi and numerous other species of fish. Along the ocean's bottom lie stingray, lobster, abalone, crab and on rocks and pylons mussels and barnacles can be found.

The skies are filled with a variety of birds including; white and brown pelican, kingfisher, loons, grebes, fork-tailed petrel, cormorants, teals, mergansers, great blue heron, bald eagle, red-tailed hawk, osprey, oystercatcher, plover, common egret, sparrow hawk, California quail, peregrine falcon, gulls, finches, sandpipers, terns and more.

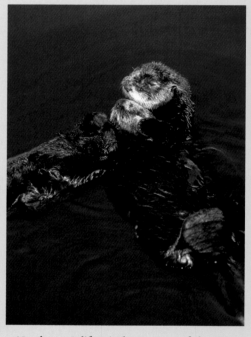

Northern California has many of the same species found in Southern California along with black-tailed deer, black bear, Roosevelt elk, sea otters, mountain beaver, mink, river otter and long-tail weasel. In species common to both regions, the Northern California Coast's less populated areas feature significantly higher mammal populations than are found in the highly developed Southern California area.

The Oregon and Washington coastal regions are home to many of the same species found

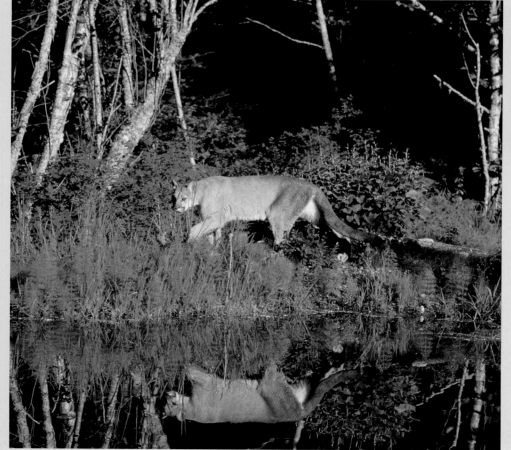

Above: Female sea otter and her pup. Sea otters must groom themselves continually to keep air bubbles in their fur, which acts as insulation from the chilly waters of the Pacific Coast.
PHOTO BY JEFF FOOTT

Left: Mountain lions (Felis concolor), also called cougars, painters, catamounts and panthers, can be found along the Pacific Coast in remote areas.
PHOTO BY JEFF FOOTT

along the California Coast and include the marmot, the largest member of the ground squirrel family and mule deer. All species are more common in Oregon and Washington habitats than in California environments. The northern Pacific Coast is home to Canadian goose, whistling swan, wood duck, pintail, teal, marsh wren, American wigeon, kestrel, pheasant, great blue heron, green-winged killdeer, great horned owl, starling, turkey vulture, long-billed kinglets, coot, snipe, robin, warblers, Stellers jay, brown creeper, nuthatches, marsh hawk, red-tailed hawk and other winged species. State and federal parks and preserves along the Pacific Coast are dedicated to preserving flora and fauna of the region in their natural habitats for our enjoyment and protection of vulnerable species.

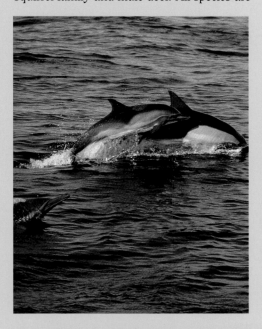

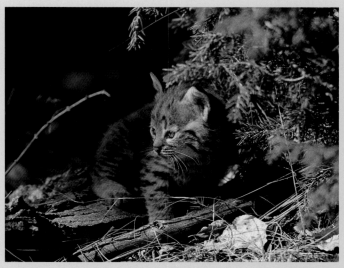

Above: A bobcat kitten, around five weeks old. This young bobcat will weigh between 18 and 25 pounds at maturity.
PHOTO BY LEN RUE, JR.

Left: A mother and young common dolphin (Delphinus delphis) off the Pacific Coast, one of four species of dolphin and eight species of marine mammals found off the Pacific Coast shore.
PHOTO BY JEFF FOOTT

THE PRECOCIOUS PINNIPEDS...

Whether lying about lethargically or dueling for domain, the pinnipeds, Latin for "feather-foot," own the coast. At least, they seem to enjoy their role in life more than most other creatures.

Their order, Pinnipedia, includes both eared seals and earless, or true, seals. Their limbs have been modified to fins for gliding through the water, and their protection against cold waters includes fur, a thick hide and a layer of fat. They are carnivorous, feeding mainly on fish and squid, which they seem to enjoy hunting almost as much as eating.

Their hindflippers act to steer the pinnipeds as they shoot through the water, propelled by their powerful fore-flippers. The guiding hindflippers are useful to eared seals on the beaches because they can be turned to facilitate movement. The true seals, who do not have external ears, do not enjoy this advantage.

The Pacific Coast is home to six species of

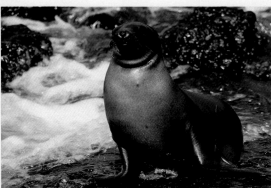

Above: California sea lion, one of six species of pinnipeds found along the Pacific Coast.
PHOTO BY LEONARD LEE RUE III

pinnipeds; Stellar sea lion, California sea lion, northern fur seal, Guadalupe fur seal, northern elephant seal and harbor seal. The sea lions and fur seals are eared pinnipeds, while the harbor seal and northern elephant seal are true seals.

In addition to the lack of external ears and rear flippers that are limited in movement, the true seal is distinguished by floating vertically in the water with its head above the surface, sinking tail first to submerge. Harbor seals, or *Phoca vitulina*, are common in most bays. They can be six feet in length and weigh up to 300 pounds. They have silvery-gray coats with black spots and big eyes. Northern elephant seals, *Mirounga angustirostris*, are the largest of true seals. They can reach 16 feet long and

weigh 5000 pounds. Males are marked by large, bulbous, inflatable snouts and dry, rough skins. The highest-ranking males mate with the most females. Principal rookeries are in the Channel Islands, at Año Nuevo in San Mateo County and on Southeast Farallon Island.

Sea lions are the most common pinnipeds on the Pacific Coast. Steller sea lions, or *Eumetopias jubatus*, have populations on Año Nuevo, the Farallon Islands and Seal Rocks. They have a tawny yellowish-brown coat, reach 13 feet and can weigh 2000 pounds. California sea lions, or *Zalophus californianus*, are widely found at the Channel Islands and Point Piedras Blancas in San Luis Obispo County. They are the seals found in circus acts and reach seven feet and weigh 500 to 750 pounds. Most sea lion and fur seal rookeries are on offshore islands, where males battle for territory, keeping up to 50 females. Until a territory is secured, younger males will not mate.

Below: Harbor seal (Phoca vitulina), a true seal.
PHOTO BY LEN RUE JR.

Left: Elephant seal (Mirounga angustirostris). Elephant seals reach 16 feet and 5000 pounds.
PHOTO BY JEFF FOOTT

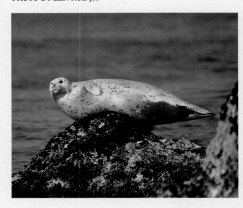

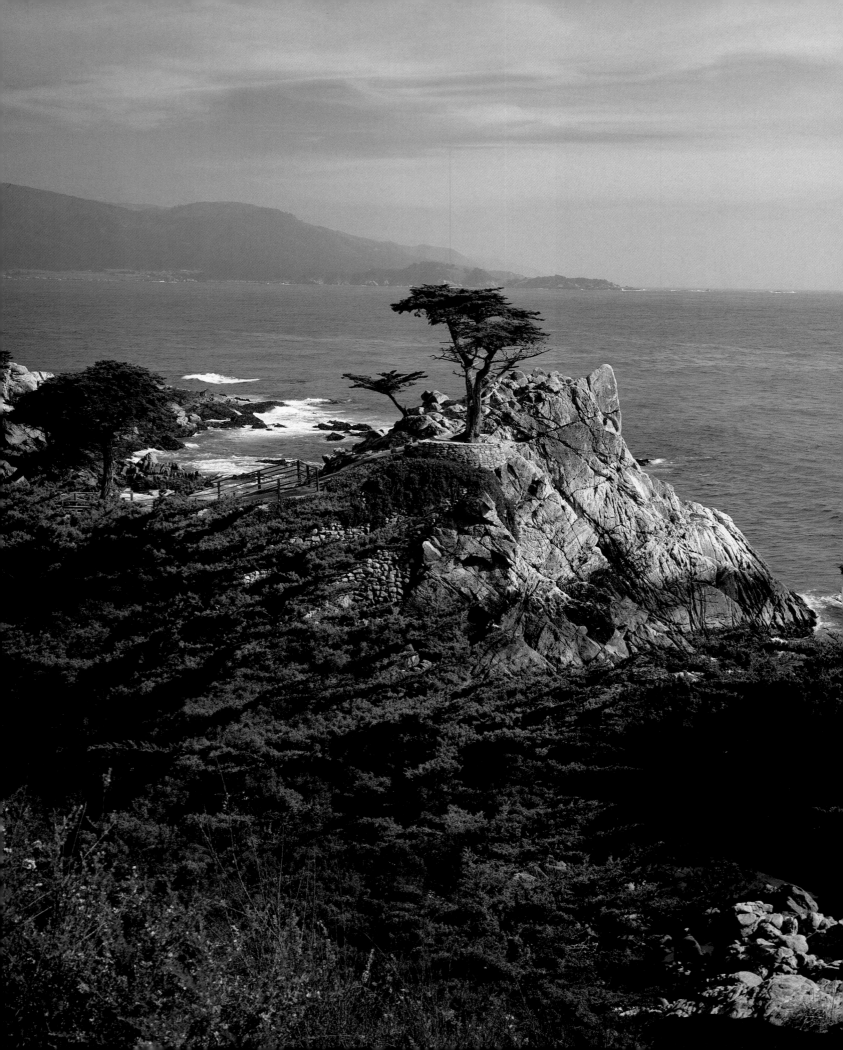

MONTEREY PENINSULA

The Pacific Coast has two species of pelicans, American white pelicans and brown pelicans. American white pelicans are second only to the California condor in terms of size of all birds found in North America. These huge birds, with wingspans of as much as nine feet, often stand between 54 and 70 inches tall. Both American white pelicans and brown pelicans use their throat pouches to capture fish; brown pelicans use powerful dives to crash through the water's surface to capture fish while white pelicans use their pouches to scoop fish while swimming or wading in shallow water.

The Monterey Peninsula holds a special place in the history of California and the Pacific Coast. Carmel was the site of Padre Junípero Serra's second mission, Mission San Carlos Borromeo del Carmelo, founded in 1770, and Monterey was California's capital under both Spanish and Mexican rule. Colton Hall, in today's downtown Monterey, was the site of the framing of California's state constitution.

In 1602, the Sebastián Vizcaíno expedition landed in Monterey and claimed California for Spain. The presence of three Carmelite friars accompanying Vizcaíno in January of 1603 as he explored a river descending from the mountains inspired the name El Río Carmelo; later, the city was to inherit the name Carmel, one of the oldest place names in the United States. The name honors an order of monks that had built the monastery at Mount Carmel, in the Holy Land, during the thirteenth century.

On April 16, 1770, the ship *San Antonio* left San Diego with Padre Serra and the supplies necessary to establish a mission. On June 3, 1770, a cross was erected representing the new mission, which would be moved to its current location near the Carmel River the next year. The mission, then Mission San Carlos Borromeo de Monterey, was later renamed Mission San Carlos Borromeo del Carmelo.

In 1770, the Presidio of Monterey was built to house the garrison charged with protecting Spain's interest in the region. Twenty-two years later, El Castillo was built on a hill overlooking Monterey Bay to protect the Presidio. Presidio Hill was once the site of a Rumsen village, an indigenous people to the area. The Presidio's military history spans its possession by four countries: Spain, Mexico, Argentina and the United States. Each country designated the hill for gun placements and forts.

The Presidio's protection of Monterey faltered in 1818 when it was attacked and destroyed by French privateer Hippolyte de Bouchard. The current presidio was built in 1902 by the U.S. Army, and today houses the renowned Defense Language Institute. John Drake Sloat, a U.S. Navy Commodore, claimed California as part of the United States, with Monterey as the capital in 1846. A monument in honor of his achievements resides in the presidio.

In addition to its role in the early governing of the state, Monterey's port has been used for a variety of commercial and industrial endeavors since its founding. Tallow and hide traders from New England used the port's docks and the area housed a sardine canning industry that was the largest in the Western Hemisphere in the 1940s. Monterey was the *Cannery Row* of John Steinbeck's famous novel.

On a global scale, it has been both a Chinese fishing village and Portuguese whaling station. Today, the city's lure is stronger than just its access to the Pacific Ocean. In September of each year, the Monterey Jazz Festival attracts visitors from around the world, aiding in the city's largest industry, tourism.

In 1833, Mission San Carlos Borromeo del Carmelo was secularized which, ultimately, left

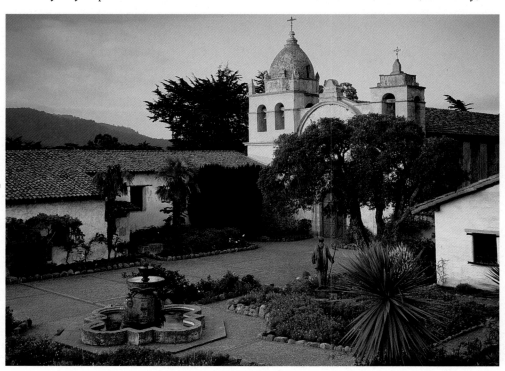

Left: The Lone Cypress, a landmark specimen of gnarled Monterey cypress, on 17 mile Drive.
PHOTO BY DICK DIETRICH

Right: Mission San Carlos Borromeo del Carmelo was founded by Padre Junípero Serra, in 1770. Padre Serra's remains are buried on the mission grounds, which were his residence until his death at the age of seventy-one.
PHOTO BY LARRY ULRICH

Above: Bird Rock from 17 Mile Drive on the Monterey Peninsula, one of the most scenic roads along the Pacific Coast.
PHOTO BY CHUCK PLACE

it in ruins for one hundred years. Finally, in 1936, it was restored. Over 3000 Indians, Padre Serra and Padre Juan Crespí are buried on the mission grounds.

In the late 1800s, the city's fortune held as the railroad brought a multitude of tourists, but when David Ashley and David Jacks appeared, the fortune seemed to falter. In 1859, Ashley was employed by the city to investigate a title to Mexican rancho lands. A $991.00 bill was presented by Ashley to the city, but funds could not be found for payment. Ashley persuaded the city to sell the 30,000 acres of Mexican rancho lands to raise the money, and the city concurred. The impending sale was advertised in an obscure Santa Cruz paper, and on the day of the sale only one man appeared to make a bid. Land investor David Jacks offered his

Below: Fisherman's Wharf in Monterey Bay.
PHOTO BY CHUCK PLACE

bid of three cents per acre and purchased the land. It was later discovered that the money he gave was only worthless script. City management remonstrated but even the U.S. Supreme Court ruled for Jacks. The lands purchased by Jacks constitute much of Monterey, Del Rey Oaks, Seaside, Pacific Grove and Pebble Beach.

The Chinese first founded the fishing village on the pier, but Americans soon began fishing for sardines from the pier. In 1902, Frank Booth built a primary fishing plant. Knute Hovden invented a system for steam-cooking sardines in 1905. Pietro Ferrante gave the sardine industry the methods to increase their daily catch with his lampara net in 1911. It became apparent by the falling prices of sardines that something had to be made of the by-products. Oil for manufacturing glycerine, vitamins, paint, tires and soap was produced, as well as animal feed. The purse seiner boat made sardines even easier to catch and it was one of the reasons for the incredible increase of the annual sardine catch, from 3000 tons in 1916 to 250,000 tons in 1945–the peak of the industry. By 1945, 23 canneries and 19 reduction plants

extended along one mile of the shoreline. Unfortunately, for reasons still not completely understood, the industry became moribund in 1951, but is now in resurgence.

In 1984, at Point Alones, the Monterey Bay Aquarium opened. The aquarium focuses on the local marine ecosystem and features 83 habitat aquariums, 5500 specimens and 525 species. It also has a Kelp Forest in a 335,000 gallon underground tank which rises 3 stories. The inhabitants feed from sea water which is pumped into the aquarium at 2000 gallons per minute from the bay. A marine biologist, Ed Rickets, has an exhibit named for him at the aquarium as well as a character in two of John Steinbeck's novels. The exhibit displays artifacts from his laboratory on Cannery Row.

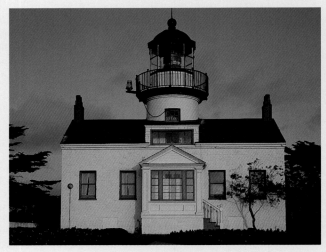

Above: Point Pinos Lighthouse in Pacific Grove.
PHOTO BY CARR CLIFTON

Between Pacific Tides (1939) is Rickets' noted work. The proposed subject was simplification

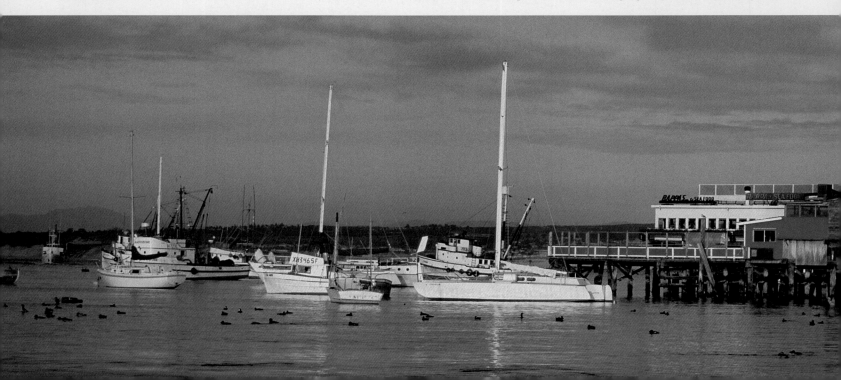

SEA OTTERS...

Perhaps the most whimsical of sea-going mammals, the whiskered sea otter is a clown with a sad past and a not-so-certain future. Once numbering as many as 20,000 individuals calling the Pacific Coast of California home, their populations were almost completely eradicated by fur traders during the 1800s. Thanks to the efforts of dedicated groups of environmentalists and conservationists, today the sea otters are on a comeback, although it is a precarious one. Their population now numbers around 2400 off the California Coast.

Sea otters were hunted to the brink of extinction for their luxuriant coats, which have as many as a million hairs per square inch, the thickest of any animal. In northern Washington, along the Olympic Peninsula, they were completely obliterated. A group of sea otters from the Monterey Bay area were introduced to the Olympic Peninsula area in 1969. They have reproduced successfully

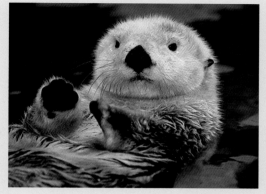

Above: Close up view of a sea otter (Enhydra lutris). Sea otters use their paws for grooming and eating, much like humans use their hands.
PHOTO BY JEFF FOOTT

and adapted well to their new habitat and have aided in reducing the sea urchin, a favorite sea otter food, populations along the Washington Coast. Urchins compete for habitat with kelp and removing the urchins has allowed kelp beds to grow, which reduces wave action and thereby slows shoreline erosion.

Sea otters have no layer of blubber, unlike other sea-going mammals, and they must continually preen their fur to saturate it with air for insulation from the cold waters of the Pacific Ocean. The continual grooming effort and high activity levels

of the otters cause them to consume around 25 percent of their body weight a day.

After mating, female otters have a gestation period of six months and give birth to a single pup. The mother then spends the following six months actively teaching the pup to survive, a process that is quite complex. The pup must be taught to groom itself to keep from freezing to death, dive to the ocean floor to forage for food and use tools to pry open and crack shellfish. Orphaned sea otter pups have a high mortality rate if they have not had time enough to learn the behaviors necessary for survival from their mothers. Staff members at the Monterey Bay Aquarium have developed methods to train sea otter pups they rescue and have been successful in reintroducing abandoned or orphaned sea otters to Monterey Bay.

Not everyone is enamored by the sea otter's playful antics. Fisherman along the California Coast still see the sea otters as competitors for shellfish crops, many wishing to restrict the sea otter population to small areas. In 1968, Margaret Owings founded Friends of the Sea Otter, a group dedicated to preservation of the species that has done much to protect the remaining sea otters.

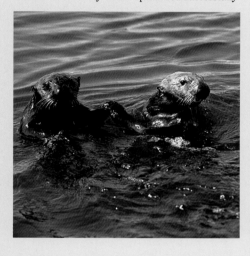

Right: Sea otter rafting in kelp in Monterey Bay. Sea otters attach themselves to kelp to keep from drifting while at rest.
PHOTO BY JEFF FOOTT

Left: Sea otter mother and pup. Sea otters spend seven months grooming pups to protect them from the cold while training them for survival.
PHOTO BY LEN RUE JR.

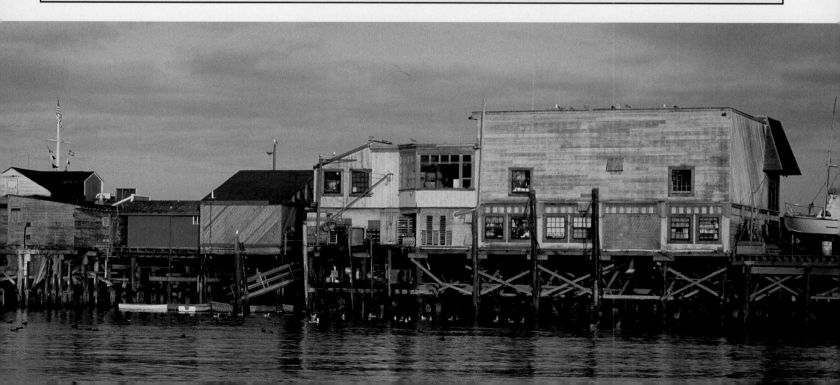

MONTEREY PENINSULA CONTINUED...

of the identification of various vertical habitat zones which run along the Pacific Coast. He also asked for realistic associations of plants and animals for each zone. Steinbeck expre-

Above: Western gull (Larus occidentalis) eating a starfish in Monterey Bay. Gulls are primarily scavengers, but will also take live prey.
PHOTO BY JEFF FOOTT

sses his adulation for Rickets in *Cannery Row* and *Sweet Thursday* where a character called "Doc" represents Rickets. The heritage of the canning days of Monterey is on display along Cannery Row and Fisherman's Wharf.

For all that Monterey has taken from the sea in the past, its residents today are among some of the most environmentally conscious citizens in the world. The Monterey area is home to Friends of the Sea Otter, an organization dedicated to the protection of the sea otter population along the Monterey Coast. Once the California Coast was home to as many as 20,000 sea otters. In the past century their populations were completely eradicated in many areas by trappers anxious to sell their luxuriant fur, which can have as many as a million hairs per square inch, the thickest coat of any animal.

Today there are less than 2400 sea otters along the California Coast, a population re-established by the efforts of conservationists during this century. The Monterey Bay Aquarium, and its staff, plays a very important role in the preservation of sea otters, rescuing sea otters in trouble, nursing them back to health and even operating a "sea otter school" to train orphans before returning them to the waters of Monterey Bay.

Neighboring Monterey to the north is Pacific Grove, first settled as a retreat for the Methodist Church in the mid-1870s. The town's Victorian past is still in evidence in the more than 250 homes that remain from its earlier days. The town has become increasing popular with area visitors as local populations have increased in Monterey and Carmel.

The Monterey Peninsula has earned praise from a wide variety of writers and artists who have chosen the area for their homes or as the subject of their work. The tree-lined streets of Carmel, with their incredible ocean vistas

Above: Monterey Bay Aquarium, one of the largest aquariums in the world, was founded by David Packard for the study of marine life.
PHOTO BY CHUCK PLACE

framed by gnarled cypress trees, rustic sea scapes of Monterey Bay and the spectacular views of the Seventeen Mile Drive, create a landscape that combines natural beauty with sophisticated architectural and design influences of man. Many people visit the area to view its fabulous homes and quaint structures. Any reason to visit this distinctive California coastal jewel is sure to be rewarded.

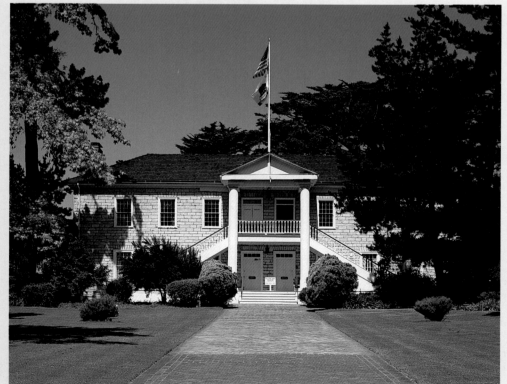

Right: The Monterey Coast on a morning in May.
PHOTO BY JEFF GNASS

Left: Colton Hall, in Monterey, is the site of the framing of California's constitution in 1849. The building served as California's first state capital and is now open to the public for tours.
PHOTO BY JEFF GNASS

Following Pages: Freshwater rills flow into the Pacific Ocean framed by a December sunset at Pebble Beach on the Monterey Peninsula.
PHOTO BY JEFF GNASS

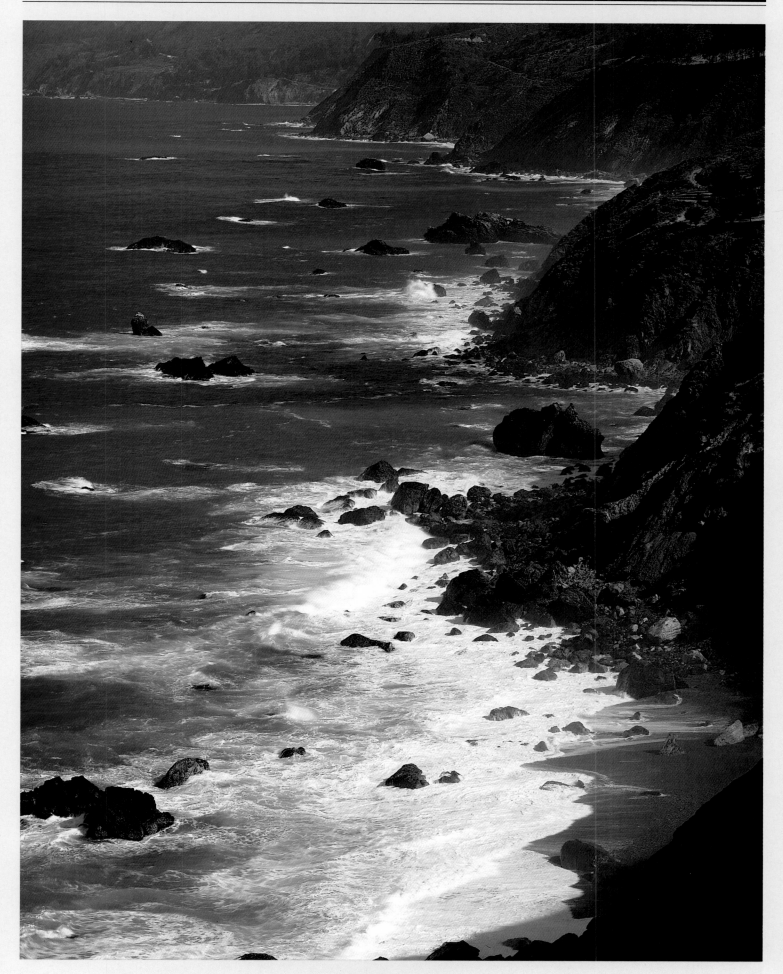

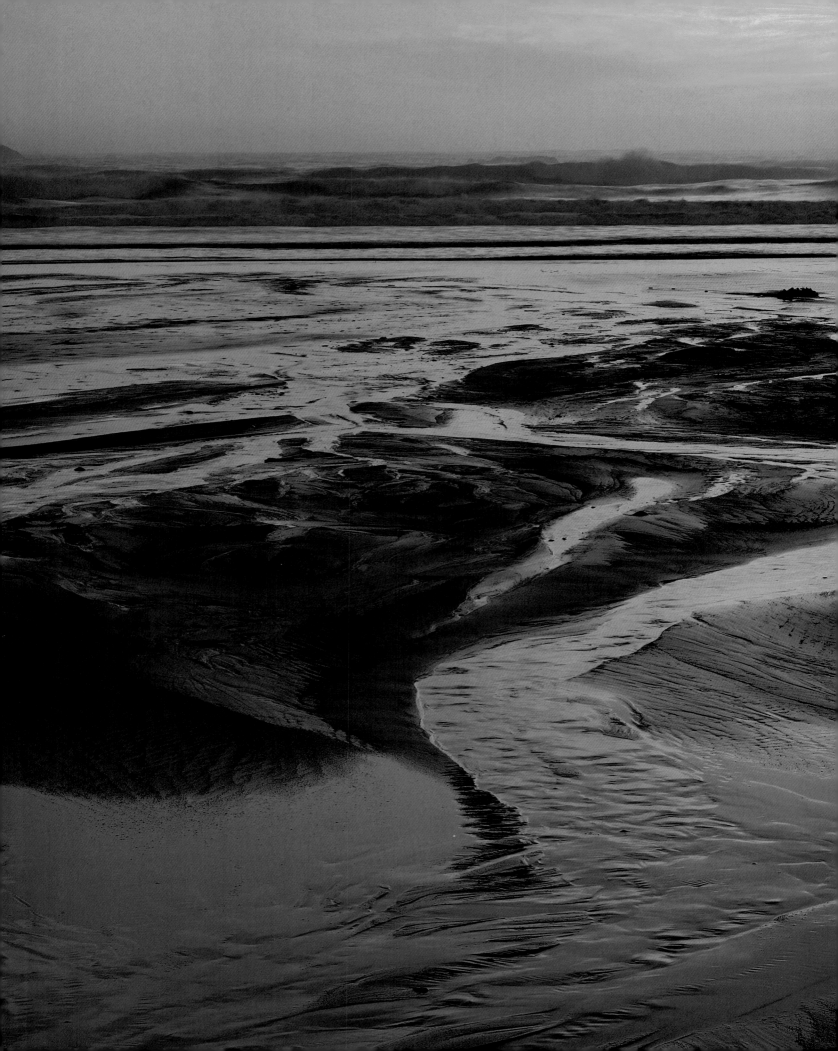

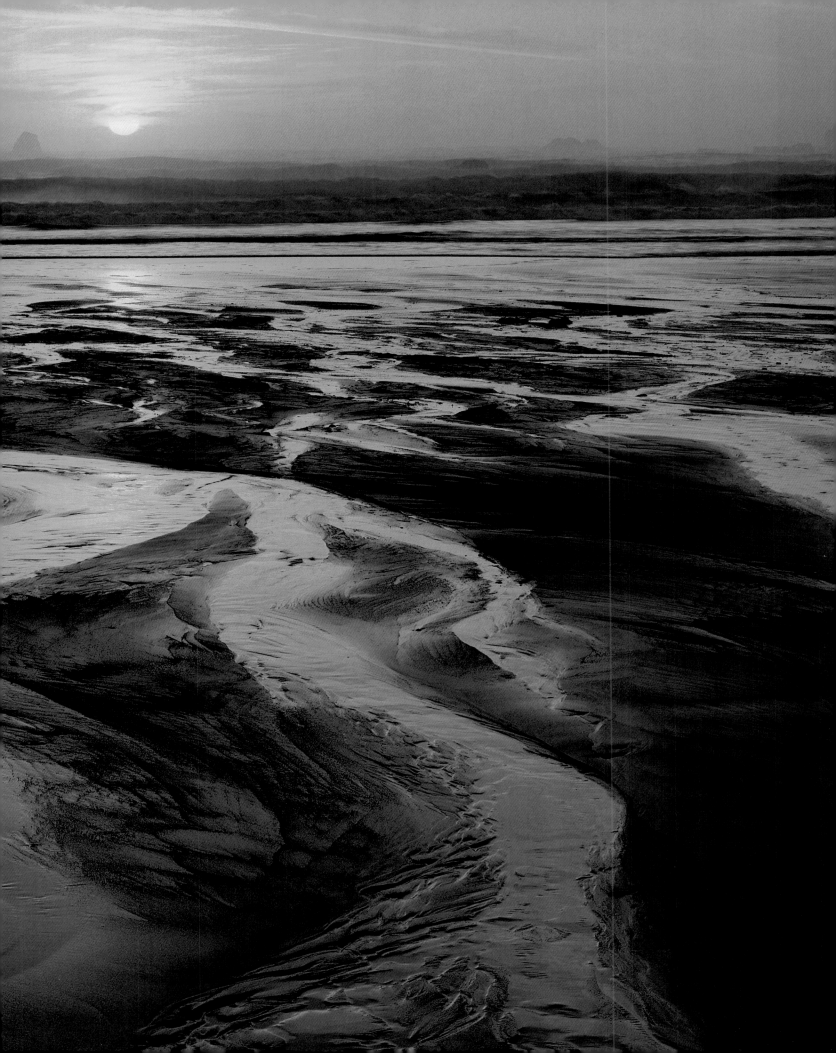

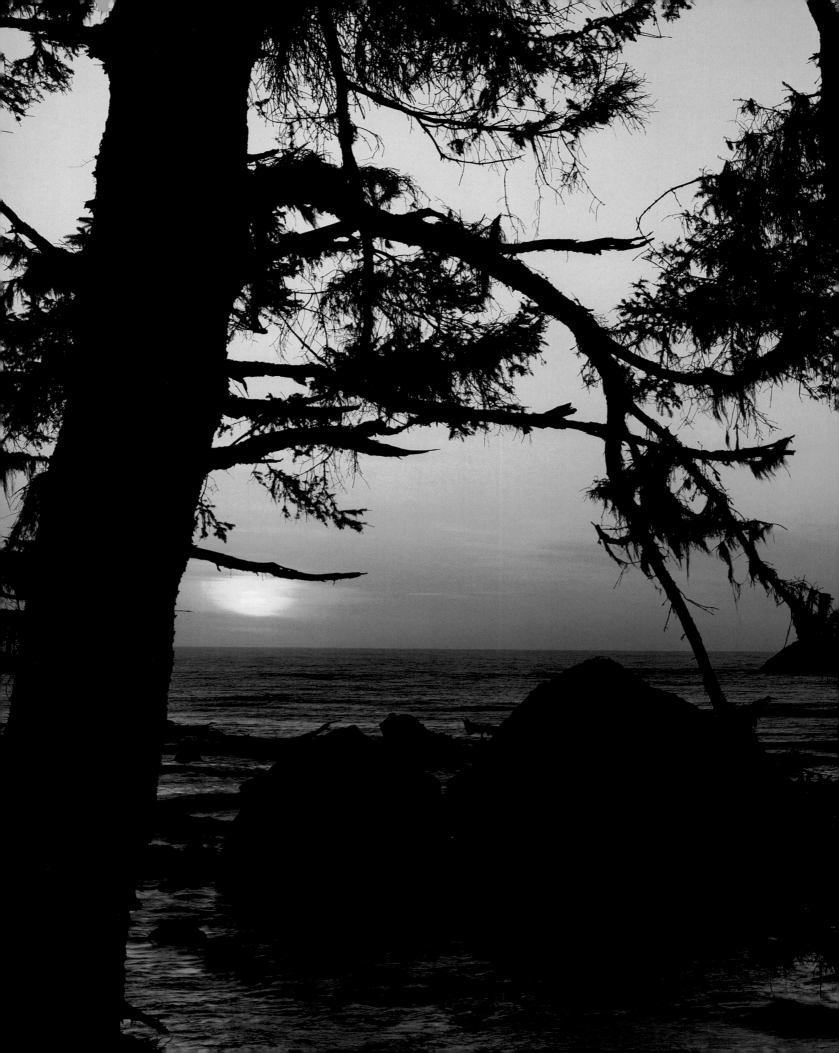

NORTHERN CALIFORNIA

California's northern coast features some of the state's most desolate coastline. Shipwrecks, caused by fierce storms, strong waves and dense fogs, were common occurrences along this coast in years past. The fog, a danger to ships, brings necessary moisture to the majestic Redwood forests that dot the northern coast.

More than miles divide the northern and southern regions of California. Differing attitudes about politics, environmental awareness and life-styles form the basis for many free-thinking Northern Californians to dream about a permanent separation from their more conservative southern half. Of course, as the state becomes more and more populated, homogenization takes effect, bringing the two regions closer together philosophically.

Native inhabitants up and down the coast of California were probably descendants of the Asian-Siberian people who crossed the Bering Strait thousands of years ago and then slowly migrated toward the coast. They may have numbered more than 50 major cultural groups and used as many as 90 languages. As with the other native North Americans, European occupation in historical times seriously affected their population. In 1776, somewhere around 300,000 Indians lived along California's coast, today, almost none remain.

While the great explorers, Juan Rodríguez Cabrillo, Sir Francis Drake, Sebastián Cermeño and Sebastián Vizcaíno sailed the waters off the Pacific coast discovering San Diego, Santa Barbara and Monterey, they repeatedly passed the foggy, yet potentially useful, San Francisco Bay, which went unseen because of its narrow opening and the foggy weather.

The first European to be credited with sailing through the Golden Gate was Lieutenant Juan Manuel de Ayala on the frigate *San Carlos*. He anchored near what is today called Fort Point on August 5, 1775. His mission was to explore and chart the bay's boundaries.

Ayala stayed aboard ship nursing a wounded foot, injured by the accidental discharge of a firearm, while his men explored the bay. He kept a meticulous journal of their findings and is responsible for naming many of the bay's landmarks including Angel Island, Sausalito and Alcatraz Island.

Juan Bautista de Anza, with his lieutenant, José Moranga, a Franciscan priest named Pedro Font, and several families reached the bluff at the tip of the peninsula on March 28, 1776, after an overland journey that began in Mexico in 1775. A cross was planted on the site to signify a future presidio. The bay was named San Francisco, for the Franciscan's patron saint. The site of the first church was named Yerba Buena, Spanish for "good herb," probably due to the wild mint growing in the area.

The official founding of San Francisco took place on June 29, 1776, when Father Junípero Serra celebrated mass under a shelter made of branches representing the site of the future mission. On October 9, 1776, official dedication of the Mission San Francisco de Asis occurred in honor of Saint Francis of Assisi.

The presidio, dedicated September 17, 1776, was destined to be heavily damaged by a severe storm just a couple of years after completion. The storm almost completely washed away the presidio's mud walls. The need for a sheltered location close to water necessitated selection of a new presidio site.

Left: The sun slips into the Pacific Ocean along the coast of Northern California.
PHOTO BY CARR CLIFTON

Right: The Boardwalk and Municipal Pier from Crowell Beach at Santa Cruz. The name Santa Cruz, "Holy Cross" in Spanish, was first given to the area by the Portolá expedition in 1769.
PHOTO BY LARRY ULRICH

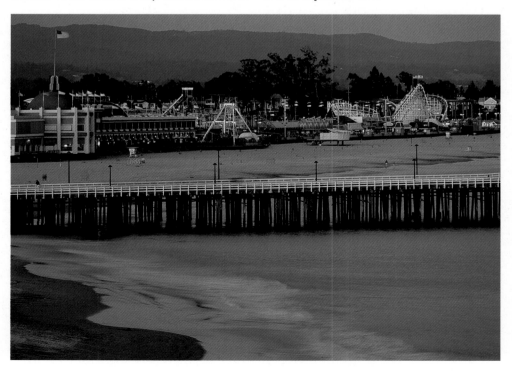

SAN FRANCISCO...

San Francisco, the city by the bay that once went unnoticed by the earliest Spanish explorers, has since become one of the world's finest cities. Its beauty, culturally diverse population and cosmopolitan charm now make San Francisco a favorite vacation destination of millions of visitors every year.

The Spanish province of San Francisco, or Yerba Buena, became the property of Mexico in 1821. Mexican land barons, known as Californios, came to rule the land for the next 25 years. Americans took possession in 1846, after winning a short war with Mexico. On January 23, 1847, San Francisco became the city's official name, in honor of the bay.

The growth of the area before the end of the 1840s could be attributed to many factors, but in 1848, a pea-sized mineral discovery changed everything.

When John Augustus Sutter, a Swiss immigrant built a sawmill on the South Fork of the American River, in a place known today as Coloma, one of his mill hands, James Marshall, made a momentous discovery.

Although gold was never discovered in San Francisco County—an oddity in itself since only

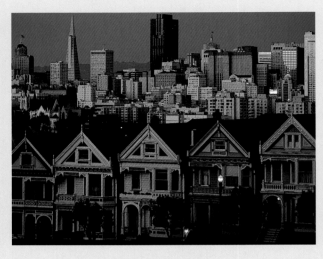

Above: Victorians at Alamo Square form a stark contrast with the city's high-rise skyline in the background. San Francisco is a blend of old and new in an ever-changing setting.
PHOTO BY LARRY ULRICH

4 out of 58 counties were found to be without gold–the city is irrevocably associated with the gold rush.

By the end of 1848, eight to ten thousand miners had appeared and were digging for their fortunes. Ships carrying treasure-seekers from around the globe arrived in San Francisco

Bay and men rushed to the gold mines. In 1848, at the height of the frenzy, prospectors were finding up to five pounds of gold per day. By 1849, over 100,000 people were en route to the area.

The gold rush had a profound effect on the population of San Francisco. At first mention of the strike, the original residents of the city left to seek their fortunes. However, once the fever subsided, the city experienced tremendous growth. Early in 1848, approximately 1000 people were living in San Francisco and at the end of 1849, the population jumped to 20,000. Since a majority of the new population consisted of men in their early twenties, family life was almost non-existent and the city took on a distinctly seedy tone. The need for food, shelter and entertainment created thousands of jobs and fortunes were

Right: The Golden Gate Bridge from the gardens above Fort Point, Golden Gate National Recreation Area, San Francisco.
PHOTO BY JEFF GNASS

Below: San Francisco Skyline above Ghirardelli Square at twilight from San Francisco Bay.
PHOTO BY CHUCK PLACE

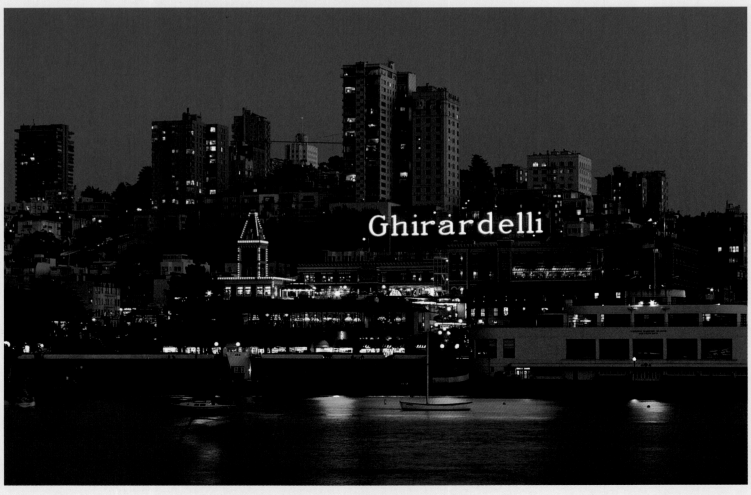

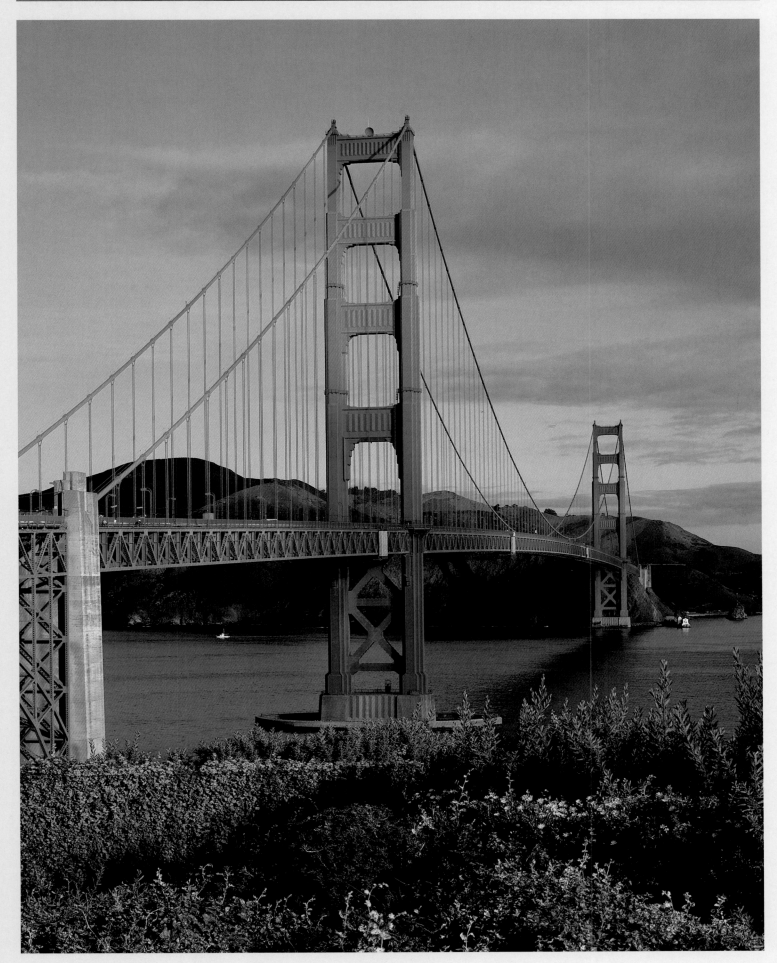

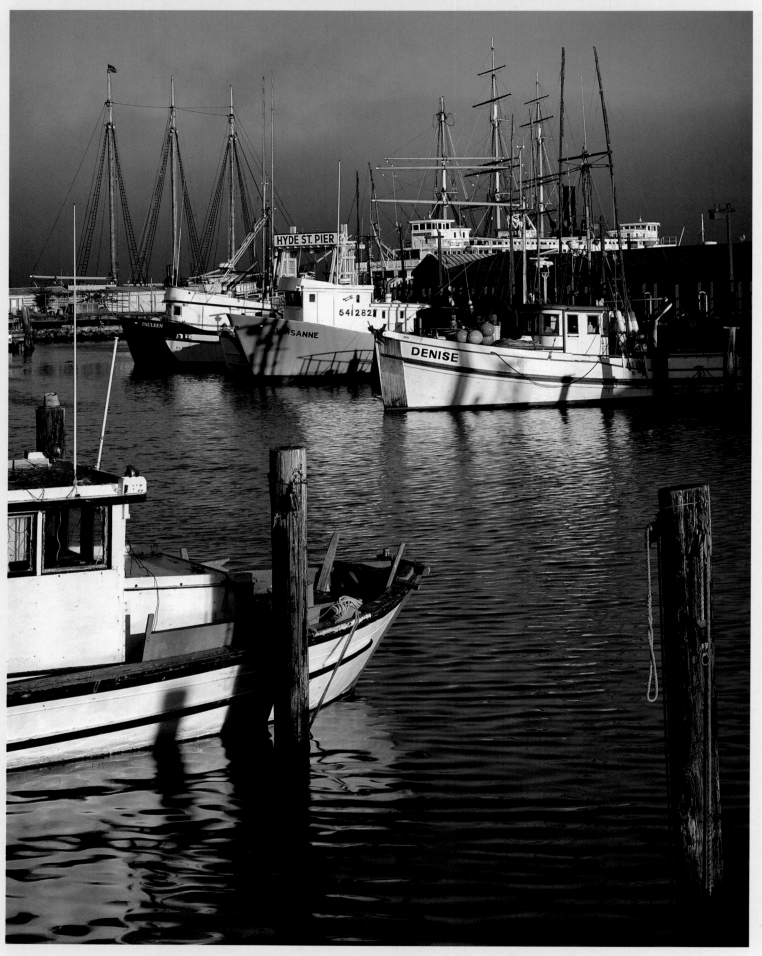

made by providing all types of services to the eager prospectors. The miners were tempted by gambling halls filled with liquor, games of chance and women of easy virtue.

The city, haphazardly constructed of canvas and wood, was extremely vulnerable to fire.

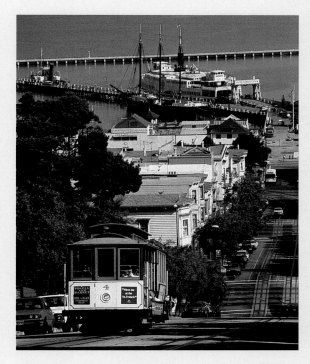

Above: Cable car on Hyde Street overlooking Hyde Street Pier. Cable cars were first introduced by Andrew Hallidie in 1873. The 112 miles of track suffered serious damage in the 1906 earthquake, but a few are still in use today.
PHOTO BY LARRY ULRICH

fires was the change of building materials used during reconstruction of the city. Store owners began to rebuild using brick and stone instead of lumber.

The gold rush affected growth both in and out of San Francisco. The demand for food created agriculture and cattle ranches in surrounding areas, Sacramento and Stockton included, which continued to grow during the Silver Rush that began in Nevada in 1859.

With the completion of the Central Pacific Railroad in 1869, San Francisco experienced a serious decline in its economy and the early 1870s proved difficult years. The city kept growing and changing. Once the gold and silver rushes quieted down, the focus of the area changed to agriculture, whaling and enjoying the prosperous years of the late 1800s.

In the decades before the turn of the century San Francisco developed in ways that are still evident today. In 1868 a strip of land was dedicated for the development of what would become the world famous Golden Gate Park. Cable cars were introduced in 1873, by Andrew Hallidie and in 1964 they were declared National Historic Landmarks. Some are still in use.

A catastrophic earthquake hit the city April 18, 1906. The first tremor shook the city of San Francisco for 40 seconds. The second tremor was much

stronger, but lasted only about 25 seconds. The Richter scale had not yet been invented, but using modern technology, the earthquake was estimated to have registered 8.3 on the Richter scale.

After the quake, broken gas mains, loose electrical wires and over-turned stoves created fires that quickly spread across the city. Disabled equipment and broken water pipes made quick response to the fires impossible. It took three days to extinguish the inferno.

The aftermath of the fires was staggering. 3,000 people died. Two of every three homes had been destroyed and 250,000 people were left homeless. Around 28,000 buildings were completely decimated, totaling $500 million in property damage, a staggering figure that was almost the size of that year's federal budget.

Surprisingly, in just a few years the city was almost completely rebuilt. During reconstruction, a political cleansing took place and the crooked politicians who had been running the city for years were booted out of office. It was a brand new San Francisco that hosted one of the grandest world fairs ever to take place, the Panama-Pacific International Exhibition, which opened in 1915.

San Francisco has become one of the most culturally and creatively richest cities in the world, which is probably why so many people have left their hearts in San Francisco.

The completion of the Golden Gate Bridge in 1937 connected San Francisco with Marin County, just north of the city. A lovely contrast to the crowded city is Muir Woods National

Buildings lined the street shoulder to shoulder and the ever-present winds spread the flames of any fire almost effortlessly.

Serious crime in the city grew. One group of hooligans used fire as their weapon of crime, starting fires and looting while good citizens fought the fight fires. The First Committee of Vigilance banded citizens together to rid the city of crime. Several gang members were hanged and order was restored. A couple of years later a Second Committee of Vigilance was organized in response to the killing of James King, an editor for a local newspaper. After King's accused killer was hanged the vigilantes were once again disbanded.

One of the few benefits stemming from the

Left: Hyde Street Pier from Fisherman's Wharf. San Francisco's active fishing fleet has made the city world-famous for its fresh seafood.
PHOTO BY LARRY ULRICH

Right: Just minutes away from the busy streets of San Francisco, across the Golden Gate Bridge, a sunlit trail through giant redwoods in Cathedral Grove offers solitude and tranquility at Muir Woods National Monument.
PHOTO BY JEFF GNASS

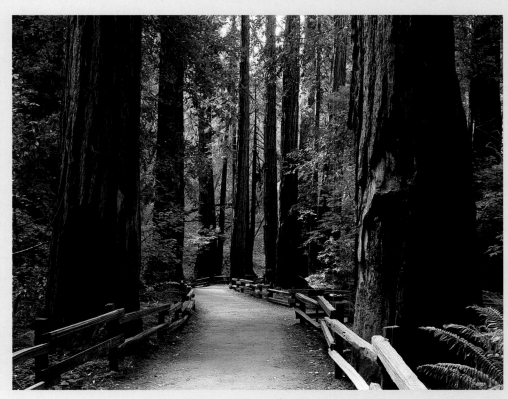

Monument, named after the famed naturalist, John Muir. The park features and protects the last redwood forest in Marin County. Just above the redwoods sits Mount Tamalpais, overlooking the Pacific Ocean and San Francisco Bay.

The Bay Bridge connects San Francisco with Oakland and was completed in 1936, replacing the ferries that carried over 50,000 commuters to the city everyday and had been unable to keep up with the growing demands for transportation across the water.

Oakland has used its access to the ocean in more industrial ways than neighboring San Francisco. The city has become a major player in the container shipping business, with the second biggest container port on the Pacific.

The University of California, Berkeley, located just north of Oakland, has a history of fighting for peace, human rights and environmental consciousness that pre-dates the much publicized 1960s and personifies the avant-garde attitudes of many of the people living in San Francisco and the surrounding Bay Area.

Right: San Francisco Bay offers exciting yacht racing opportunities. Here, *Revenge* leads on a spinnaker run in the Big Boat Series.
PHOTO BY CHUCK PLACE

ALCATRAZ ISLAND...

Alcatraz, originally named *Isla de los Alcatraces,* or Pelican Island, in 1775 by Juan Manuel de Ayala, captain of the Spanish ship *San Carlos,* whose pilot was the first European to explore and chart the San Francisco Bay. Later the name was misspelled Alcatrazes as people copied the map and was shortened to Alcatraz in 1851. Alcatraz was uninhabited during the Spanish and Mexican rule. When California became part of the United States, President Millard Fillmore decided to reserve the island for military use.

Because of its location, the island was first designed to be used for defense of the city of San Francisco against sea attack and from 1859 to 1907, the island served as a United States Army fort.

In 1854 a lighthouse was built on the island, which was the first Pacific Coast lighthouse to flash its piercing beam out to ships at sea.

The guardhouse, an armed gate often called a sally port, was built in 1857 to protect the island's wharf, the only safe place for boats to dock. It still remains as a reminder of its original occupation. The isolated base, just over a mile from the nearest shore, was later converted to a military prison and began its long history of incarcerating criminals in 1912.

When the prison was completed, in 1911, it was among the largest reinforced concrete structures in the world. It was constructed so that no cell had walls that were on the exterior of the structure. Tunneling through a cell wall left the would-be escapee still within the prison confines. No one ever successfully escaped.

The island was designated as a "maximum security, minimum privilege" federal penitentiary in 1934, possibly in response to the gangsters of the 1930s. Within its walls passed many of the era's most notorious criminals. Perhaps the most infamous criminal sent to "The Rock," as Alcatraz was known, was Al Capone, a famous Mafia chief who was imprisoned by the tireless efforts of the Internal Revenue Service. Although Capone was known to have been involved in scores of serious crimes, he was able to escape justice until he was tried and convicted for the evasion of income tax. Capone did not die on The Rock, but did his time and was released to die a short time later of venereal disease at his winter estate in Florida.

Other famous criminals include Alvin Karpis, one of Ma Barker's henchmen, who was convicted on kidnapping charges; and Robert Stroud,

Above: A tour group gazes upon the prison cellhouse from the recreation yard at Alcatraz Island, Golden Gate National Recreation Area, San Francisco.
PHOTO BY JEFF GNASS

the "Birdman of Alcatraz," a convicted murderer who became an ornithological disease expert while serving out a life sentence. Unlike the celebrated movie version of Stroud's life, he was never allowed to keep birds in his cell. He went insane and died at the age of seventy-two.

Robert Bradford Moxon, transferred in to Alcatraz in August of 1934 from McNeil Penitentiary, was another notable prisoner; he had the distinction of serving time on Alcatraz when it was a federal penitentiary and when it was still a military prison.

By the end of 1934 the prison held more than 200 inmates and continued to import dangerous criminals from prisons on the mainland. The prison's twelve acre site, more than a mile from the nearest land, proved extremely capable of constraining even the most difficult prisoners. Its tight security was legendary; there was a guard for every five prisoners.

Life on The Rock was purposefully hard for the inmates and even the slightest infraction of the rules was met with swift and severe punishment. Privileges, such as library visits, receiving visitors and

Right: Alcatraz buildings thru sally port window on a dreary December morning. No one ever escaped from Alcatraz and lived to tell about it.
PHOTO BY JEFF GNASS

mail, were withheld from inmates who did not adhere to prison rules.

Two unusual aspects of prison life on Alcatraz were the surprisingly appetizing food and the generous portions of tobacco given to the prisoners to prevent violent outbreaks at meal times and the use of cigarettes as a prison currency, which has remained a common problem in prisons throughout the years.

After 29 years, Alcatraz finally proved too expensive to run and was closed by Attorney General Robert Kennedy in 1963.

In 1969, Indian activist Richard Oakes, with about 90 other people claimed the uninhabited island as rightfully theirs, according to a treaty from 1868 which stated that excess federal lands would be returned to Indian ownership. After a 19-month stand off with the Indians, the government arrested all of the remaining occupants of the Island

Alcatraz Island, opened to the public in 1973, became a part of the Golden Gate National Recreation Area. Restoration of the buildings and grounds continues today and almost a million visitors flock to the island every year to experience the desolation and despair felt by the many prisoners who were imprisoned in the legendary prison.

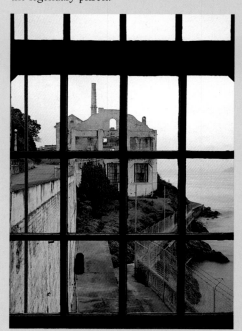

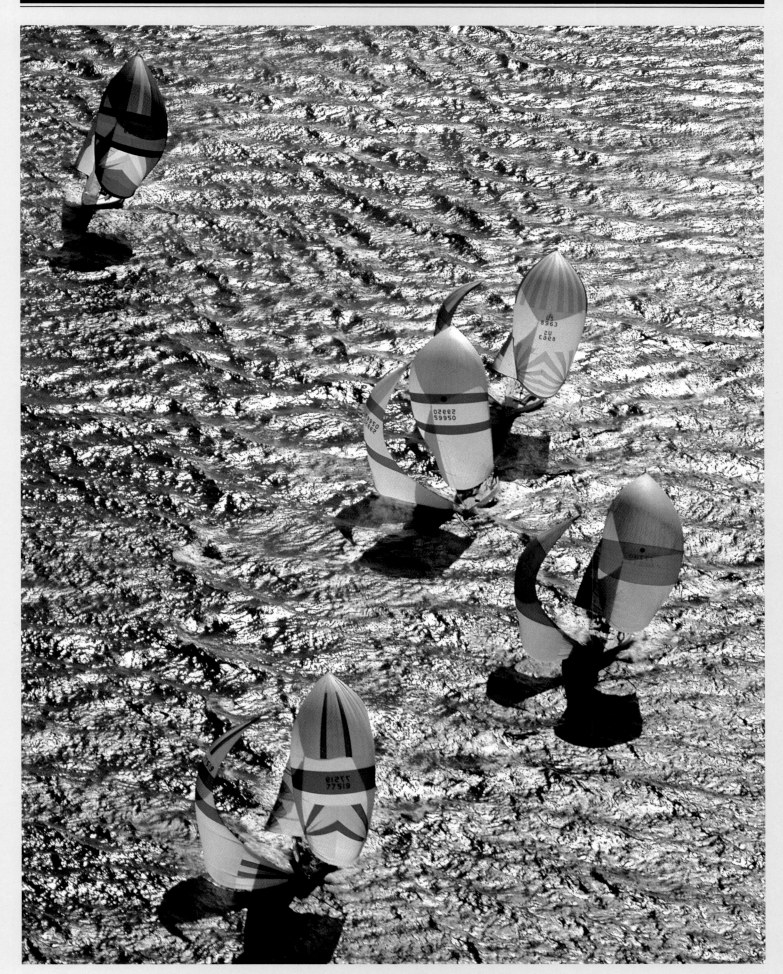

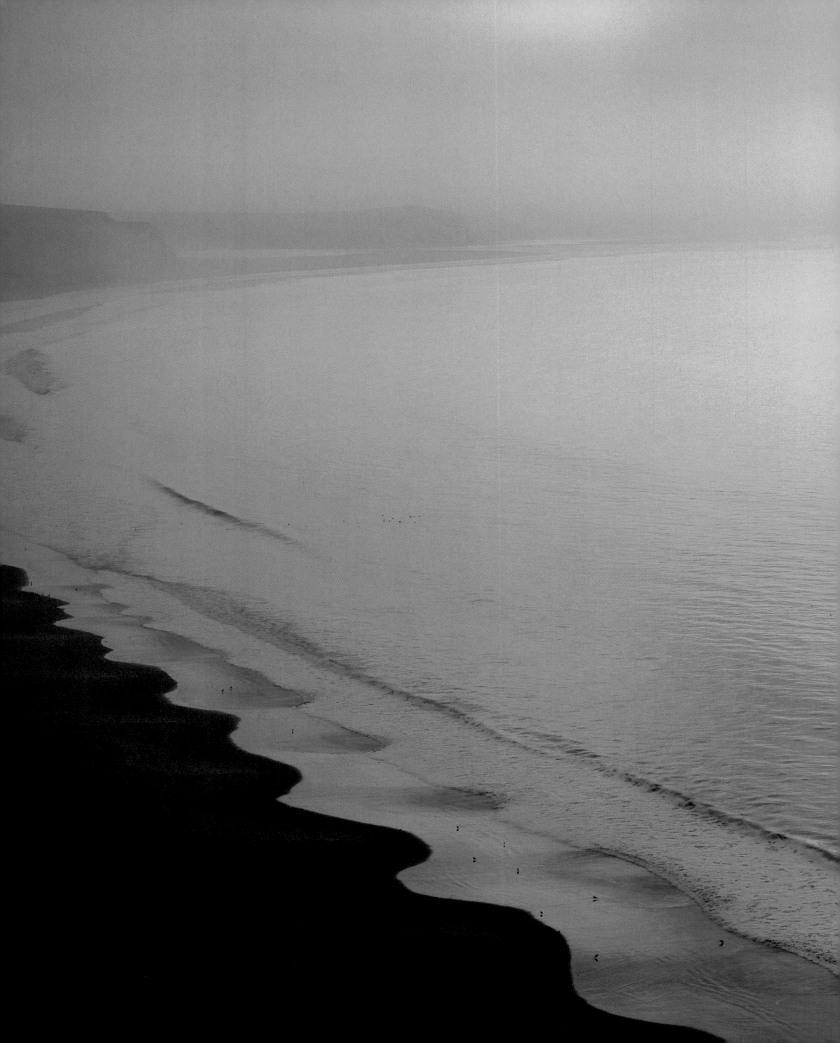

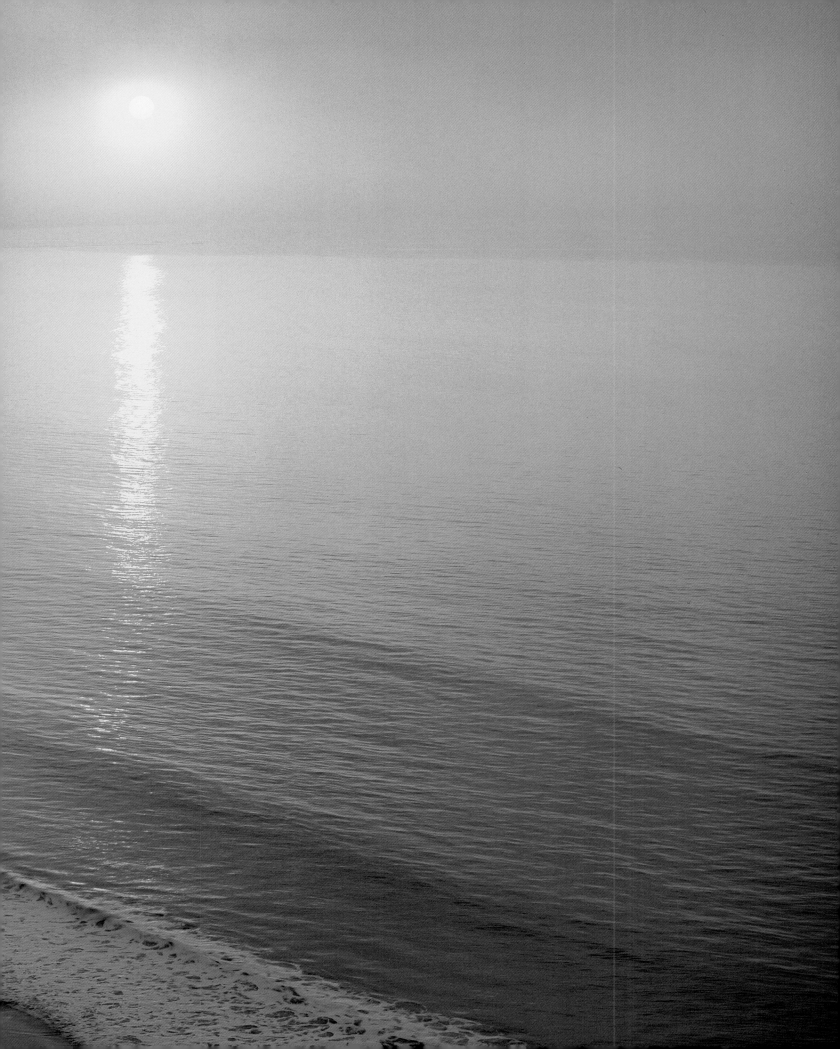

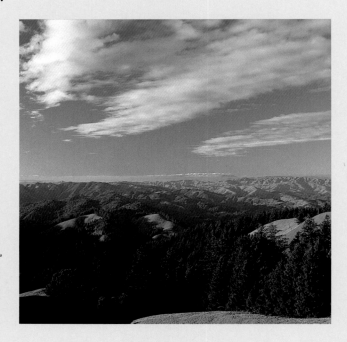

Right: North Coast Ranges from Bolinas Ridge in Mount Tamalpais State Park, Marin County. Mount Tamalpais 2,571 foot summit offers 360° views from San Francisco to the Sierra Nevada mountains. The state park, with its 6,300 acres surrounding Muir Woods National Monument, is one of the oldest in the California park system.
PHOTO BY LARRY ULRICH

Preceding pages: Sunrise over Drakes Bay at Point Reyes National Seashore.
PHOTO BY CARR CLIFTON

Below: Point Reyes Lighthouse was in service from 1870 to 1975. Congress authorized addition of Point Reyes National Seashore to the National Park Service on September 13, 1962. Point Reyes is less than fifty miles north of San Francisco.
PHOTO BY WILLARD CLAY

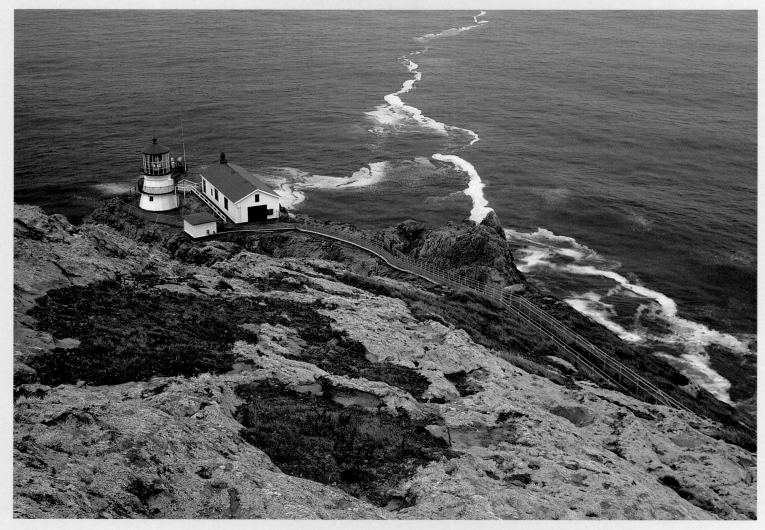

Above: Russian cannon and the chapel at Fort Ross State Historic Park, Sonoma County. Twenty-five Russians and 80 Aleuts built Fort Ross, in 1812, to defend their claim to the Sonoma Coast against the Spaniards.
PHOTO BY LARRY ULRICH

Below: Surf rounded boulders along the Sonoma County coastline at Salt Point State Park.
PHOTO BY CARR CLIFTON

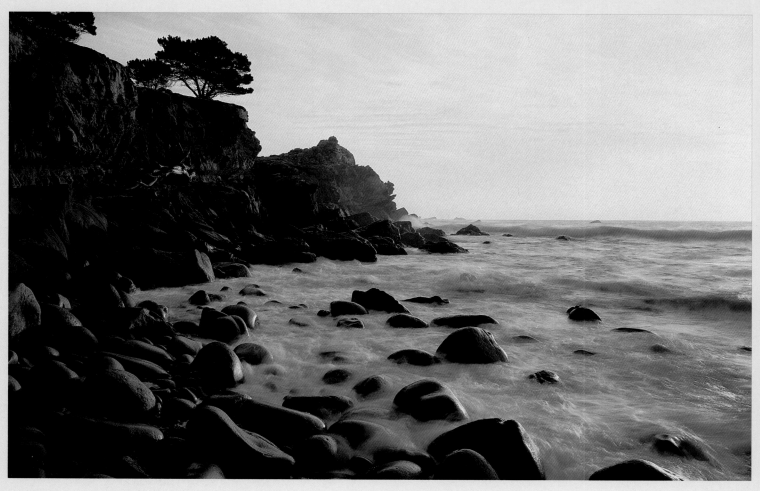

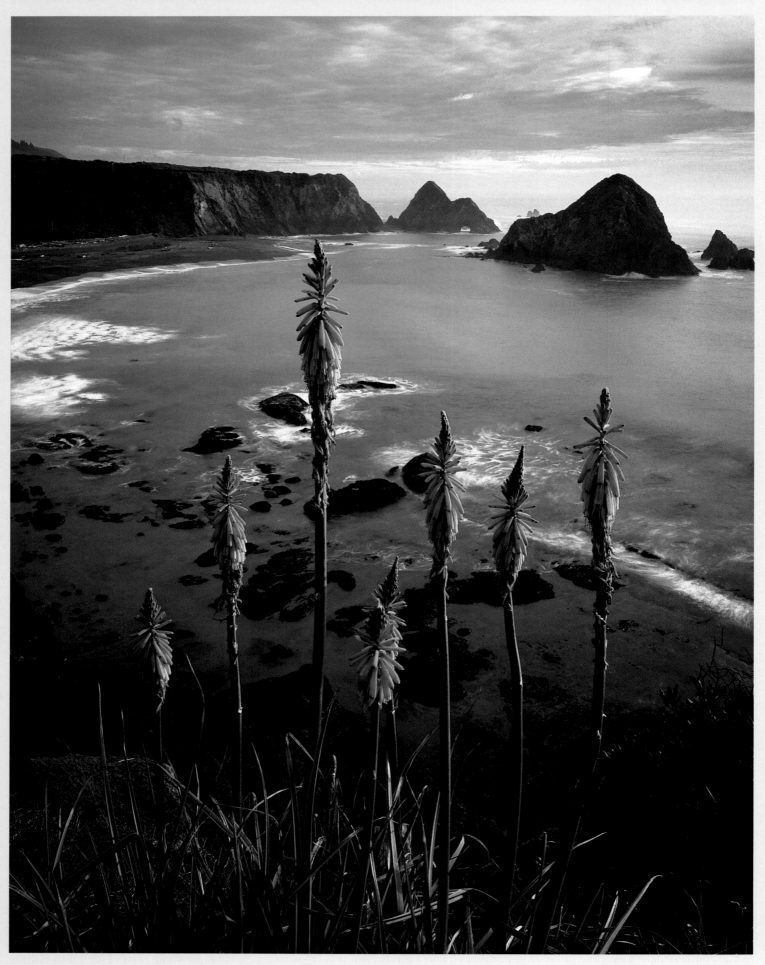

NORTHERN CALIFORNIA COAST...

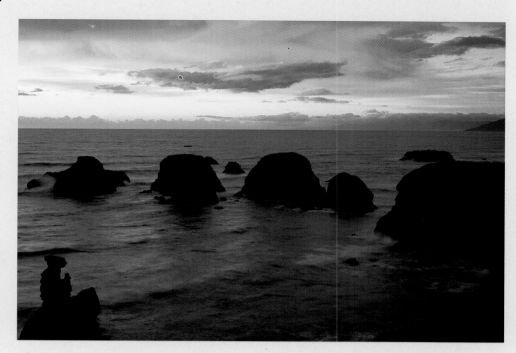

Left: Cuffy Cove near the town of Elk. The Pacific Coast of Mendocino County has remained largely unspoiled. Mendocino was established in the mid-1800s as a logging town. Today, the town's restored Victorian buildings, picturesque setting and casual lifestyle attract visitors from the San Francisco Bay Area in ever-increasing numbers.
PHOTO BY CARR CLIFTON

Above: Mistake Point from Westport-Union Landing State Beach in Mendocino County, California.
PHOTO BY LARRY ULRICH

Below: Mendocino's eroded headlands from Russian River State Park in Mendocino County.
PHOTO BY LARRY ULRICH

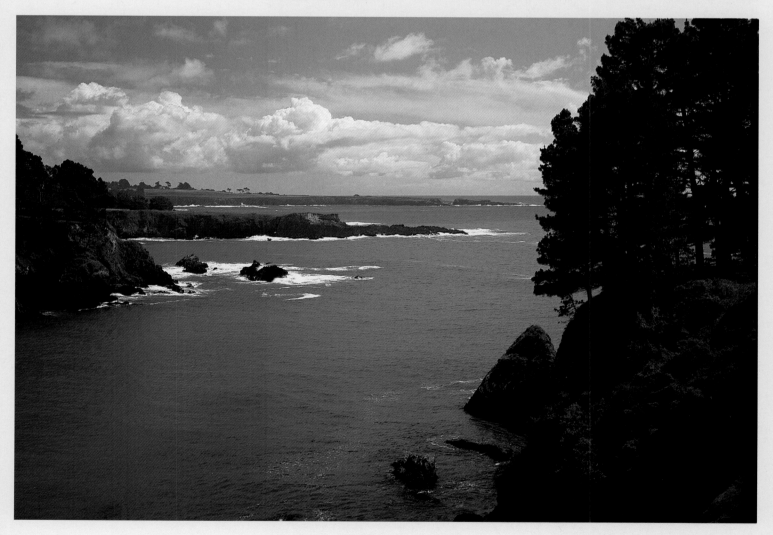

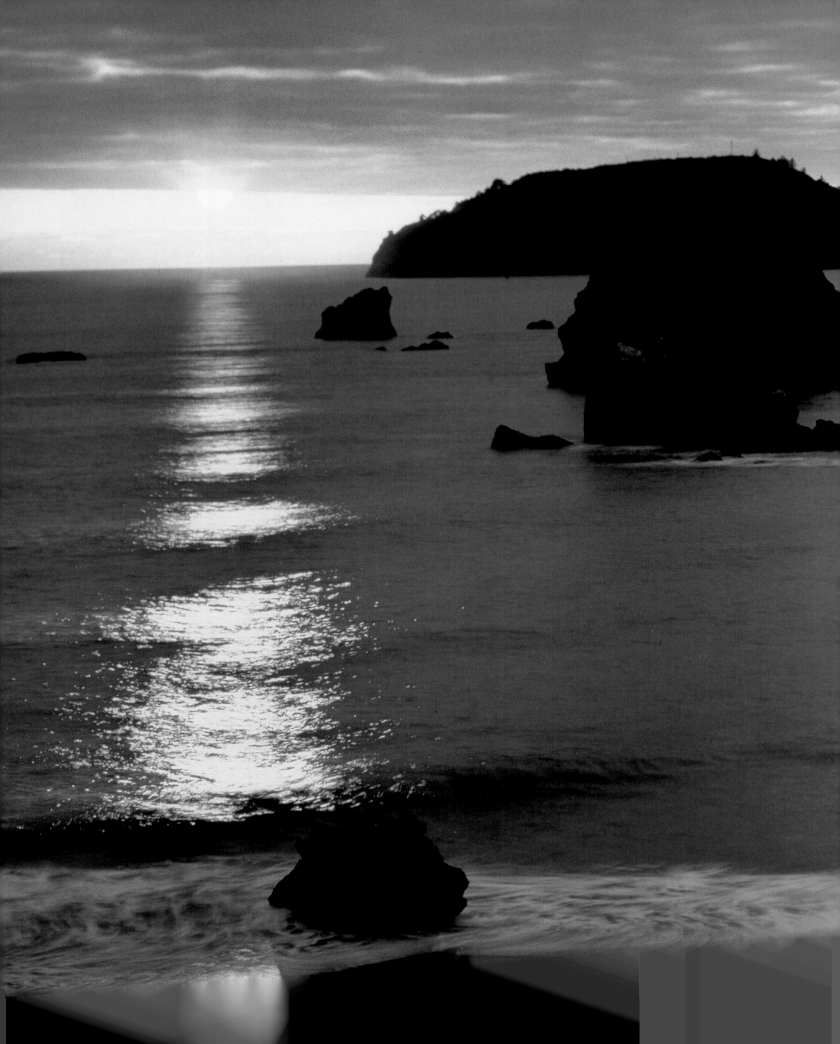

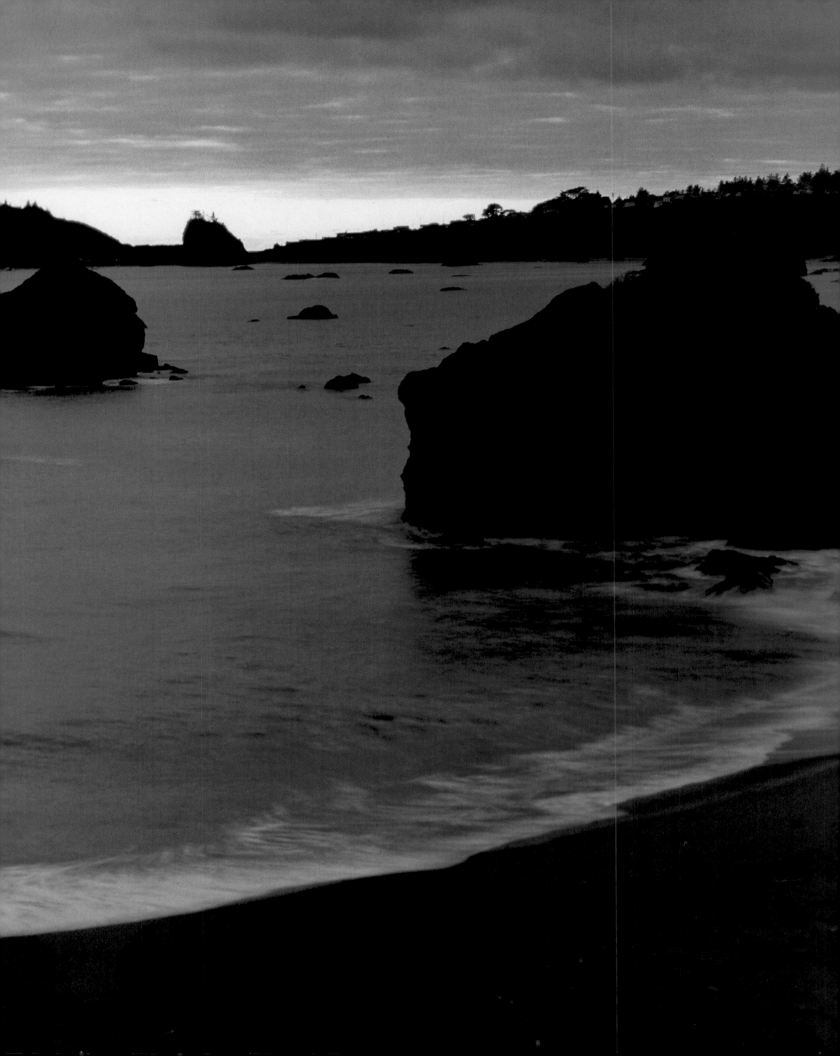

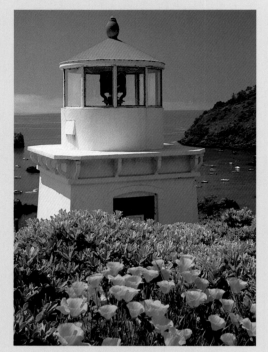

Right: Red alders frame the tranquil waters of Stone Lagoon at sunset. Humboldt Lagoons State Park, Humboldt County.
PHOTO BY LARRY ULRICH

Left: California poppies, California state flower, and Memorial Lighthouse overlooking moored boats in the protected waters of Trinidad Bay. Summer brings hordes of sports fishing boats in search of salmon to Trinidad Bay.
PHOTO BY LARRY ULRICH

Preceding pages: Summer sunset over Trinidad Head from Luffenholtz Beach County Park at Trinidad in Humboldt County.
PHOTO BY LARRY ULRICH

Below: The sun's last rays back light a stand of pines covering an offshore seastack at Trinidad State Beach in Humboldt County.
PHOTO BY CARR CLIFTON

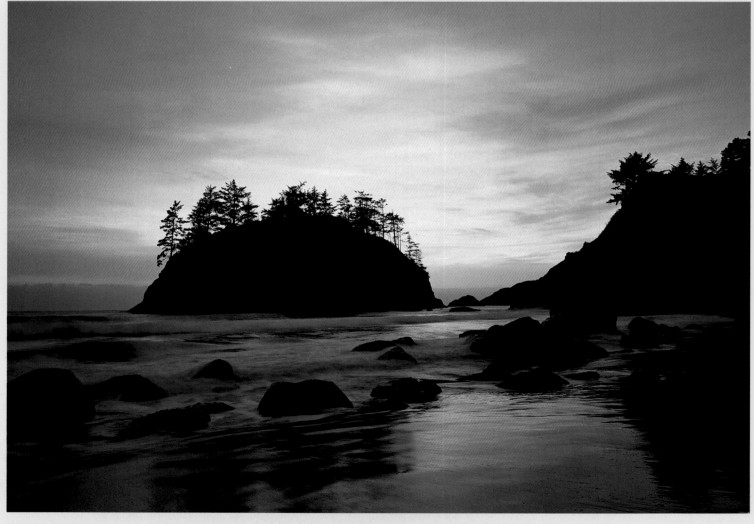

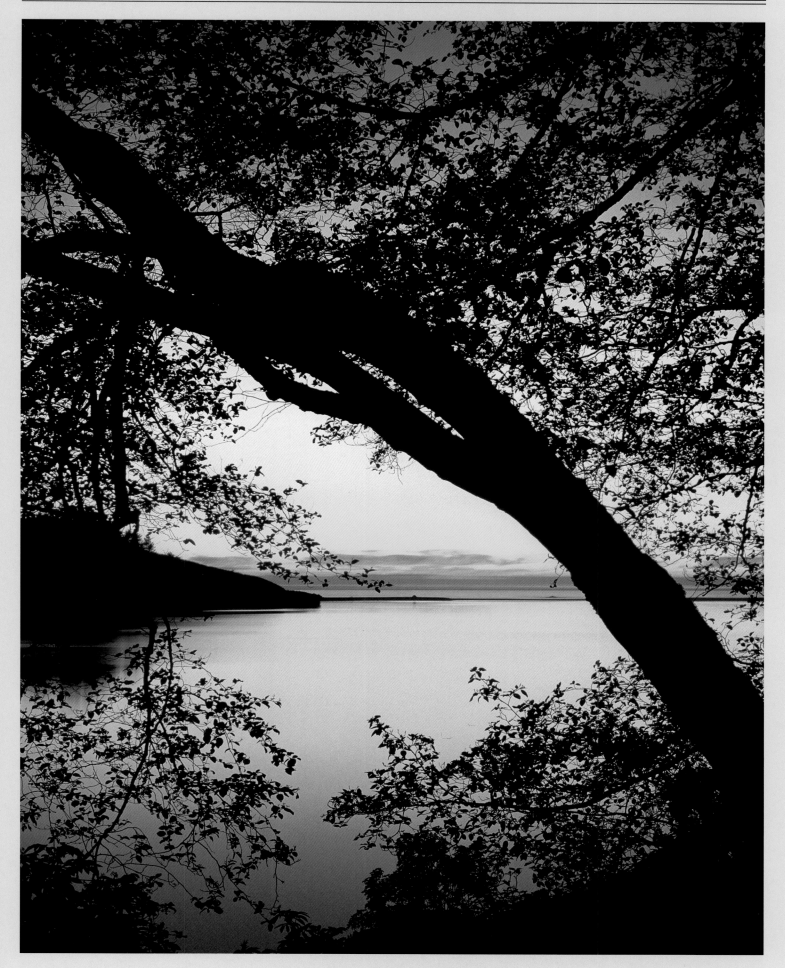

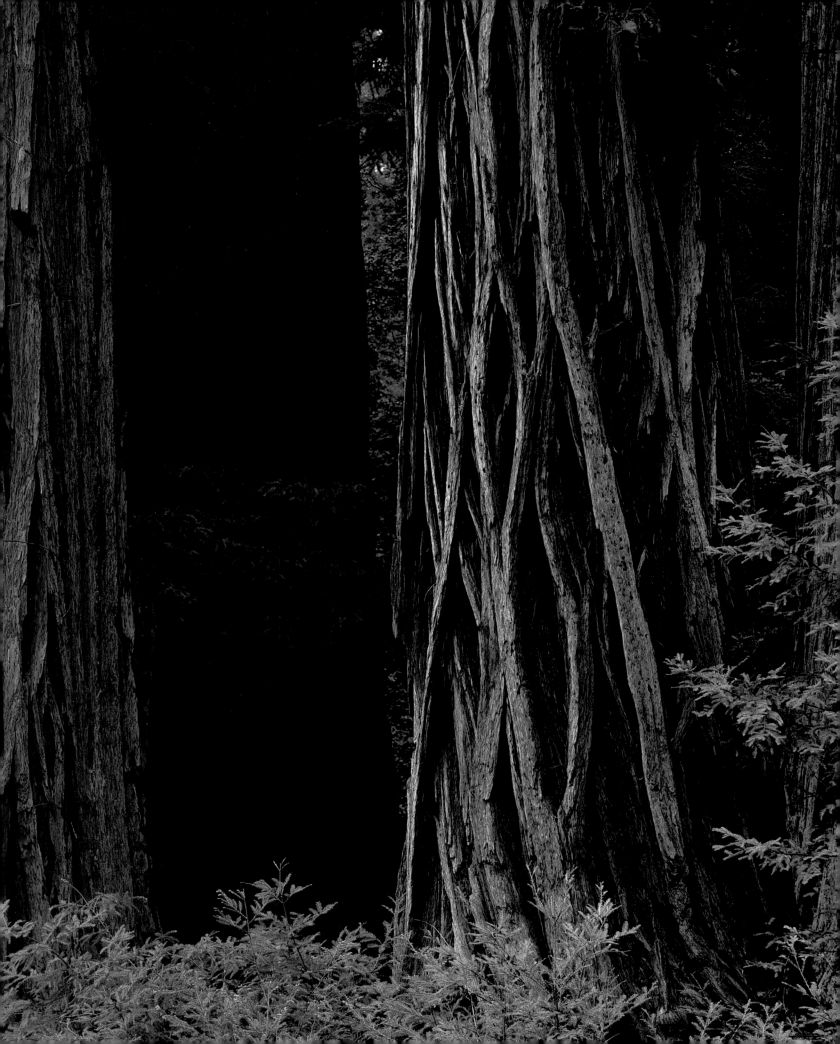

REDWOODS

The majestic redwood forests gracing the rugged shoreline along the Pacific Coast, from north of the Oregon boarder to Big Sur, once covered large portions of the northern hemisphere. Drastic changes in climate affected the range of the redwoods and restricted their growth to about two million acres on a thin strip of the western coast of the United States. Heavy logging over the last century reduced the remaining redwoods to less than 50,000 acres of virgin, or old growth, forests today.

Coast redwoods, or *Sequoia sempervirens*, need a temperate environment in which to thrive. The cool, moist fog and plentiful rainfalls of the Pacific Coast make a perfect climate for the immense conifers to grow to heights of over 350 feet, making them the tallest living things in the world.

The tallest tree in the world, measuring 367.8 feet tall, can be found on the Tall Trees Trail which meanders along Redwood Creek in the Redwood National Park. Several other record setting redwoods grow in nearby areas.

Giant in height, coastal redwoods reach maturity in about 200 years. Most old growth coast redwoods can easily reach the age of 1,000 years and several have been known to live for more than 2,000 years.

While these massive trees seem to grow independently towards the sky, their very existence is dependent upon other trees. Redwoods have very shallow root systems, growing only about ten feet deep, that spread out and become intertwined with roots of other trees, effecively

stabilizing each other. The close proximity of other trees creates a wind barrier that protects the top-heavy redwoods. Redwoods that are taller than those surrounding them are often toppled during heavy winds, and sometimes will knock over other trees on their long fall to the forest floor.

Although wind can be a serious threat to the behemoth trees, they protect themselves from other natural disasters fairly well. The tannin contained in their thick bark helps to prevent insect attacks and deters several types of tree rot. Because of the moisture in the tree, from rain and fog, most redwoods are able to easily survive fire. When flooding leaves heavy silt deposits redwoods survive by growing newer roots higher up their trunks.

As far back as 1852, concerned citizens urged the government to create a national forest for the protection of the remaining old growth redwoods. When all attempts failed, a group of preservationists decided to procure the land for a state park instead. In 1918 the Save-the-Redwoods League was created and purchased land with funds raised specifically for preservation of the redwoods.

Before the Save-the-Redwoods League was formed, another small group of preservationists assembled to protect a stand of towering coast redwoods placed along a small stretch of the Santa Cruz Mountains. The group called itself the Sempervirens Club and protected the land that would become California's first state park, Big Basin Redwoods State Park.

Much of the preservation of thousands of acres of virgin, or old growth, coastal redwoods can be credited to the formation of the Save-the-Redwoods League, which was created in 1918. Other conservation groups, including the Sierra Club and the Sempervirens Club, have also contributed greatly to the preservation of these magnificent forests, home to the tallest living things on the earth.

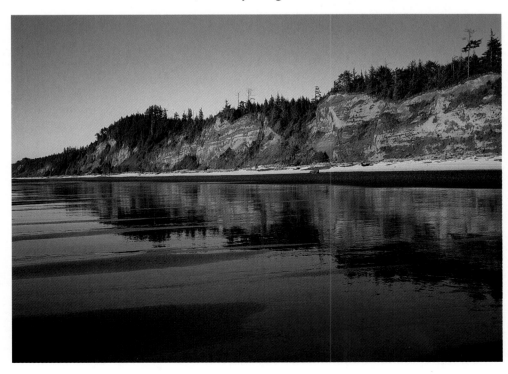

Left: Coast redwoods in Big Basin Redwoods State Park. Redwood bark contains tannin which protects the tree from insects and tree rot.
PHOTO BY LARRY ULRICH

Right: The sun reflects the bluffs at Gold Bluffs State Park into the Pacific Ocean at sunset in Prairie Creek Redwoods State Park on the Northern California coast.
PHOTO BY JEFF GNASS

Above: Lupine on Counts Hill Prairie, Redwood National Park.
PHOTO BY CARR CLIFTON

In 1928, the California State Park System was formed and today there are over 30 redwood state parks to preserve and protect thousands of acres of old growth, second growth and cut- over forests in California.

Shortly after the discovery of the world's tallest tree in 1963, the federal government, after a long and difficult battle between conservationists and the logging industry, finally established the Redwood National Park, dedicated in 1968. The culmination of almost a century's effort brought together state, federal and privately held land to form one of the most beautiful and unique protected environments in the world, recognized by UNESCO, in 1982, as a World Heritage site, one of only nine in the United States and 113 worldwide.

Coast redwood forests contain more biomass, the total mass of living matter per unit area, than any other tropical forest, contibuting greatly to our atmosphere.

Trees growing in the shadows of the soaring redwoods include, Sitka spruce, Douglas-fir, broad-leaved tanoak, Western hemlock, Pacific madrone, Port Orford cedar, red alder, Pacific dogwood, and California laurel.

The cool, damp floor of the redwood forest is made up of layers of duff, decaying leaves and branches that protect the soil below from erosion. Duff also contributes to the livelihood of other plants by absorbing the water that keeps the forest floor moist and by adding essential nutrients to the soil.

The shaded floor of the redwood forest is filled with lush coastal wood fern, deer fern,

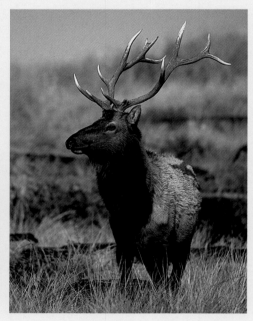

Above: Roosevelt Elk on grass-covered dunes at Gold Bluffs Beach. Prairie Creek Redwoods State Park, Northern California.
PHOTO BY GREG VAUGHN

goldenback fern, five-fingered fern, leather fern and the graceful sword fern.

Some of the shrubs that flourish in the cool damp forests are varieties of azaleas, Oregon grape, rhododendron, twinberry, salal, thimbleberry, California hazel, hairy honeysuckle, vine maple, and the always irritating poison oak.

A myriad of flowers adds an extra colorful dimension to the dense forest. Douglas iris, monkey flower, western buttercup and bleeding heart along with baby blue eyes, crimson columbine, red fireweed, pussy ears, giant trillium, wild cucumber, leopard lilies and several types of violets make up a small selection of

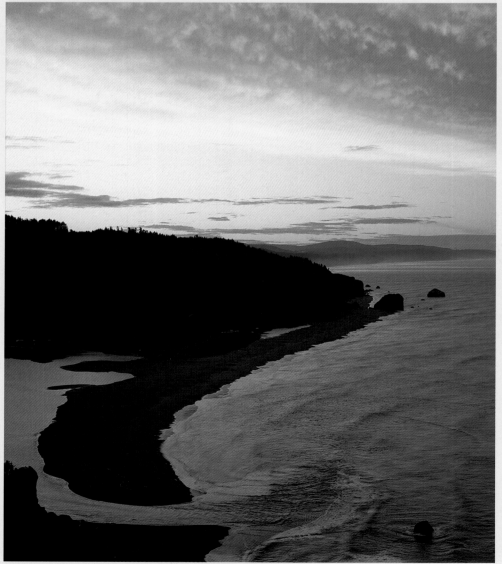

Left: The Klamath River flows into the Pacific Ocean at sunset. View from Klamath Overlook, Redwood National Park.
PHOTO BY LARRY ULRICH

Right: Smith River shoreline with California pink (Silene Californica), lupine (Lupinus sp.) and common yarrow (Archillea millefolium) in bloom in Jedediah Smith Redwoods State Park.
PHOTO BY JACK W. DYKINGA

the delicately beautiful flower specimens that grow alongside the towering redwoods.

Old growth forests are not the only types of parkland found within the redwood forests.

Above: Foxglove stalks in bloom, Redwood Creek Watershed, Redwood National Park.
PHOTO BY CARR CLIFTON

Lush rolling prairies are often surrounded by oak woodlands that attract deer and elk.

Streams and ponds that meander through the forest play host to the beaver, salamander, brush rabbit, bushy-tailed woodrat, lizards, several kinds of snakes, plus a bevy of birds including short and long-billed dowichers, Cassin's auklet, gulls, finch, and at least four kinds of hawks. Rivers offer cutthroat trout, steelhead and salmon.

The beaches also attract a wide variety of wildlife. Shorebirds share beaches with gulls and sanderlings. Many other animals such as the skunk and grey fox visit the beaches at night in their constant quest for food. Grey whales cruise the ocean near the shore and river otters play in marshes where the rivers meet the ocean.

Cousin to the coast redwood is the *Sequoiadendron giganteum*, or giant sequoia. While the coast redwood is the tallest living being, the giant sequoia is the *largest* living being and can grow to be well over 2,000 years old. Some have been known to live to 3,000 years old.

The largest tree in the world is the General Sherman Tree at 274.9 feet high with a circumference of 102.6 feet. The General Sherman Tree is located in the Sequoia National Forest.

Above: Giant redwoods (Sequoia sempervirens) and rhododendron (rhododendron macrophyllum) in fog at Prairie Creek Redwoods State Park.
PHOTO BY JACK W. DYKINGA

Following Pages: Battery Point Lighthouse at Crescent City was established in 1859.
PHOTO BY LARRY ULRICH

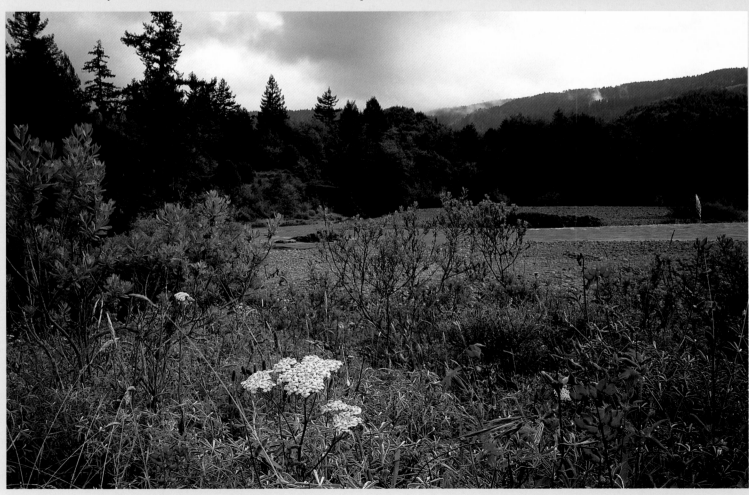

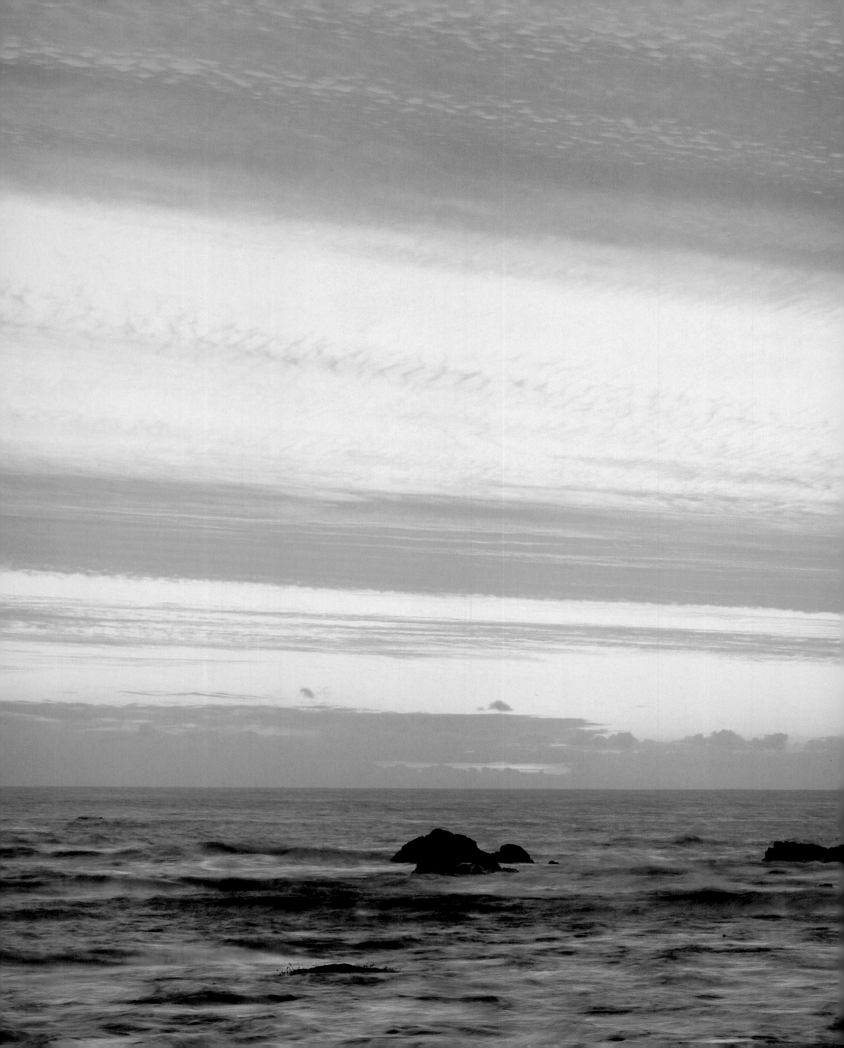

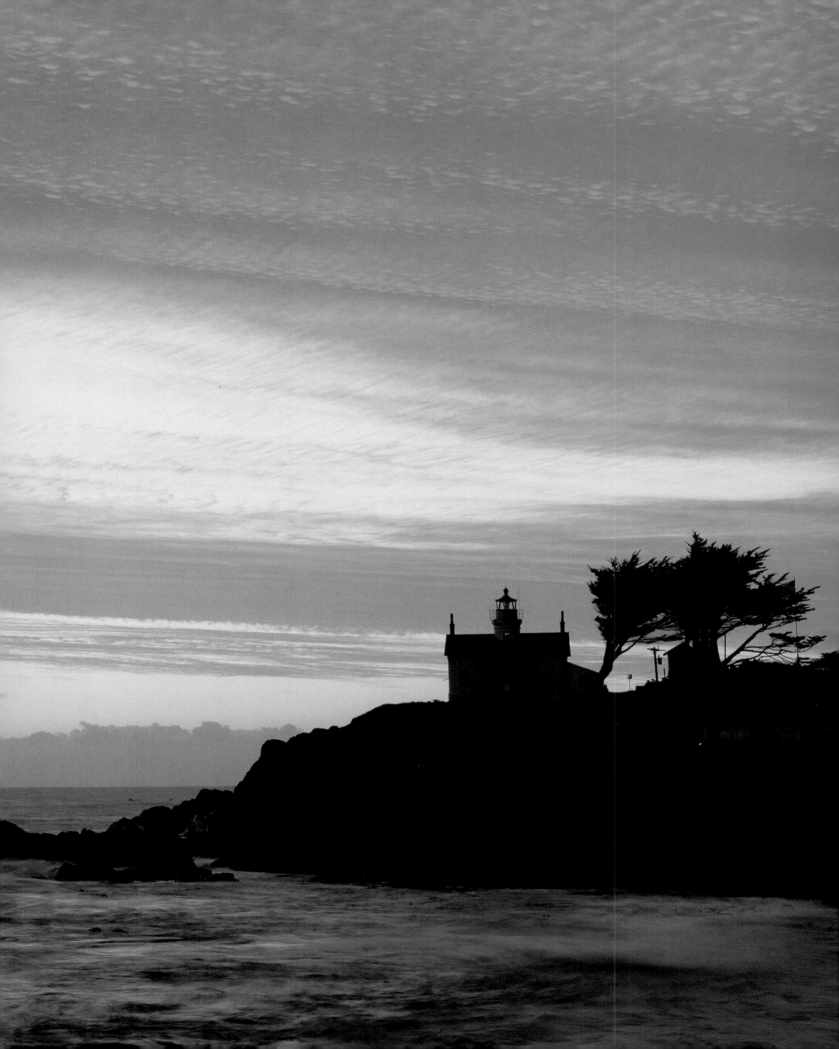

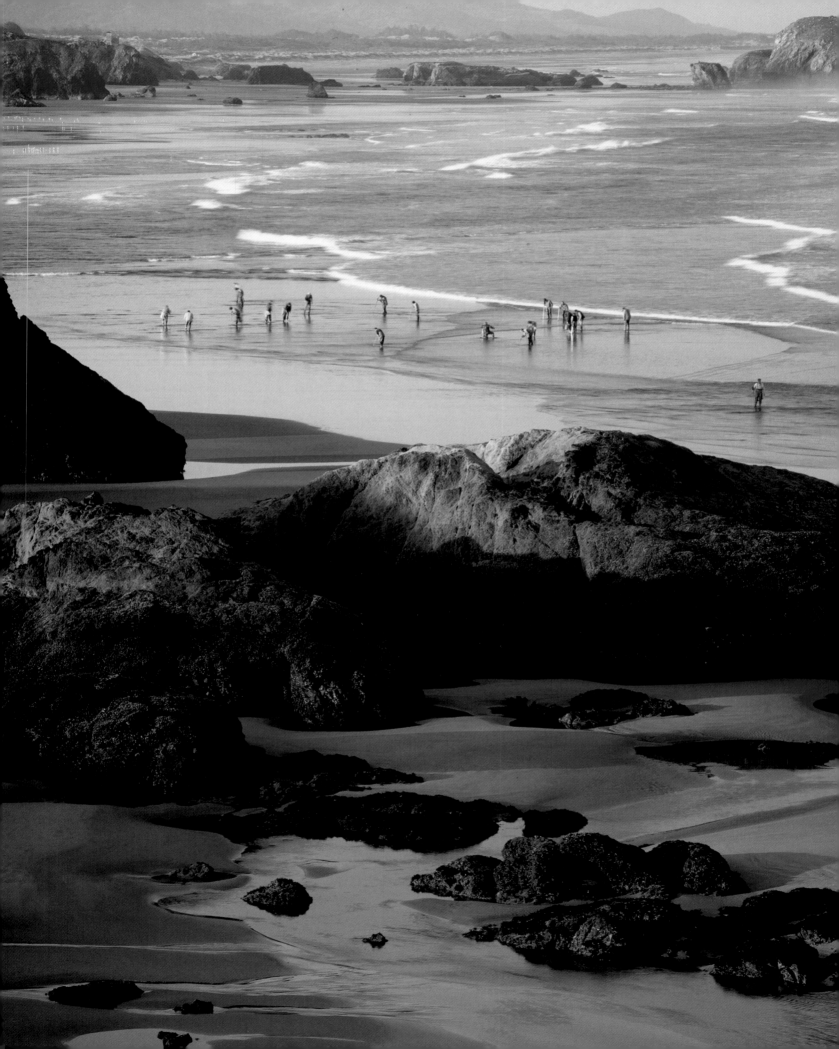

THE OREGON COAST

Although Oregon's coastline is considered heavenly today, older place names echo the sentiments of the region's early explorers who often experienced high winds and rough seas offshore. Coastal place names include Devil's Punchbowl, Devil's Elbow, Devil's Churn and Devil's Kitchen, which all attest to difficulties encountered by the early seafarers.

Breathtakingly beautiful is the phrase most often associated with the Oregon coastline. Still considered a remote paradise, the coast of Oregon is one of the Pacific's most pristine stretches of coastline. Years ago, the people of Oregon decided to maintain ownership of their natural areas, and today most of the coast is public land. They also believed that successfully inviting tourism meant upholding their half of the bargain: if you were to invite guests to stay, you had to have some place to put them. With this idea in mind, Oregonians started acquiring as much land as possible and ended up preserving and protecting the natural resources and scenic beauty of their state.

One of the many people responsible for such preservation efforts was Samuel H. Boardman, the State Parks Superintendent from 1929 until his retirement in 1950 at the age of 75. During his time in office, over 50,000 acres were set aside for the enjoyment of the people. Within those 50,000 acres are stands of old-growth forest that otherwise may not have survived the logging industry.

The dramatic beauty of the coast of Oregon is rivaled only by its colorful history. The earliest exploration of the Oregon coast by Europeans was by Juan Rodríguez Cabrillo, a Portuguese explorer sailing under the Spanish flag, and his navigator Bartolome Ferrelo in 1543. After the death of Cabrillo on San Miguel Island off the coast of Santa Barbara, Ferrelo assumed command and sailed as far north as the Rogue River in Southern Oregon. English explorer Sir Francis Drake sailed around Cape Horn in 1579 and reached the southern boundaries of Oregon. The rocky coastline, harsh weather and hostile inhabitants forced the Europeans to remain along the more tranquil southern coasts for the following two hundred years.

In 1775, exploration of the Oregon coastline was resumed by Russian fur traders from their bases in Alaska and by American, British and Spanish explorers in search of an inland waterway believed to connect the Pacific and Atlantic oceans. Bruno Heceta, sailing for Spain, had claimed to have seen a great river but had not been able to enter it. The English Crown sent Captain James Cook, who discovered the Hawaiian Islands en route to join the race to claim the Northwest Passage. Cook sailed as far north as Vancouver Island before abandoning this futile endeavor. In 1792, British Captain George Vancouver, who had sailed on Cook's final expedition, traveled the Pacific Coast from California to Alaska and the dream of an inland waterway was finally put to rest.

Although the native inhabitants along the Oregon coast were able to deter European invasions for the first two centuries of the area's exploration, it was only a matter of time before death and destruction befell the dozens of Indian tribes living along the coast, who were killed or driven off by the white man and his infectious diseases.

Meriwether Lewis and William Clark, at the behest of President Thomas Jefferson, were the first noted explorers of their time to cross the

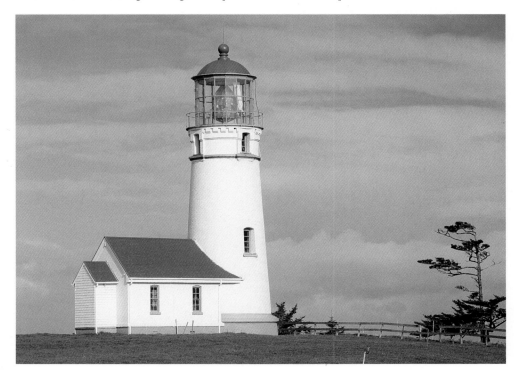

Left: Clam diggers on Bandon Beach at Coquille Point, Bandon Oregon.
PHOTO BY JEFF GNASS

Right: Built in 1870 on the westernmost point of land in Oregon, the Cape Blanco Lighthouse is Oregon's oldest active lighthouse. Its French Fresnel lens is original and has faithfully flashed every twenty seconds for 125 years.
PHOTO BY LARRY ULRICH

continent. They spent a cold, wet winter a few miles from the Pacific coast, near the mouth of the Columbia River, where they constructed

Above: A container ship plows the waters off the Pacific Coast working trade routes between the West Coast and the Orient. Shore Acres State Park, Charleston, Oregon.
PHOTO BY DICK DIETRICH

Fort Clatsop to survive the winter of 1805 and 1806. Fort Clatsop was the first United States military settlement on the West Coast. Today Fort Clatsop National Memorial showcases a detailed reconstruction of the original fort, built from sketches and descriptions found in the expedition's journal. Lewis and Clark returned east in 1806, having been long overdue and presumed dead. Their adventures were widely

published and the race to settle the Oregon Territory was on. Wagon trains headed west along the Oregon Trail, bringing thousands of hopeful immigrants to the fertile valleys of the Pacific Northwest.

Oregon also has the distinction of being the only place in the continental United States to be attacked by the Japanese during War War II. One of the attacks occurred in 1942 when a Japanese submarine surfaced off the southern coast, near Brookings, and a small seaplane was dispatched on a bombing raid. A myrtle tree was the only casualty.

Fort Stevens, near Astoria, also experienced a bombing raid in June of 1942. Luckily no one was hurt and the fort did not find it necessary to return fire.

The most tragic episode occurred in May of 1945, when a balloon bomb was discovered by a minister and his family on a picnic. The bomb exploded as they attempted to remove the balloon from a tree and the minister's wife and five children were killed.

The flora species of Oregon are spectacularly beautiful and can be easily enjoyed by all who visit the area. With the vast amount of rain received by the Coast Range, tree and plant species are widely varied and specimens are abundant. One tree, the Port Orford cedar,

grows nowhere else but on a small stretch of the Northern California and Southern Oregon coast. Sitka spruce, Douglas fir (the state tree), and myrtlewood can be found, as well as many species of flowering trees, shrubs, vines and plants. On the southern coast, where weather is usually warmer, Azalea State Park features five different kinds of azaleas along with lilies and tulips. Everywhere along Oregon's coast, rhododendron blaze with spectacular displays of showy flowers in the spring and summer,

Above: The botanical gardens at Shore Acres State Park were built by Louis J. Simpson for his wife Cassie Henricks in the early 1900s.
PHOTO BY DICK DIETRICH

with clusters of flowers in an incredible array of colors.

Wildlife of the region includes game animals such as deer and elk as well as marmot, black bear, red fox, coyote, bobcat, skunk, porcupine and other land animals. Sea mammals include gray whale, killer whale (Orca), dolphin, sea otter and several species of sea lions and seals. Whale watching along the coast is a favorite pastime for visitors and locals alike. Boat tours are available at harbors up and down the coast, or visitors can view the fascinating mammals by stopping along the ocean and looking for telltale water spouts, some up to fifteen feet high, an indication that whales are present.

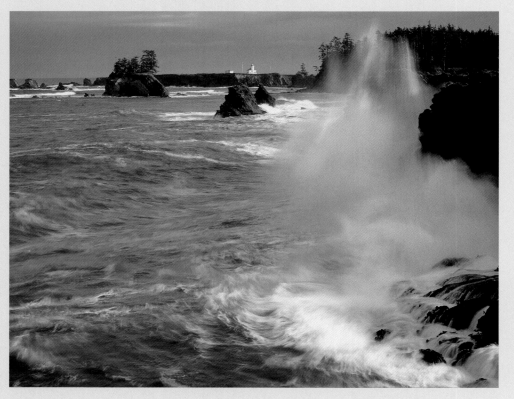

Left: Storm surf crashes upon the rocky shoreline at Sunset Bay. In the distance, Cape Arago Lighthouse stands as a silent sentinel.
PHOTO BY LARRY ULRICH

Right: Windsurfers off the coast of Pistol River State Park. In 1856, the battle of Pistol River, named for James Mace who lost his pistol in the river in 1853, was fought near here in the Rogue River Indian War.
PHOTO BY GREG VAUGHN

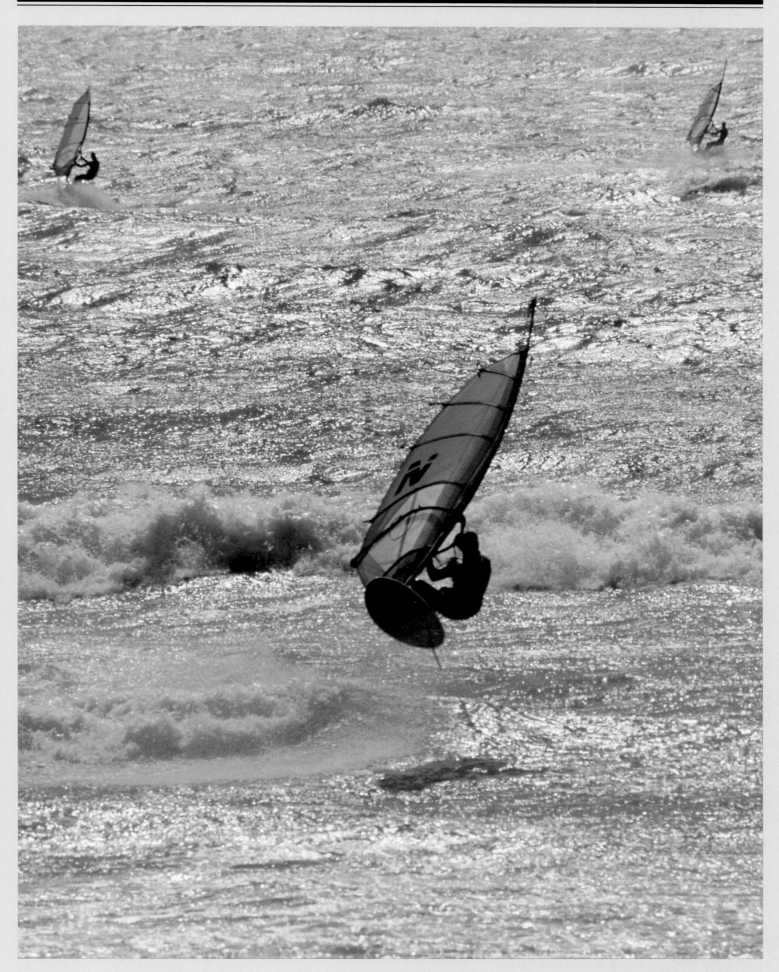

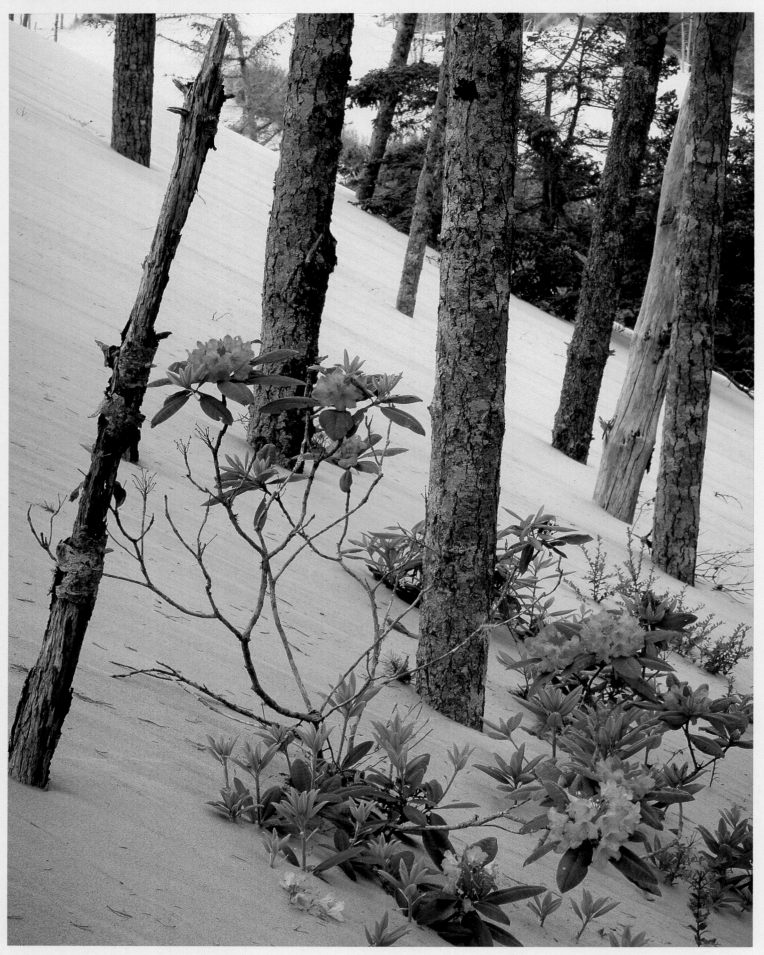

OREGON COAST CONTINUED...

Bird watchers can find tufted cormorants, puffins, terns, great-horned owls, ravens, bald eagles, red-tailed hawks, goshawks, golden eagles, dippers, gulls, woodpeckers, thrushes, plovers, finches, juncos, pelicans, nuthatches, sanderlings oystercatchers, and sparrows, which are only a few of the many species found along the coastal regions of Oregon.

Salmon fishing is one of the biggest attractions to the coast and to the rivers and streams that empty into the Pacific. Born in fresh water, Salmon migrate to the ocean to live before returning to the place of their birth to spawn and die. There are several types of salmon; coho and sockeye (or red salmon) are two.

The small town of Brookings in southern Oregon claims to have the nicest winter weather along the coast. Because the harbor faces south, away from gusting winds, it also boasts the safest harbor on the coast,

Left: Western rhododendron and beach pine in Oregon Dunes National Recreation Area.
PHOTO BY LARRY ULRICH

making it popular with people who live to fish.

With over 360 miles of coastline, Oregon has only 11 harbors, of which only one is natural, Port Orford, about 60 miles north of the Oregon

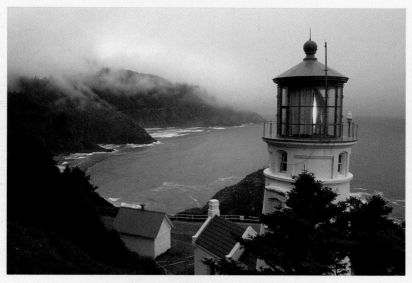

Above: The Heceta Head Lighthouse was named for Bruno Heceta, a Spanish explorer along the Oregon Coast in 1775. The lighthouse was placed into service in the 1890s. Its residence building has been rumored to be haunted.
PHOTO BY GREG VAUGHN

border. All of the other harbors have bars that must be crossed which sometimes makes passage into the harbors difficult.

The Rogue River was named by French fur traders who believed the local Indians to be as dastardly as the name implies. Of course, history has shown that it was the fur traders whose behavior was roguish.

Popularized by the writings of author Zane Grey, who fished for steelhead, the Rogue has become a mecca for not only fishermen but for whitewater rafters and kayakers as well.

Near the mouth of the Rogue River is Gold Beach. Named by optimistic miners who arrived in 1852 hoping to strike gold, Gold Beach did not pan out. It has become the desired destination for those who enjoy the pleasures the river, forest and the ocean have to offer.

Jutting into the ocean sits a grassy bluff called Cape Blanco. Named by Spanish sea captain Martin de Aguilar, Cape Blanco is the home of a picturesque lighthouse operated by the U.S. Coast Guard.

Below: Heceta Head near Florence, Oregon. The 640 glass prism Fresnell lens of the lighthouse can be seen from twenty miles offshore.
PHOTO BY DICK DIETRICH

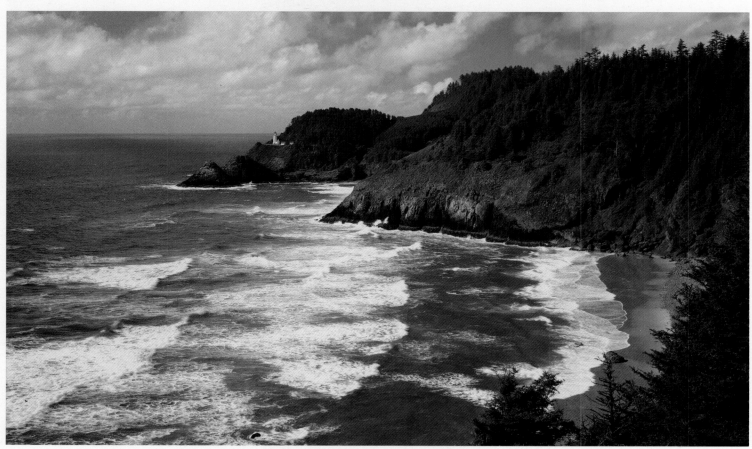

OREGON COAST CONTINUED...

Once the Klamath Mountains, which parallel and isolate this section of the southern coast, relax into milder plains one encounters calmer rivers, majestic dunes and serene estuaries.

Above: South along the coast from the Cascade Head Natural Area. Today, the management of the land at the end of Cascade Head is under the auspices of The Nature Conservancy.
PHOTO BY GREG VAUGHN

The small town of Bandon sits at the mouth of the Coquille river, the location of the South Slough Interpretive Center and its 4,000 acres of reserve on the southern coast of Oregon.

When a river and tidewater come together they create an estuary. Fresh and salt water mix together to create a unique natural environment complete mud flats, bogs and swamps–with marshes that clean the water. Estuaries attract many kinds of fish and shellfish and act as havens for the many bird species that migrate up and down the Pacific Coast.

The South Slough reaches up to Charleston, North Bend and Coos Bay, or, as the locals say, the Bay Area. Near Charleston there are three state parks that are considered to be among the most beautiful parks on the Oregon Coast: Sunset Bay, Shore Acres and Cape Arago State Parks. They should not be missed in your travels.

The Oregon Dunes National Recreation Area features a stretch of sand dunes unlike anything else on the Pacific Coast. Located just north of the Bay Area and extending about 50 miles north to the charming town of Florence, the Oregon Dunes National Recreation Area lies within the southwest boundary of the Siuslaw National Forest.

Sand created by the continual pounding of the Pacific Ocean on the sandstone cliffs along the shoreline, combined with the sand deposited by rivers and streams, is washed

Above: The town of Yachats, just north of Cape Perpetua and Devil's Churn. Cape Perpetua is one of the largest headlands along the Oregon Coast.
PHOTO BY GREG VAUGHN

Below: Kayakers in Sunset Bay State Park.
PHOTO BY GREG VAUGHN

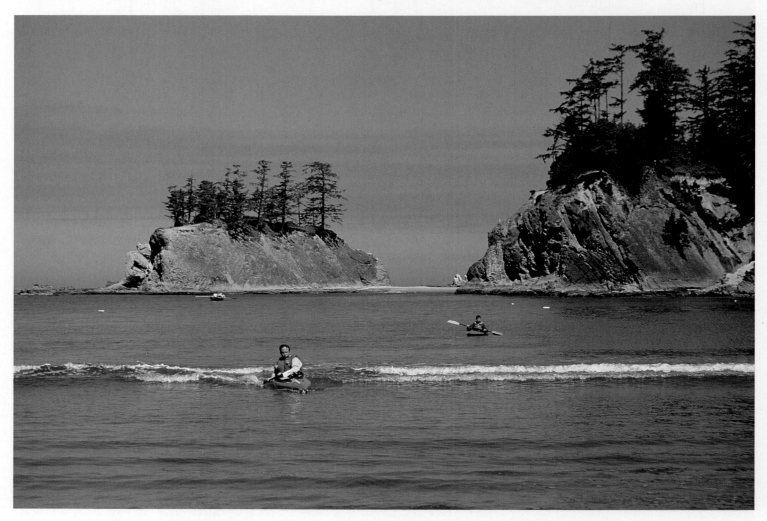

ashore. The sand dries during low tide and is blown inland to the dunes.

Constantly shifting from seasonal prevailing winds, the dunes can reach heights of several hundred feet. Siltcoos, Tahkenitch, Woahink and Munsel Lakes are fresh water lakes along a 21-mile stretch of the coastline dunes. These lakes were originally streams that were cut off from the ocean by the shifting dunes.

Today, Oregon Dunes National Recreation Area is a mecca for sand buggies and other off road vehicles. Not all of the area is open to off-roading, a good portion is still available to hikers and others wanting to enjoy the beauty of the dunes without the bothersome noise of off road vehicles.

The Siuslaw National Forest is broken into two sections. The southern section includes forests, dunes, creeks and streams and the highest peak in the coast range, Mary's Peak, elevation 4,097 feet. The boundaries stretch

Below: The Yaquina Bay Bridge and South Beach Marina in Newport, Oregon.
PHOTO BY GREG VAUGHN

from Coos Bay north to Newport.

The northern section reaches as far north as

Above: Fishing boats at Garibaldi Harbor. Salmon fishing in the Pacific Northwest's rivers, streams and coastal waters is one of the regions most popular pastimes.
PHOTO BY GREG VAUGHN

Cape Look Out and almost to Depoe Bay in the south. Smaller in size than the southern part,

the north section of the Siuslaw National Park has Mt. Hero, elevation 3,154 feet, another notable peak in the Coastal Range.

Although the Coastal Range has been affected by the timber industry, there are still some stands of old growth forest. Forests on the Coastal Range experience about 90 inches of rain a year. The vast amount of rainfall produces a lush undergrowth abundant in blackberry, Oregon grape (state flower), and colorful wildflowers.

Wildlife in the forest is plentiful. Over 100 species of birds inhabit forests as well as beavers, bats, bobcats and black bears, not to mention deer, elk, squirrel, rabbit and other mammals.

The Three Capes Scenic Drive, a two-hour detour away from Highway 101, north of Neskowin, is worth the extra travel time to get there. Winding past the Pacific Dory Fleet in Pacific

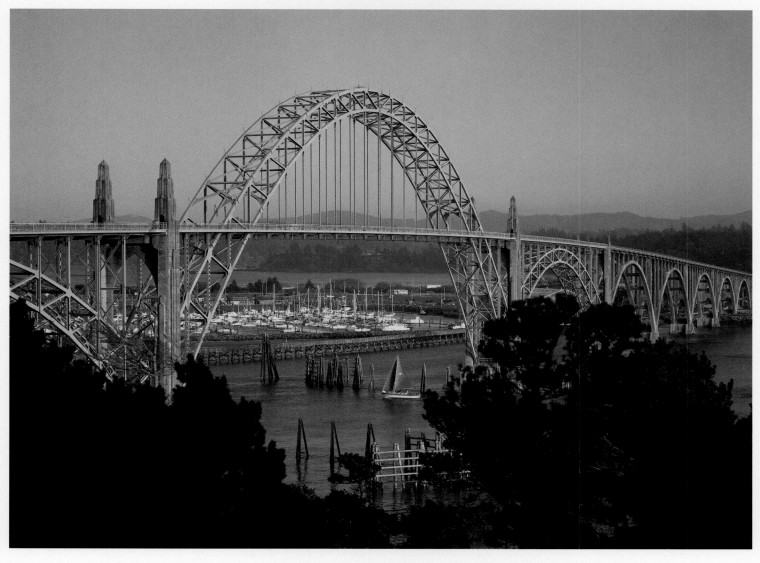

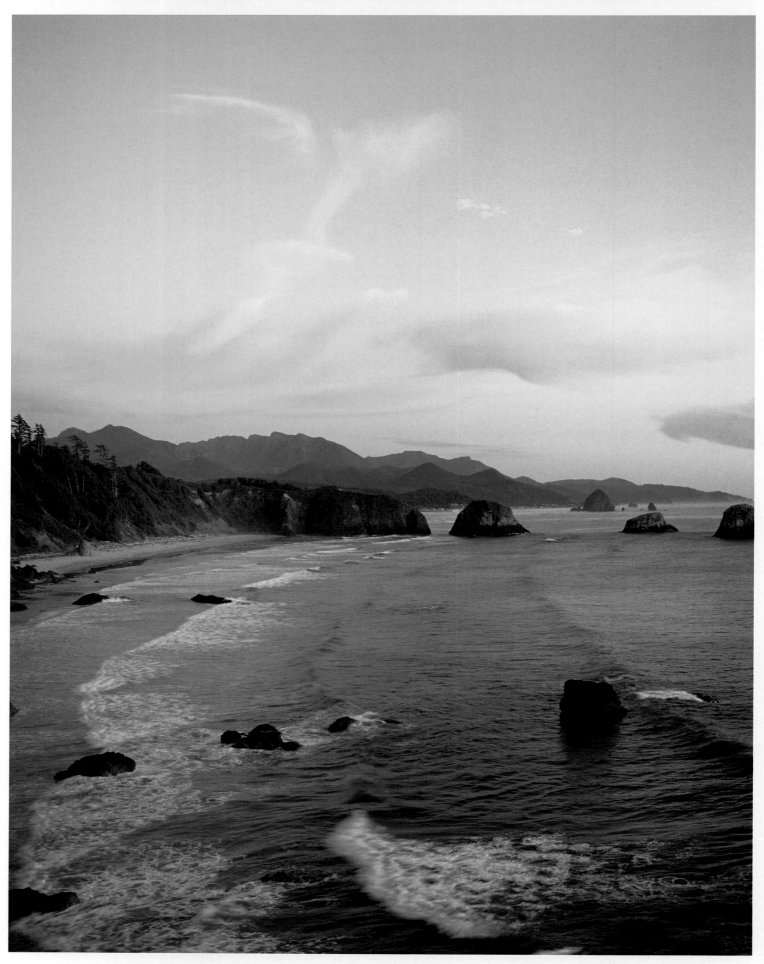

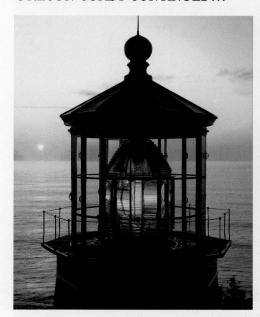

Above: Cape Meares Lighthouse, named for John Meares who explored the Oregon Coast in 1788.
PHOTO BY JEFF GNASS

Left: Crescent Beach and Chapman Point.
PHOTO BY JON GNASS

Below: Sand dunes at Cape Kiwanda at dusk.
PHOTO BY JEFF GNASS

City, the road continues by Cape Kiwanda, with its pristine sand dunes and weathered rock formations, past Cape Lookout and on to Cape Meares, where an enormous, albeit malformed, Sitka spruce known as "The Octopus Tree," is a popular attraction.

The scenic drive curves around the bottom of Tillamook Bay and ends at Highway 101 and the city known for its cheeses, Tillamook.

From 1804-1806, Lewis and Clark and the Corps of Discovery journeyed from St. Louis, Missouri across the continent under orders by President Thomas Jefferson to record the flora, fauna and all Native American tribes they encountered along the way. Their westward trek ended near the mouth of the Columbia River in the late fall of 1805.

Once settled, they named their new base Fort Clatsop, after a local Indian tribe. A small party of soldiers was sent to set up a salt-making camp in what is today the town of Seaside. The camp was close to the ocean with access to fresh water. The soldiers boiled the sea water and labored almost seven weeks to produce the 20 gallons of salt necessary for their return journey.

When it came time for the Lewis and Clark expedition to begin their return journey in the spring, they gladly left the wet and soggy fort. In the four months of their stay they had been

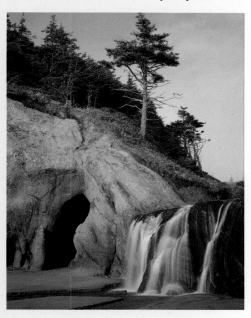

Above: Cave, cliff and waterfall on the creek at Hug Point, Hug Point State Park, Oregon.
PHOTO BY JEFF GNASS

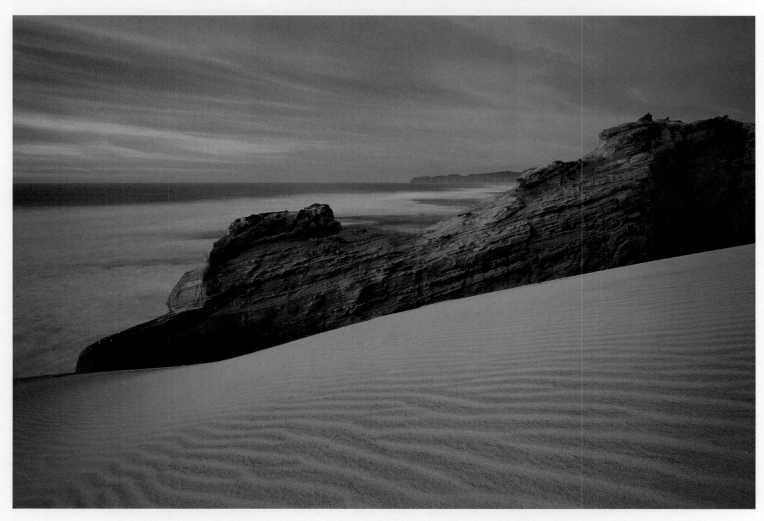

able to enjoy only 12 days without rain.

In 1810, one of the richest men in America, John Jacob Astor, decided to compete with the Canadian fur traders, Hudson's Bay Company and the North West Fur Company, which were a large part of the overall effort that shipped nearly 50,000 sea otter furs to China between 1798 and 1802. Astor sent one expedition to the mouth of the Columbia River by land and a second, under command of Captain Jonathon Thorne, went by sea.

Unfortunately, Captain Thorne's maniacal treatment of the Nootka Indians provoked an incident in which most of the crew of Astor's ship, the *Tonquin*, and a number of Nootka, along with the ship itself, were blown up in an act of revenge by a desperate crew member who lured the indians aboard and set fire to the ship's powder magazine.

The land party also experienced problems. Beating the British by only a few months to establish Fort Astoria, which they built at the mouth of the Columbia River, Astor's triumph was short-lived. The War of 1812, between the U.S. and England, broke out and as British warships made threats on Fort Astoria, Astor sold the fort to the North West Fur Company, later merged with the Hudson's Bay Company, which still exists. Astoria's name was changed to Fort George for a time, but was returned to the Americans at the war's end. Astor never regained ownership of the fort.

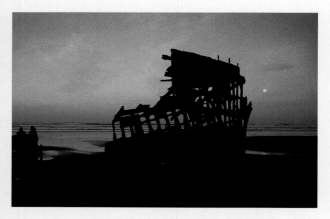

Above: Wreck of the 278 foot British bark *Peter Iredale* blown ashore in 1906. Fort Stevens State Park, Oregon.
PHOTO BY CHUCK PLACE

Right: Astoria Bridge and Columbia River at dusk. The Astoria Bridge links Washington and Oregon.
PHOTO BY JEFF GNASS

THE LEWIS AND CLARK EXPEDITION...

On May 14, 1804, Meriwether Lewis, the private secretary to President Thomas Jefferson, and William Clark, who had served in the army with Lewis in the Indian Wars, set forth on an expedition to cross the continent to the Pacific Ocean. It was to be an expedition that captured the imaginations of Americans of their day and the students of American history for generations since.

President Jefferson gave specific instructions for Lewis and Clark to scientifically collect as much information as possible on the Indian tribes they met along their journey as well as to gather detailed information on the flora and fauna, weather and geography of the uncharted territory. Jefferson also instructed them to treat all Indian tribes with respect.

The Lewis and Clark expedition began near St. Louis, Missouri, where Lewis and Clark had spent the winter of 1803-1804 interviewing the potential members of the expedition, assigning work details, assembling supplies and gathering information on the territory they were about to traverse from Indians and traders passing through St. Louis.

In the spring of 1804, Napoleon sold the United States all lands held by France from the Mississippi River to the Rocky Mountains and from the Gulf of Mexico to the Canadian border. This fabulous real estate deal, called the Louisiana Purchase, cost the United States a mere 15 million dollars and added a new legality to the expedition.

Lewis, Clark and their newly formed Corps of Discovery, consisting of 42 soldiers and Clark's slave, York, traveled more than sixteen hundred miles up the Missouri River by the winter of 1804-1805. They passed a tolerable winter thanks to hospitality they received from friendly Mandan Indian villagers. It was while wintering with the Mandans that they hired an interpreter named Toussaint Charbonneau who was accompanied by his young Shoshone wife, Sacagawea, who was pregnant. During the winter, Sacagawea gave birth to a son, Jean Baptiste, who she carried in

Above: Fort Clatsop, named for a local Indian tribe, was built by members of the Corps of Discovery to weather the winter of 1805 and 1806.
PHOTO BY CHUCK PLACE

a cradle board across countless miles while acting as a guide, interpreter and source of inspiration to the men of the expedition. Sacagawea was an integral ingredient to the success of their journey. Presence of a woman and child on the expedition helped to prove that they were a peaceful group, not a war party.

Both Lewis and Clark kept meticulously detailed journals filled with the detailed information and drawings President Jefferson's orders had required. Although they were trained as soldiers and not as scientists, they were extremely careful in the documentation of their discoveries and kept identical journals, each copying the other's entries. This ensured that in the event of a lost or damaged journal there would be a copy.

The expedition continued in the spring of 1805 on to the headwaters of the Missouri River and crossed the Continental Divide in early August. They were aided by the Shoshone to the land of the Flathead Indians in Montana, who proved also to be peaceful. By September's end, they were in

the land of the Nez Perce (French for pierced nose) Indians who were also receptive to the party.

In November of 1805 the explorers had their first glimpse of the Pacific Ocean as they traveled down the Columbia River. They made camp near what is today McGowan, Washington, but decided, on the advise of local Indians, to move to the southern side of the river. In late December of 1805, Fort Clatsop, named for a friendly Indian tribe in the area, was completed.

During the fort's construction, Clark sent a small party of soldiers to the ocean to make salt. The salt making camp was about 15 miles southwest of the fort at what today is Seaside. The camp had to be close to the ocean with easy access to fresh water. The soldiers began boiling sea water as soon as their camp was completed and almost seven weeks later they had 20 gallons of salt for their return journey.

The explorers spent a grueling winter suffering constant rain and food shortages. Their diet was primarily of elk and whatever roots they could dig up. They often traded with the local Indians but the Indians wanted more than they felt was reasonable or affordable. Lewis and Clark made several references in their journals about the miserable weather and the ceaseless rainfall. Of the four months spent at Fort Clatsop the expedition endured rain for all but 12 days, and only saw the sun on six of those days.

March 23, 1806, the Corps of Discovery began their return journey, which took only six months to reach St. Louis on September 23. Their return surprised many who had long feared they were dead after a two year, four month and ten day absence. In all, their journey had covered 8,000 miles through the wilderness.

Meriwether Lewis was appointed Governor of the Louisiana Territory upon his return. He died a few years later under mysterious circumstances while traveling to the East Coast. William Clark was appointed Indian Agent upon his return and later became Governor of Missouri.

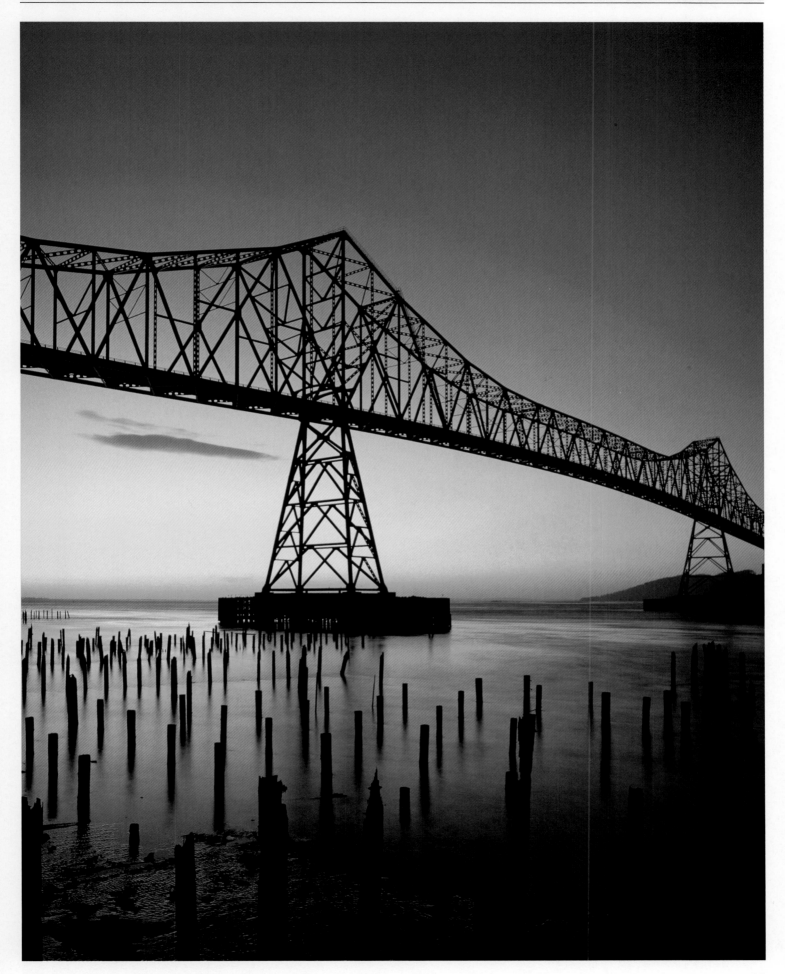

LIFE BELOW THE SURFACE...

The Pacific Ocean waters are literally home to life on many levels. Marine biologist, Ed Rickets, in his noted work *Between Pacific Tides* (1939), proposed a simplification of the identification of various vertical habitat zones along the Pacific Coast. Rickets also worked to make realistic associations of the plants and animals found in each vertical zone. These zones are not exclusively populated by certain species of flora and fauna, but are generally found to have distinctly similar occupants in most instances.

The surface waters of the Pacific Ocean are home to whales, dolphins and six species of pinnipeds; Stellar sea lion, northern elephant seal, northern fur seal, California sea lion, harbor seal and Guadalupe fur seal. These mammals are air-breathing and are normally found near the surface, although some whale species are capable of diving great depths to feed.

The surface waters

Above: Purple and orange Spanish shawl Nudibranch, a sea slugs that is primarily a carnivore.
PHOTO BY JEFF FOOTT

also include a wide variety of sharks–including great white, nurse, lemon, hammerhead, tiger and more–in addition to, marlin, tuna, barracuda, bat rays, kelp bass, sea bass, albacore, opaleye, garibaldi and numerous other species of fish. In the craggy recesses of rocks moray eels may be found, predators with an impressive arrays of teeth well worth leaving alone if encountered.

Along the Pacific Ocean's bottom lie stingray, which can be found in waters of varying depth including shallow areas right offshore. The stingray's barbed tail can inflict razor-like wounds to the unwary wader who happens to enter a stingray's territory.

In tidepools and shallow waters an impressive array of marine invertebrates (those creatures that lack a backbone and an internal skeleton) can be found. This catch-all category includes lobsters and crabs, with their spiny external skeletons, and creatures as far-ranging as squid, octopus and jellyfish which do not

Above: Hermit crabs (Pagurus granosiuanus) live in empty mollusk shells, protecting their soft underside from attack.
PHOTO BY JEFF FOOTT

have internal or external skeletons.

Among marine invertebrates are also many creatures that at first glance resemble plants more than animals. Primitive sponges attach themselves to rocks, pilings shells, boats or any other surface they can find. A sponge reproduces by releasing eggs and sperm. It is thought sponge species may be between 5,000 and 10,000 in total number.

Sea anemone also appear to be plant-like at first glance and are often seen with clownfish

THE SALMON'S SAGA...

The salmon certainly personify the cyclic patterns of nature. They are born in the headwaters of rivers, and it is at the exact spot that the salmon come into being that they die, completing the circle of life. The headwaters are not the only places to observe the phenomenon of the carefully planned paths of the salmon, for they also follow the swimming patterns of their biological parents.

Mating habits among the Pacific salmon species are similar. The female finds an area in a basin whose floor is sandy, or gravelly, and builds her nest, called a redd. While the female prepares the redd, the male works to keep possible intruders at bay. Once the female centers herself in the redd, the dominant male approaches her. Together, they lay gametes by vibrating violently. The female covers the fertilized eggs–which are up to 7 mm–with sand and gravel.

In the Pacific, the spectrum of salmon can be divided into six different species, their genera

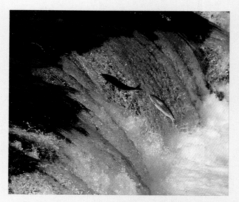

Sockeye salmon (Oncorhynchus nerka) jumping a waterfall to reach spawning grounds.
PHOTO BY JEFF FOOTT

instincts. After four years, it heads upstream while its jaws curve to the point it can no longer close its mouth–causing an impasse for feeding–its remaining instinct is only to spawn.

Coho, or silver salmon, *Oncorhynchus kisutch,* and sockeye, or red salmon, *Oncorhynchus nerka,* each weigh about 4.5 to 6.5 pounds at maturity. The red salmon exists in two ecotypes: the anadromous migratory form–migrating up rivers from the sea to breed in fresh water– and the form which lives out its life in predominately fresh water pools. The masu salmon, *Oncorhynchus masou,* rounds out the spectrum. It is generally anadromous and rarely grows longer than 28 inches nor heavier than 17.5 pounds.

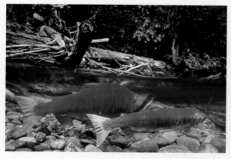

Above: Male and female sockeye salmon, jaws curved and no longer capable of eating, swim upstream to the place of their birth to spawn.
PHOTO BY JEFF FOOTT

being *Oncorhynchus.* The largest of the Pacific salmon is the Chinook salmon, *Oncorhynchus tshawytscha,* which can reach as long as five feet at maturity and 100 pounds in weight. The pink salmon, *Oncorhynchus gorbusha,* travels about the Arctic waters and Sea of Japan on its predestined migration, growing to as long as 28 inches and as reaching weights of as much as 15 pounds. The chum, or dog salmon, *Oncorhynchus keta,* is comparable in size and weight, but it is known for its great homing

Below: Recently hatched sockeye salmon in the Alevin stage, as fry developing from the egg.
PHOTO BY JEFF FOOTT

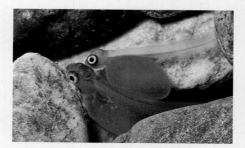

Above: Giant green sea anemone (Anthopleura xathogrammica). Although appearing plant-like and to be rooted in one location, Sea anemone are actually animals and will move slowly from place to place as they feed.
PHOTO BY JEFF FOOTT

swimming through their leaf-like tentacles. Although the clownfish are welcome in the sea anemone's tentacles, other small species of fish and small shrimp are quickly grasped and devoured if they venture too close.

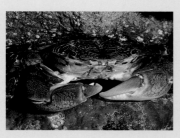

Above: A lined shore crab (Pachygrapsus crassipes). Crabs use their large front claws for grasping and shredding prey and to protect themselves and their territory.
PHOTO BY JEFF FOOTT

Barnacles are also sea animals, a crustacean that attach themselves to rock and underwater marine surfaces by secretions from their antennae.

They feed by filtering water through their finely branched feet and into their limestone shells. It may be hard to imagine, but they are closely related to crabs, shrimps and lobsters.

Crabs and lobsters are often called "the insects of the sea" for good reason, they look like insects with antennae, a distinct head, a thorax and an abdomen. These crustaceans are armored by a cuticle of chitin that they must shed as they grow, a process they accomplish by backing out of their shells after they split open from the growth of their body parts. Any legs or claws the animal lost before the moulting process will be regenerated after the shell is lost and before the new shell is produced.

Above: Leaf barnacles (Pollicipes polymerus) and a sea star.
PHOTO BY JEFF FOOTT

Marine mollusks have been important to man for several thousand years as a food source, a decoration for jewelry, cutting tools and as a major trade item. It is from the mollusk species, of which there are more than 100,000 species, that sea shells originate.

Mollusks have heads, although they have been almost completely erased by evolution in some species but are still present, a single muscular foot with which they propel themselves and a "visceral mass," which houses their digestive and other organs.

Shells are grown to protect the mollusk's soft body and are as varied as the colors of the rainbow. They are composed of conchiolin and calcium carbonate. The inside of the shell is often covered with crystalline calcium carbonate, which is called nacre, or, when found in thick layers, mother-of-pearl.

Some species of mollusks are almost completely made of nacre, including the pearl oyster and the chambered nautilus. The abalone and limpit use their shells for protection and are able to clamp rocks tightly to be kept from being swept out to sea or being removed by predators.

Squid, cuttlefish and octopi are Cephalopods, the most highly evolved form of mollusks in

Above: Sculpine in a Monterey Bay tidepool. The camouflage coloring of this shallow water species makes it difficult for predators to detect.
PHOTO BY JEFF FOOTT

terms of size, locomotion, and intelligence. Some of the squid species are so large that they have long inspired tales of horror among sailors. The giant squid has been known to reach lengths of 66 feet, and more, and rumored to have been found as large as 100 feet long.

Mouths of cephalopods are surrounded by their tentacles, used to capture their prey, which is then shredded by a strong beak. All species are predators and will catch and kill any animals they can.

THE WHALE'S TALE...

Each fall the gray whale, *Eschrichtius robustus,* begins its migration down the Pacific Coast, from Alaska or Siberia, to the calving grounds off the coast of Baja, Mexico.

These whales, named for their color, can reach lengths of over 40 feet long and are often plagued by barnacles and whale lice growing on their skin, which give the mammoth mammals a somewhat spotted look.

Usually traveling in groups of two or three, gray whales stay close to the shore and feed by filtering mouthfuls of mud and sand through baleen plates which leave behind the minute planktonic crustaceans and fish that make up their diet.

Another fascinating mammal living in the Pacific Ocean is the dramatic black and white orca, *Orcinus orca,* also known as killer whales for their feeding habits. Orcas reach lengths of over 22 feet and prey on an impressive variety of sea life including; seals, penguins, turtles, sea lions, most cetaceans, sharks, octopus and several types of fish. They have been known to take seals right off the beach, temporarily beaching themselves until the next wave comes in to wash them back into the sea with their bounty.

Also sharing the waters with the orcas and gray whales is the short-finned pilot whale, *Globicephala macrorhynchus,* difficult to spot from above water because of its almost invisible blow. Short-finned pilot whales travel in pods of up to 45 and are usually dark gray or black in color with a short dorsal fin that slants towards

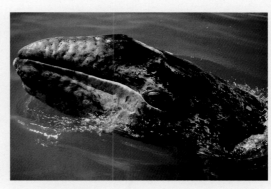

Above: Gray whales can reach lengths of 40 feet.
PHOTO BY JEFF FOOTT

Above: Gray whale tail.
PHOTO BY JEFF FOOTT

the back of the animal. Often captured for public display in mainland marine exhibits, their survival rate in captivity is only 50 percent.

While gray whales have one of the longest migrations of any whale, approximately 6000 miles, the orcas and short-finned pilot whales have no noticeable migration patterns. Both orcas and pilot whales live in oceans all over the world, with orcas found in both cold and warm waters and short-finned pilot whales found in more temperate waters.

All three species of whales can be found all along the Pacific Coast, from Canada to Baja, Mexico, with the short-finned pilot whale's territory extending to South America.

Below: Two mature orcas with young.
PHOTO BY JEFF FOOTT

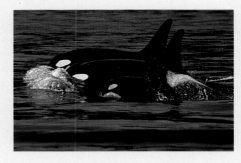

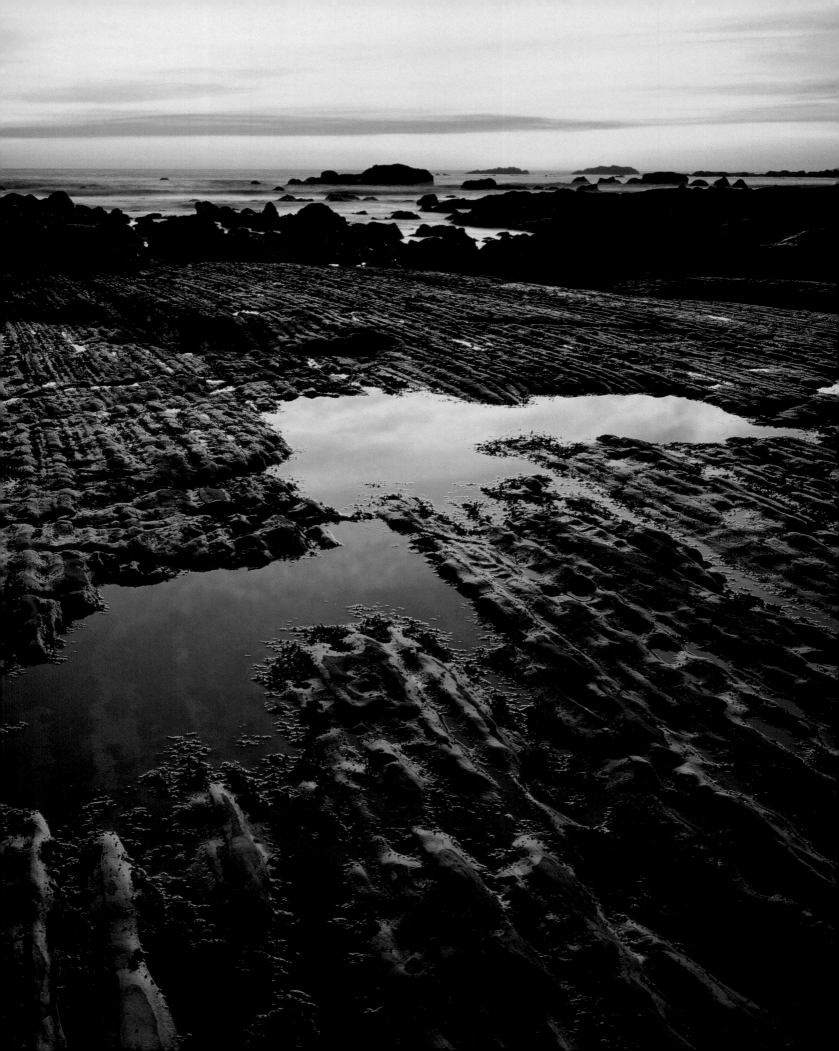

THE WASHINGTON COAST

Washington's coastline, from the north banks of the Columbia River to the south shores of the Strait of Juan de Fuca, was a formidable obstacle for early explorers. Those who thought themselves lucky to reach the shore, in spite of severe weather and ocean conditions, often were attacked and killed by local Indian tribes. Today, the conditions for travel are markedly improved although the ocean can still be quite rough.

Many early explorers searched the Pacific coastline for a great river they believed would connect them to the Atlantic Ocean. James Cook, John Meares and George Vancouver, all British sea captains, searched for the fabled river supposedly glimpsed by the Spanish explorer Bruno Haceta in 1775. They repeatedly passed a river with a seemingly uncrossable bar, not realizing that they were missing the largest river on the Pacific Coast. It took a clear day and an American fur trader to finally make the discovery.

On May 11, 1792, Boston sea captain Robert Gray braved the hazardous bar and passed into the mouth of a great river. Gray sailed a small distance up river before returning to the coast to resume his business of trading. The discovery of the river, named after his ship, the *Columbia*, was a very important find for America, although the river was sizeable it certainly was not a passage to the Atlantic. It would, however, later become the boundary dividing the states of Washington and Oregon.

The naming of Cape Disappointment, located on Washington's southern coast, by Captain John Meares who attempted but failed to cross the bar is an indication of the frustration felt by the many early explorers–English, Spanish, American and Russian–who attempted to lay claim to the Columbia River.

One of the first lighthouses ever built on the Northwest coastline lies at the tip of Cape Disappointment. The lush beauty of the cape is never a disappointment to those stopping to picnic or enjoy the panoramic ocean views.

Although the most popular attraction on the coast of Washington is the Olympic National Park on the northern end of the peninsula, there are several noteworthy places to stop and visit along the southern coast.

One of the largest harbors along the Pacific coast is located in Washington. Grays Harbor is also the northern most harbor on the Pacific Coast and was another discovery of Captain John Gray. Leadbetter Point and the Willapa National Wildlife Refuge are also of interest.

Washington's rich history is filled with stories of the indigenous people who lived there long ago, and is still home to the ancestors of those ancient peoples. The earliest inhabitation by man on the Washington Coast is currently thought to have been more than twelve thousand years ago. Indian groups in this area included the Queets, Quinault, Klallam, Ho, Elwha, Vance Creek Twana, Skokomish and the Quileute. The forests offered a plentiful selection of roots, berries and wildlife for the Indians to survive on, with diets supplemented by a wide variety of seafood. They also fished the rivers for spawning salmon which often were dried for later consumption.

The first documented meeting between the Europeans and Native Americans who lived on the Olympic Peninsula occurred in 1775, when Spanish soldiers came ashore near the Hoh River. They were attacked and killed, as were many other Europeans and Americans who explored the area in later years.

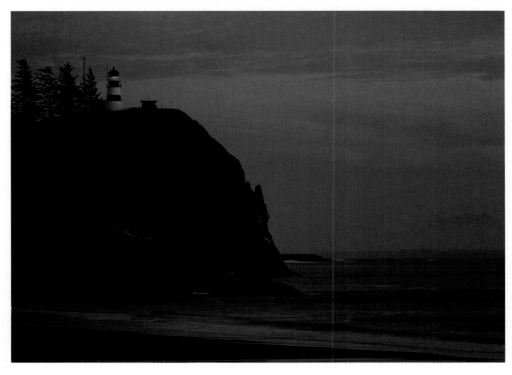

Left: Sunset on Rialto Beach, Olympic National Park, Washington.
PHOTO BY CARR CLIFTON

Right: Cape Disappointment Light. John Meares, a British explorer, named Cape Disappointment after his lack of success in finding the entrance to the great river thought to be the Northwest Passage from the Pacific Ocean to the Atlantic Ocean. Fort Canby State Park, Washington.
PHOTO BY CHUCK PLACE

OLYMPIC NATIONAL PARK...

Although Olympic National Park is the most visited place on the Washington Coast today, it was not explored or mapped until the late 1880's and the early 1900's.

Surrounded by water on three sides, the isolated Olympic Peninsula's more than 6000 square mile region is home to several diverse environments including miles of rugged shoreline along its western boundary with the Pacific

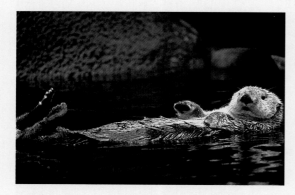

Above: Sea otters were exterminated during the previous century by fur traders. In 1969, a group of sea otters was reintroduced and have fared well.
PHOTO BY FRED HIRSCHMANN

Ocean, its northern border at the shores of the Straits of Juan de Fuca and its eastern edge on the Puget Sound.

The Olympic Peninsula's Pacific coastline is constantly changing as winter storms throw huge waves, some up to thirty-feet high and more, against rocky headlands, ripping rocks into the sea, to be ground into ever smaller pieces until it remains only as sand. In places with less exposure to the surf's pounding the headlands become islands, which are in turn reduced to seastacks and finally remain only as rocks offshore. In areas with the most exposure to the Pacific the shoreline has places eroding more than 300 feet every hundred years.

Offshore, several species of cetaceans–warm-blooded, air-breathing sea mammals–can be found including gray, blue, fin, humpback, minke, sperm, sei, pilot, orca (killer whale) and several other species of whales, dolphins and porpoises.

Sea otters were completely eradicated from the region by fur traders during the last century who found markets for the otter's luxurious pelts so lucrative they put themselves out of business by harvesting them down to the last animals. In 1969, a group of sea otters was reintroduced in the region and have aided in reducing the sea urchin, a favorite sea otter food, population along the coast. Urchins compete for habitat with kelp, removing the urchins has allowed kelp beds to grow, which reduce wave action thereby slowing shoreline erosion. River otters are found along the coast in streams and on beaches but spend only part of their lives in

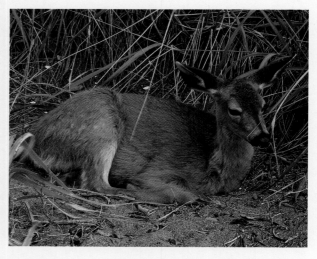

Above: Mule deer (Odocoileus humionus) bedded down in beach grass at Cape Alava in Olympic National Park.
PHOTO BY FRED HIRSCHMANN

the water, unlike the sea otters which even give birth to their young in the ocean. The otters share offshore waters with five species of pinnipeds (fin-footed mammals): northern sea lions, elephant seals, harbor seals, northern fur seals and Steller sea lions.

Olympic National Park's more than 50 miles of coastline support several species of clams, sea urchins, crabs, barnacles, snails, algae, mussels, anemones, kelp, sea stars and other intertidal zone creatures and organisms. These species can be viewed in tidepools along the shore at low tide. Beaches along the Olympic National Park coastline are sometimes difficult to access but will reward the determined hiker with beautiful views and unspoiled beaches. Care must be taken to assure that changing tides, or the occasional rogue wave, does not surprise the visitor or eliminate safe exits from the shore. Being swept offshore into the ocean along the northern Pacific Coast almost always results in disaster. Please do not to disturb life forms found within tidepools, each member forms part of an interrelated environment.

As difficult as access to the coastline of the Olympic Peninsula may have been for early explorers, charts of the forests and mountain regions of the peninsula were unavailable until 1885, when an expedition led by Lieutenant

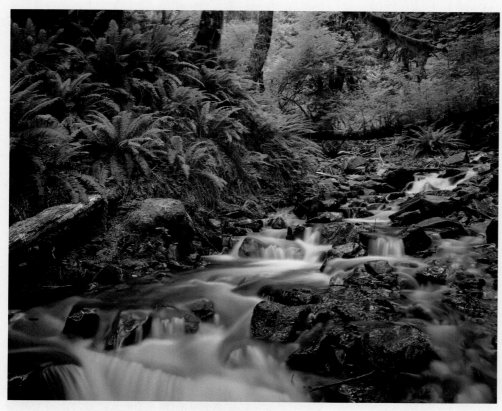

Left: Olympic National Park, Hoh Rain Forest, side drainage flowing into Hoh River with sword ferns (Polystichum munitum) lining the banks.
PHOTO BY JACK W. DYKINGA

Right: Wooden bridge over Soleduck Falls in Olympic National Park.
PHOTO BY CHUCK PLACE

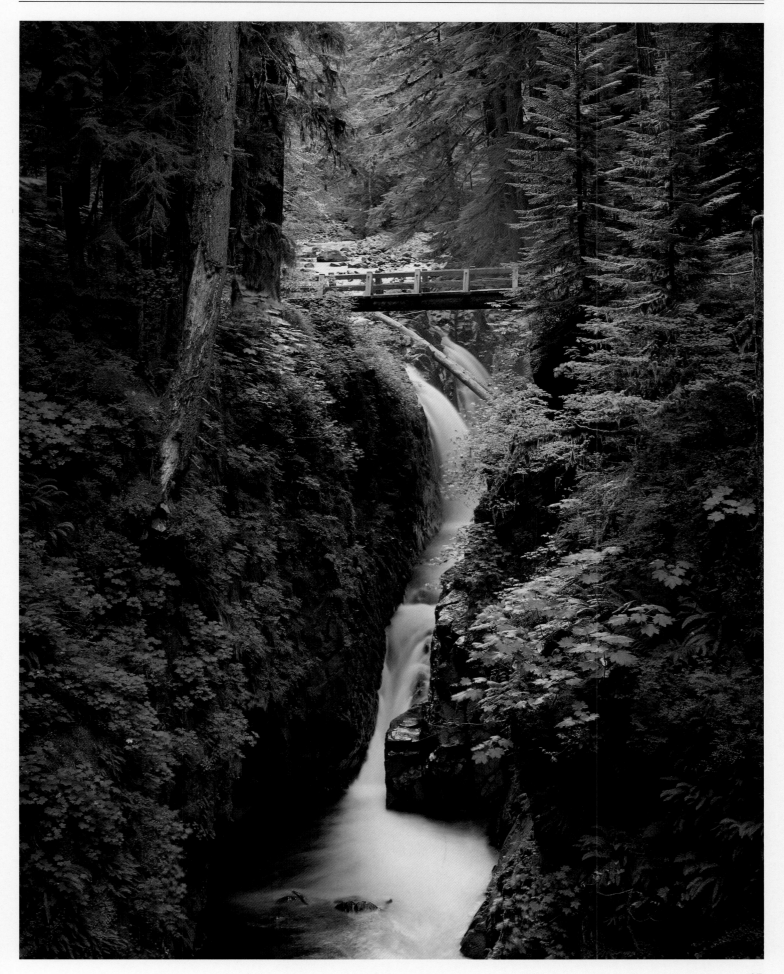

Joseph P. O'Neil forged a mule trail to Hurricane Ridge. In 1889, the Seattle Times sponsored James H. Christie in what became known as the *Press Expedition*, a five and a half month journey from Port Angeles, on the Strait of Juan de Fuca, to Lake Quinault on the southern border of what is today's Olympic National Park. This trip is now hiked in less than a week, thanks to the trail blazing of the Press Expedition and the tireless and ongoing efforts of the Park Service.

The past few decades has done much to advance the study of forests and the relationships of the organisms found within forest environments. Scientists have discovered relationships between above-ground plants and fungi that show the fungi aiding tree and plant roots in absorbing water and nutrients in exchange for the plant sending food it processes through photosynthesis, a process that must include the sunlight unavailable to the below-ground fungi. Mushrooms, the reproductive organs of an underground fungus, are often connected below the surface to common fungi. Several different species of plants and trees can often be found connected by mycorrhizae, a network of hair-like fibers joining fungi and tree root hairs. Great portions of a forest environment may be interconnected by mycorrhizae.

There are three temperate rain forests located on the seaward side of the Olympics. The Hoh, Queets and Quinault rain forests each receive up to 150 inches of rainfall annually, more than any other area in the continental United States. This heavy rainfall coupled with the additional moisture formed from dense coastal fog creates

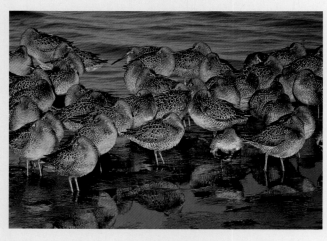

Above: A flock of short-billed dowitchers rests in shallow waters as the sun fades into twilight. Wildlife of Olympic National Park was protected by the park's formation in 1938.
PHOTO BY ART WOLFE

a perfect environment for Sitka spruce, western hemlock, Douglas fir, western red cedar and big-leaf maple that join maidenhair fern, oxalis, trillium, blackberry, sword fern and other lush plants in this forest habitat. The big-leaf maple attracts epiphytes, plants that grow on other plants without becoming parasitic. Epiphytes receive sustenance through rain and air and are usually harmless to the host tree, although sometimes the weight of the epiphytes can cause limbs to fall from the trees. The mosses, ferns, lichens and liverworts that cover big-leaf maple trees, a few of the more than 130 species of epiphytes found in Olympic National Park, add to the vast amount of biological material, up to a million pounds per acre, found in the temperate rain forests of the Northwest, the highest concentrations of organic material found in any ecosystem in the world. The rains that feed these forests flow into the many surging rivers tumbling down the mountain to the ocean, thus completing the cycle of precipitation.

The beauty of the Sitka spruce stands found on the offshore seastacks is as rugged as the temperate rain forests are delicate. Surrounded by crashing waves and pounded by wind and sea spray, the Sitka spruce specimens here often are gnarled and develop large burls.

The lowland forest features grand fir instead of the Sitka spruce, although occasional spruce can be found, red alder, Douglas fir, western hemlock and Pacific madrone, which has a bright orange bark. In higher elevations of the Olympic Mountains Douglas fir, silver fir and western hemlock are prevalent.

The subalpine forest is covered with snow until late in the summer and the subalpine fir, Alaska cedar and mountain hemlock found in these elevations often is stunted from the weights of heavy snowfalls.

The Alpine meadows above the subalpine zone are devoid of trees. Here snow is still on the ground in August and in some places ice and snow never melts. Wildflowers and low ground covering plants are only exposed for short periods in late summer and early fall.

High above the forest sits Mount Olympus with its three peaks, the highest being West Peak with an elevation of 7,965 feet above sea level. The rugged tips of the Olympics were carved by glaciers that have scraped out the earth to create a cluster of peaks and valleys. Over sixty of these glaciers are still present in the mountain range today. Many can clearly be viewed from Hurricane Ridge on the north side of the park. Snowfall near the top of the Olympics often reaches 200 inches annually.

Olympic National Park's diverse forest environments, constantly changing coastline and spectacular Olympic Mountains are home to a

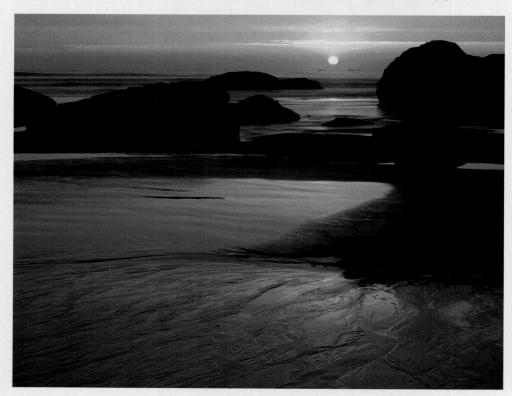

Left: The sun's yellow sphere about to set into an orange sea in a September sunset at Hobuck Beach, Mukkaw Bay, on the Olympic Peninsula.
PHOTO BY JEFF GNASS

Right: Drift logs line the banks of Kalaloch Creek estuary at seashore in Olympic National Park.
PHOTO BY GREG VAUGHN

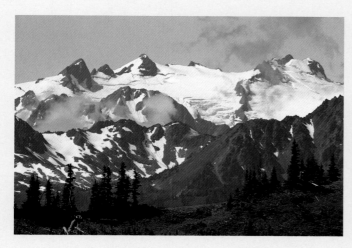

Above: Snow-covered slopes of Mount Olympus from Hurricane Ridge in Olympic National Park. Mount Olympus was named after the mythical Greek God by Captain John Meares in 1788.
PHOTO BY GLENN VAN NIMWEGEN

wide variety of wildlife including Roosevelt elk, mountain lion (or cougar), Olympic marmot, snowshoe hare, Columbia black-tailed deer, Olympic chipmunk, flying squirrel, bobcat, river otter, Olympic short-tailed weasel and fisher can be found in addition to rodent species.

Historically, a number of species commonly found throughout other areas of the Northwest

Left: Western rhododendron and beach pine in Oregon Dunes National Recreation Area.
PHOTO BY DICK DIETRICH

have not been found on the Olympic Peninsula, although red fox and porcupine are now appearing.

Bald eagle, ruffed grouse, great blue heron, red-tailed hawk, black oystercatcher, belted kingfisher, blue grouse and ravens are but a few of the many bird species found in the Peninsula's diverse natural habitats.

For more than two thousand years Indian cultures living on the Olympic Peninsula left few signs of damage to the environment or its inhabitants. Skilled at harvesting the regions plant and animals for the survival of their people, they did not destroy huge tracts of land with clear cutting nor did they eliminate entire species by their greed, unlike the white-men who arrived in the past two hundred years. Luckily, dedicated men and women were able to preserve large tracts of this splendid wilderness.

President Grover Cleveland designated the Olympic Forest Reserve in 1897 in an act to prevent logging interests from eradicating the

forests of the Olympic Peninsula. In 1909, then President Theodore Roosevelt raised the forest reserve's status to that of national monument, protecting wildlife including Roosevelt elk since named in his honor. In an act that further preserved the flora, fauna and natural resources of the Olympic Peninsula President

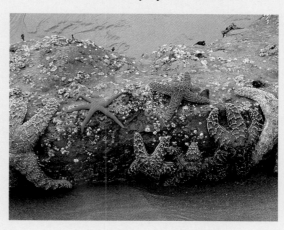

Above: Multicolored starfish cling to a rock at low tide at Second Beach. Starfish feeding habits often cause problems in oyster and mussel beds.
PHOTO BY TOM TILL

Franklin D. Roosevelt signed a bill creating Olympic National Park in 1938.

Following pages: A heavily forested seastack at sunset in Olympic National Park.
PHOTO BY DICK DIETRICH

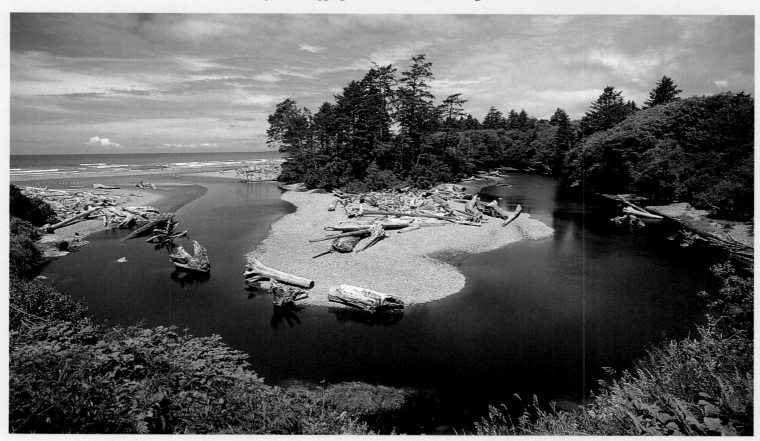

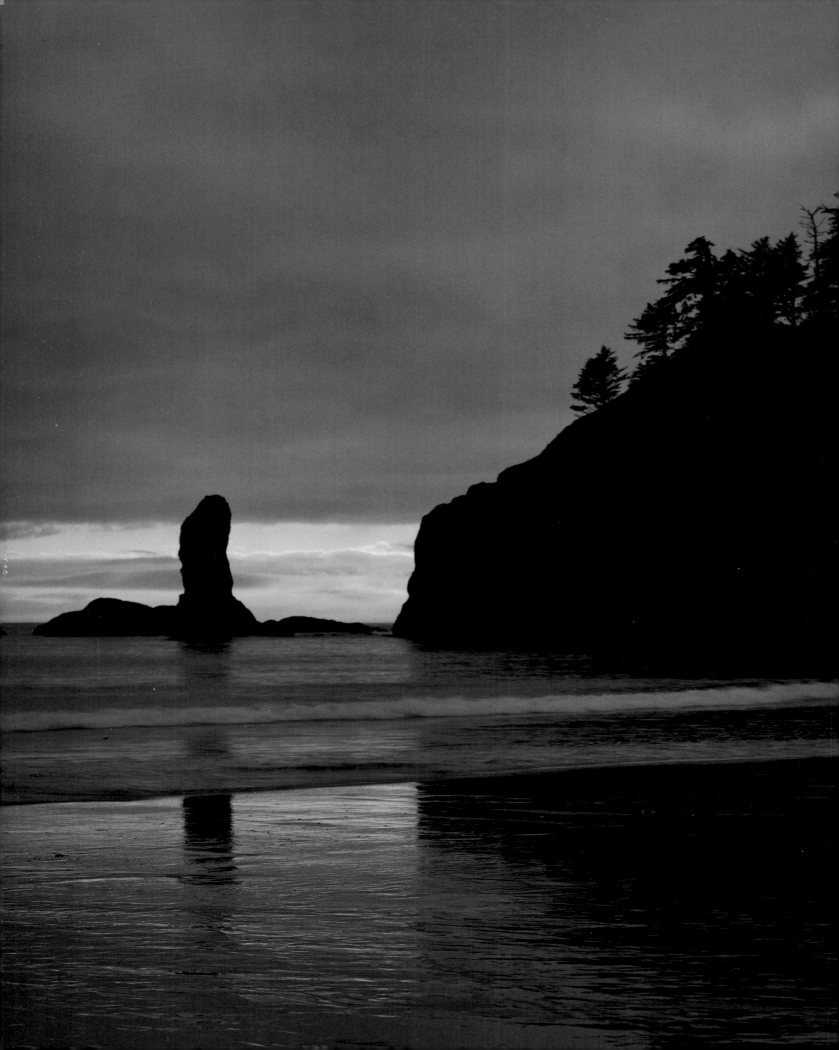